ITALIAN ART

1500-1600

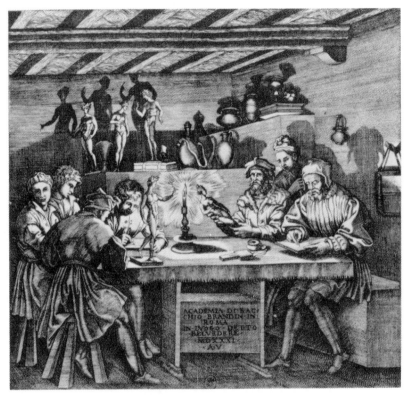

The Academy of Baccio Bandinelli, *1531, engraved by Agostino Veneziano after Bandinelli*

Italian Art

1500—1600

SOURCES and DOCUMENTS

Robert Klein

Henri Zerner

NORTHWESTERN UNIVERSITY PRESS

Evanston, Illinois

Northwestern University Press
Evanston, Illinois 60208-4210

Copyright © 1966 by Prentice-Hall, Inc., Englewood Cliffs, New Jersey.
Northwestern University Press edition published 1989 by arrangement with
Prentice-Hall, Inc. All rights reserved

Printed in the United States of America

Second printing, 1994

ISBN 0-8101-0852-6

Library of Congress Cataloging-in-Publication Data

Klein, Robert, 1918–1967.
 Italian art, 1500–1600 : sources and documents / Robert Klein and
 Henri Zerner.
 p. cm.
 ISBN 0-8101-0852-6
 1. Art, Italian—Sources. 2. Art—16th century—Italy—Sources.
 3. Art—Early works to 1800. I. Zerner, Henri. II. Title.
N6915.K55 1989
709'.45'09031—dc20 89-38657
 CIP

The paper used in this publication meets the minimum requirements of the
American National Standard for Information Sciences—Permanence of Paper for
Printed Library Materials, ANSI Z39.48-1984.

Contents

8. On Beauty *177*

Index of Artists *193*

Introduction

The Italian Cinquecento has left us with more documents on art and artists than any other era previous to it; to the natural growth in the quantity of texts is added the more important trait that they are no longer principally archival documents. The same men who created the history and criticism of art almost from scraps tried to see the art of their own time in a critical and historical perspective, and thus to leave a coherent picture of it for posterity. It is obvious that later historians could not accept this picture unaltered, but most fortunately the Cinquecento was less mistaken than most periods about the value of its artists; there are few misunderstood artists (Lotto, Schiavone, the late Pontormo), and those who were most controversial, like Bandinelli, were worth the discussion. Late in the century, public misconceptions seem to have become more numerous, but happily the error was usually an excess of admiration rather than an ill-placed disregard.

In brief, the rise of critical and historical consciousness during the 16th century has acted upon the documentary sources which have come down to us: the texts have become more numerous than before; often they are already written, selected, or grouped for the future reader or historian; and they comprise several entirely new categories of documents.

TYPES OF SOURCES AND DOCUMENTS

Raw Material

The historian of western art is provided with a set of records, official or not, which serve as a source without being originally meant as such. However varied they may become with closer periods, their exploitation always depends on the classic methods of history. This raw material is found, for instance, in parochial registers, income tax statements, inventories, accounting books, wills, records of civil, penal, or ecclesiastical law suits, the registers of guilds, official letters of recommendation, the statutes of brotherhoods and academies, and, in some cases, private letters.

Another group more specifically related to the history of art com-

prises records and documents which concern particular works of art. Some of these may be found in archives: contracts, payments, consultations of experts, projects, etc.; others may have been designed for publication, such as iconographic programs furnished for the artist or by him, and critical discussions. The inscriptions and signature which the work itself may bear belong to the same category. Of course, the visual evidence, such as sketches, models, copies, and so on, goes into the same files and undergoes the same historical criticism. Already in the Middle Ages major religious architectural enterprises had instituted archives with a great wealth of documents. Profane art was less fortunate: for example, the account books of treasuries are much less informative. But in this respect the Cinquecento showed striking originality. A commission given to a great artist became an important business and was dealt with as such; the wealth of evidence concerning the tomb of Julius II is explicable because neither the successive popes nor the heirs of Julius II could afford, in view of their immediate prestige and future reputation, to let any opportunity escape of employing Michelangelo. For many important works, the files now contain documents which were scarce or hitherto unknown: signed iconographic programs, commentaries, publicly printed letters announcing the acquisition of a painting by a prince, booklets describing a public festival and preserving the memory of its ephemeral artistic decor.

In a third group may be considered the artist's own notes and private records. Developed from accounting books and family records, *ricordi* sometimes take a more personal tone, become diaries, and can be elaborated into autobiographies. This is an entirely new development, obviously related to the liberation of the artist's personality during the Renaissance.

Let us add that private correspondence can not be summarily classified under any of the three groups. Letters may contain one chance allusion to art, or be entirely concerned with it. They go from almost illiterate, informal notes to elaborate epistles written with a definite view to publication. The great prestige of the epistler, which made statesmen out of humanist chancellors, was not yet entirely damaged by print; Bembo commanded it, and Aretino, who drew his income from it, made it serve art criticism. It required a Michelangelo to write letters at once so powerful in personal expression and with so little literary care in their composition.

Historical and Critical Literature

Halfway between purely informative description and art criticism, there appeared a kind of work entirely new to Christian Europe: the

what one called "the aim of art"—whatever this might be according to the particular writer and context. Moral, religious, and literary considerations, as well as novelties of history and criticism, find their place in writers like Armenini, Comanini, or Lomazzo, in addition to the scientific data, or rather, are inseparable from them.

Art is now so little isolated from literature and philosophy that a kind of treatise which up to then was entirely foreign to art and its history begins to have some source value for us: the writings on beauty and love. For a long time discussions on these themes had remained strictly philosophical, often scholastic, and mostly ornamented with literary formulae; in the 16th century, for the first time, they tangibly reflected the evolution of style and the opinions of lovers of art.

SOCIAL STATUS OF THE ARTIST AND IDEAS ON ART

The full significance of the ideas and discussions of art can only be understood in relation to something which such discussions rarely include: the social status of the artist.

Art as a Liberal Profession and the Gentleman Amateur

It has been often pointed out that the claim of the visual arts to the rank of liberal arts came from the artist's will to escape the protective rules of guilds. This controversy runs through the 15th century; and its importance becomes obvious when one remembers that the guilds usually forbade artists to work in a city where they were not registered as masters; the guilds could furthermore prevent a bronze sculptor from making marble statues, and vice versa. As one would expect, the politically powerful inevitably obtained the necessary immunities for the artists whom they patronized until the obsolete regulations were either forgotten or abolished. In the 16th century the struggle was over, and if a guild happened to sue an artist, its case was lost almost in advance.

Nevertheless, by freeing himself from the guild, which, to a point, guaranteed him a market and customers, the artist became almost entirely dependent upon the patron who had helped him to free himself. For some time, particularly in the 15th century, some artists like Leonardo could hope for ideal conditions by adopting the status of free-lance technicians or engineers called from city to city and from court to court, sometimes with several functions at the same time: architects, festival organizers, machine builders, military advisers. In the 16th century, with the decline of the art-science ideal, the engineer was

replaced by the poet as a model. Art had become an ornament of social life, and often the artist was treated as a friend of his cultured employer. Collectors who were, along with the Church, the painter's most important customers, were not enthusiastic about a scientific art and preferred an agreeable, sophisticated, and musical one like Giorgione's or Raphael's.

This social status of the artist was viable, but dangerously unstable because there was no institutional system to guarantee the equilibrium of supply and demand. The artist had to advance through personal connections if he wanted to win public recognition, which had become his only chance for success. The workshops where he learned the crafts did nothing to prepare him for the new problems of the artist as man of the world. In addition, the stupendous success of a few giants had drawn far too many young men into art.

One can understand how eager the artists were to secure the only means of success that was more or less dependable—the friendship of a man of letters, like themselves attached to patrons, but the effective adviser of both artist and buyer. The helpful recommendation of such a critic was paid for in drawings or more important works. Aretino, who exploited the situation cynically, is the best known example, but there were many such friendships between artists and men of letters which—if discreet and disinterested like Raphael and Castiglione—were based on the same kind of relations.

The main positive contribution of the period was the generalization and the systematization of the cultural training of artists. They had to travel and to be acquainted with the art of other centers in order not to seem ignorant to their patrons. In addition, plaster casts and reproductive engravings soon contributed to keep them constantly informed. The differences between local schools and their respective traditions were consequently lessened, and fashions constantly changed. On the other hand, the art of the past was made available for the artists as a repertory of typical solutions to a great many problems. In turn, the cultured patrons wanted to be well informed, and their literary education naturally inclined them to an historical approach; thus the creation of the history of art as a phenomenon parallel with, and complementary to art criticism was encouraged and favored on all sides.

The New Servitudes and the Aspects of the Crisis

We have remarked that the moment of equilibrium, made manifest in Raphael's classical idealism and in the classical naturalism of Venice, corresponded in the relations between artists and the public to a situa-

artistic guidebook. It emerged slowly from a mixture of previous genres: eulogies of cities, local chronicles, and pilgrim's manuals. The appearance of guidebooks for visitors particularly interested in art occurred at the beginning of the 16th century; their number increased at the same time as their public. Late in the century, when there were already professional *ciceroni* in Rome, these books dealt even with private collections. With Bocchi's *Beauties of Florence* (1591), the genre is already mature, complete with suggested itineraries. This work implies such a cult for the Florentine artistic past that one feels the whole city had resigned itself to be content with the remembrance of bygone masters.

Artistic topography was, in fact, one of the principal foundations of the history of art. Marcantonio Michiel, who had before Vasari conceived a general work on the subject, started to collect his material by taking notes which were organized by cities and then by collections which he visited; he also had friends who gave him additional information on cities other than his own. Thus the inventory preceded the chronicle.

As for Vasari, literary sources seem to have played a more important part. He continued, to a certain extent, the tradition of biographies of famous men, which for a long time in Florence had been the consecrated form of historical writing on art; the example of Monsignore Giovio had recently confirmed this prerogative of the genre.

But it would be false to conceive of topography, the general chronicle, or biography as the sole and strictly independent ground from which a history of art could grow and thrive. First, one must take into account another kind of literature where art history could naturally find a place, the technical and theoretical treatise; it had a long tradition, exemplified by Ghiberti and Gauricus, and was to have an ample following during the 16th century. Secondly, Vasari has brilliantly proved that these genres were not mutually exclusive. If the general form of his *Lives* is that of the biography and the chronicle, he has adapted the organization of his material to the often topographical character of his information (particularly in the 1568 edition). And as often as possible, he has articulated the plan of his work by the insertion of technical and historical digressions. But for a long time, no one except Vasari was capable of such a powerful synthesis.

Art criticism does not have the same formal unity as history or guidebooks. It can be expressed in a great variety of forms, from the libelous sonnet affixed by night on one of Bandinelli's statues, to Gilio's turgid treatise. Criticism should be considered and classified according to its different purposes rather than by its outward presentation.

One purpose is related to the collecting of works of art and the development of the art market. Venice, city of great merchants and

admirable collectors, where artists even painted uncommissioned works at times and sold them later, was the first center of art criticism. With Aretino, this criticism was openly venal: it was meant to spread a friend's reputation or suggest an acquisition to a patron. But the Venetians developed criticism into something with a more general interest. Well aware of the specific character of their art, of its strength and weaknesses, they resolutely opposed it to that of Tuscany, and thus created a militant and argumentative criticism based on a well-defined taste.

The second reason for art criticism was moral and religious; in this case, the inspiration came principally from the Counter-Reformation. In spite of all sources and precedents that may be found for it—either obvious like the Fathers of the Church, or unexpected, like Aretino—the rise of censorial criticism around the middle of the century came as a shock. From then on, one had to reckon with it.

But the most interesting and fruitful criticism was that which, like Vasari's, was related to history. It was the only one which could understand and appreciate different styles in a positive way; the only one to make an effort to be fair to each artist. Thereby it gave a glimpse of a truth which was very hard for the 16th century to admit: the criteria of judgment should not be established *a priori,* but suggested in each particular case by the work itself. It is among historians that one finds the best critical insights formulated in the 16th century.

Art Theories and Treatises

The art treatise as a collection of precepts had been known in Europe for a long time. What changes during the Renaissance is its value as a source. It will now give us much more than the technical details which it aims to teach. This transformation started in the 15th century when art aspired to become a science and developed closer relations with natural philosophy and humanism. Afterwards there was an eclipse of the theoretical treatise during the first half of the Cinquecento. It was replaced by more literary discussions: controversies on the parallel between art and poetry, on the comparative merits of the figurative arts, and on their liberal character. These discourses, which may seem idle, served in fact to establish that art was not, after all, a science any more than it was manual labor—that, in the end, it was an activity by itself which one had to define as best one could through inadequate analogies with literature and music.

When, in the second half of the century, treatises became numerous again, they benefited from this discovery. The description of processes and what was considered the scientific basis of art (perspective, proportions, anatomy, optics) was continued, but now only as subservient to

tion unstable because of a lack of institutional foundations. This equilibrium was soon to be utterly upset.

With the growing prestige of art, the most important patrons—the Church and the sovereigns—stopped following the tone set by the collector-man of letters, and began to demand more specific and supposedly effective service from art in exchange for the commissions they distributed. Thus the free artist became a propagandist. All that had been said in apologies of art about its political, moral, religious, and didactic function took on a more concrete significance. If art was a kind of rhetoric, a means of persuasion, as had been claimed by those who assimilated it to the *trivium*, it had to prove it in action. Decorum, that fundamental criterion of classicism, became a key word for the stiffest conformism, either political, in the glorification of sovereigns, or religious, in the art of the Counter-Reformation. This all-important aspect manifested itself in art criticism, not only in obvious cases like the attacks on Michelangelo's *Last Judgment* or the elaborations on the decisions of the Council of Trent, but even in writers who intended to be unprejudiced in their writing on art: R. Borghini in *Il Riposo,* or Comanini in *Il Figino.*

As always when the artist's criteria do not coincide with the public's, there were misfits and bohemians, along with conformists. They did not turn to rebellion but, as with Cellini, for instance, to an exaggerated self-consciousness or susceptibility and to a taste for scandal. Cellini is by no means an isolated case, as is amply proved by his own descriptions of the Roman artistic environment. One can also observe, especially among young artists, a glorification of art for art's sake, which shocked the moralists of the Counter-Reformation, but which is only a normal counterpart to the conformism and exaggerated humility as exemplified by the old Ammannati.

The contrast between servile propaganda and eccentric freedom was one of the most striking symptoms of the crisis. Another appeared in the change in the development of amateurs. Better educated and informed as they were, the amateurs ended up by not trusting themselves any longer, but humbly following their artistic advisers; for the first time since antiquity artistic snobbery became a widespread phenomenon. The hedonism of the High Renaissance was now outdated; sometimes one even explicitly admitted that only artists were competent judges of art. This, of course, cast a serious doubt upon the social value of their whole activity. Still, the collector with little trust in himself could educate his sensibility and find some enjoyment in art; the theoretician was more seriously cut off from creative activity.

Artists and collectors had become familiar with the history of art and the distinction between different schools and styles; they could, therefore,

appreciate the value of personal expression which was theoretically unaccountable. But the theoretician stuck to the notion that the dignity of art was entirely dependent upon its intellectual content. These opposing views led to insoluble conflicts for writers between the dogmatic, humanistic, or rhetorical tendency and the historico-critical attitude. Among artists there was a definite and comparable split, particularly later in the century, between a noble ambition for large scale enterprises and a taste for the niceties of art, for subtle or bizarre experiments or for the mere virtuosity of handling.

These problems grew worse with time. An important material factor, the multiplication of young artists, made the situation hardly tenable. It is significant and rather comic that in the last suit over the liberal status of an artist (Genoa, 1590), the painters of the city were almost unanimous in demanding the protection of their corporative status against a competitor, G. B. Paggi, himself from Genoa, but established in Florence, who wanted to return. Provincial painters were, in Genoa as elsewhere, crushed by the "liberal" art of the international *virtuosi,* who were protected by the great. The Genoese Senate decided against the painters of the city.

The academies which were founded toward the end of the century improved the situation considerably. As their main task, they assumed the education of the young which had become impracticable in isolated workshops. The workshops did not have the necessary materials such as plaster casts, *écorchés,* etc.; nor could they offer more for an education than the technical training one learned while assisting as an apprentice. The head of the studio could not spare enough time for teaching, and often did not command the wide information on the movements in ideas and taste and the theoretical knowledge which had become indispensable for the intellectual preparation of new artists. This could be offered by the academies, which also established a new institutional scheme for the relations between artists and clients, distributed official commissions which supplied work for all, established criteria of judgment, assumed the responsibility of arbitrating the numerous quarrels between colleagues, and gave official certification to artistic reputations, although not always with perfect discrimination. They trained connoisseurs and established a doctrine which tried, as best it could, to solve the conflict between the dogmatism of theoreticians and the historico-critical empiricism of connoisseurs (the solution being a sort of idealism qualified by an eclectic recognition of several utilizable "manners"). The moral crisis brought about by the abolition of the guild system was not altogether solved, but the academies did a great deal to alleviate it.

* * *

Our purpose is to present a choice as varied as possible of both kinds of sources—raw documents and critical literature—and the problems treated in them. In addition, we have tried to let the historical evolution described above outline itself in the arrangement of the documents.

We have not tried to insert all the important writers or texts of the century (Comanini's *Figino* and Zuccaro's *Idea* have been omitted), and we have sometimes used extracts from the same writer or the same work in different chapters. We have hoped that the examples chosen would be as eloquent as possible in their illustration of each point.

All the translations not made specifically for this book, and which are used and reprinted with the authors' and publishers' kind permission, have been revised with reference to the original Italian and have sometimes been altered.

The original texts have very different origins, and the language changes considerably from one to another. But one feels a general difficulty of expression. In the elaborate texts, the aesthetic and critical terminology, which is borrowed for the most part from poetry or rhetoric, is often so inadequate that it obviously does not correspond to the author's meaning. Artists, on the other hand, who usually wrote fast and carelessly, left texts which would make no sense if literally translated. We have in all cases preferred giving a clear meaning which we believe to be implied by the text than to be faithful to the frequent confusion of the original. The reader will find himself confronted with sufficient obscurities in any case.

<div style="text-align:right">

ROBERT KLEIN
HENRI ZERNER

</div>

BIBLIOGRAPHY

BASIC LITERATURE

J. Schlosser Magnino, *La letteratura artistica,* 3d ed., enlarged by O. Kurz, Florence-Vienna: 1964; see pp. 189-457. Fundamental, with extensive bibliography. Quoted as Schlosser.

Sir Anthony Blunt, *Artistic Theory in Italy, 1450-1600;* Oxford: 1940.

R. W. Lee, "Ut pictura poesis: The Humanistic Theory of Painting," *The Art Bulletin,* XXX (1940).

Many interesting references and extracts in R. and M. Wittkower, *Born under Saturn,* London: 1963.

COLLECTIONS OF DOCUMENTS

G. Bottari and St. Ticozzi, *Raccolta di lettere sulla pittura, scultura ed architettura,* 8 vol., Milan:1822-1825. Quoted as *Lettere pittoriche.*

Giovanni Gaye, *Carteggio inedito d'artisti dei secoli XIV, XV e XVI,* 3 vol., Florence: 1839-1840. Quoted as Gaye, *Carteggio inedito.*

Robert Goldwater and Marco Treves, *Artists on Art,* New York: 1945.

E. G. Holt, *Literary Sources of Art History,* Princeton: 1947.

COLLECTION OF TREATISES

Paola Barocchi, *Trattati d'arte del Cinquecento, Fra Manierismo e Controriforma,* 3 vol., Bari: 1960-1962 (*Scrittori d'Italia,* no. 219, 221, 222). With extensive bibliography. Quoted as Barocchi, *Trattati.*

MEASUREMENTS USED IN THE TEXT

Braces:

Florentine	1 ft. 10 in. $\frac{7}{8}$
Milanese	1 ft. 11 in. $\frac{1}{4}$
Venetian	silk brace 2 ft. 1 in. $\frac{3}{16}$
	wool brace 2 ft. 2 in. $\frac{3}{4}$

Ounces are, in principle, $\frac{1}{12}$ of any measure, either foot, brace, or palm.

ACKNOWLEDGMENTS

For help and advice, we are grateful to the following persons besides our editors: Prof. André Chastel, John Friedman, Sharon Katić, Ida Mayer, and Prof. Rudolf Wittkower. Charles Rosen had the patience to go over the whole manuscript and was helpful at all stages of its preparation.

I

Art
and the
Cultured Public
(The High Renaissance)

INTRODUCTION

The study of anatomy, proportions, and perspective, the observation of nature, and the technical inventions during the 15th century gave to the visual arts the character of a natural science; around 1500, the artists and the public seemed once more to become aware that art was primarily an agreeable ornament of civilized life. It was at this point that innumerable collectors appeared who prided themselves on their connoisseurship; and many artists now gained an entry into the society of the aristocracy and the wealthy upper-middle class.

The comparison between the arts (paragone) was not a very rewarding theme for conversation. The great popularity this topic enjoyed during the High Renaissance proves the good will exerted both by artist and his public in order to understand each other's language (p. 4). A complete example of such a conversation on art has been preserved in one chapter of Castiglione's Courtier (p. 16). Many of the most important texts on early 16th century art come from nonprofessionals: for example Sabba di Castiglione's description of the ideal dwelling of a gentleman collector (p. 23), or Marcantonio Michiel's descriptions of actual collections in and around Venice, in which the author's refinement of connoisseurship strikes us no less than the wealth of the private galleries (p. 25). Rome, where Raphael was the friend of the great and of the most distinguished minds, saw the creation of collections of antiques which were generously open to visitors; in Naples, the humanist poets Pontano and Sannazaro were well enough acquainted with artists and works of art for their friend Pietro Summonte to draw most of his information from them when he wrote the long report on the art of his city, which he sent to Michiel (1524). And the first guide of Florence comes from a priest who tried to make some money by writing, but was enough of a dilettante to have made his own project for the façade of the Cathedral (p. 30).

There is no document that satisfactorily illuminates the general ideas of the men—artists or patrons—who created the classic art of the High Renaissance; patterns borrowed from humanism and poetry muddled their written expression and probably muddled their thinking. A brief and rather mysterious letter from Raphael to Castiglione sheds a sharp but only tantalizing light (p. 32); Francisco de Hollanda's dialogues with Michelangelo express with remarkable precision not so much Michelangelo's ideas as those current among Italian artists of the late '30s (p. 33).

3

COMPARATIVE MERITS OF THE ARTS

The controversy or comparison (paragone) *between the different arts and sciences was an extremely frequent literary theme during the middle ages. The disputation on the superiority of either painting or sculpture is only the last and most persistent instance; Galileo was still to add his opinion on the matter.*

The concrete reason for the controversy was that the artists (artifices) *claimed the right to be admitted among the members of the seven liberal arts* (artistae), *which would free them from corporative rules and restrictions, and secure them a higher social status. The original* paragone *opposes the visual arts to intellectual or liberal disciplines, among which were poetry and music. But soon literary commonplaces gained ground in these disputes, and the painter, who had definitively proved that his profession was a science, engaged in quarrels of prestige with the sculptor. These quarrels sometimes became venomous, but remained without practical outcome.*

The abundance of documents on the paragone *in the first half of the century can be explained by the literary and genteel character of the debate; it was one of the most popular topics for conversation among artists and men of letters. In spite of the repetition and continuous reappearance of the main arguments, it is often possible through the choice of arguments and details to guess the true artistic convictions and interests of the writers: whether they appreciate more the effect of the work or the skill of the artist, whether, as humanists, they are moved by the dignity of the sculpture which preserves the memory of great men, or, as connoisseurs, are more sensitive to the richness and subtlety of pictorial effects.*

We start with some fundamental passages from Leonardo on the relation between painting and sculpture; these are fragments of a more comprehensive paragone *that included poetry, music, and even mathematics. Thus we can see that the discussion was still inseparable from the liberal and scientific claims of painting. The real importance which the problem had for Leonardo accounts in part for his extraordinary wealth of arguments. Varchi's enquiry represents the next stage, that of the friendly and rather pretentious exchange between artists and scholars. The extract from Pino is significant for the link between these discussions and actual artistic production.*

Leonardo on the Paragone

The so-called Treatise on Painting *by Leonardo is a collection of some of the painter's notes, transcribed and somewhat roughly arranged*

around the middle of the century by an unknown copyist. It consists largely of texts which can still be checked on Leonardo's original manuscripts. The manuscript of this treatise (Cod. Urbinas Latinus 1270, Vatican) was published only much later, and first in an abridged version, but even before publication it was widely known; Leonardo's ideas on the dignity of the arts are found, either used or attacked, in many texts of the 16th century.

Fragments from the Treatise on Painting [1]

51. *Difference between painting and sculpture.* I do not find any difference between painting and sculpture except that the sculptor pursues his work with greater physical fatigue than the painter, and the painter pursues his work with greater mental fatigue.[2] This is proved to be true, for the sculptor in producing his work does so by the force of his arm, striking the marble or other stone to remove the covering beyond the figure enclosed within it. This is a most mechanical exercise accompanied many times with a great deal of sweat, which combines with dust and turns into mud. The sculptor's face is covered with paste and all powdered with marble dust, so that he looks like a baker, and he is covered with minute chips, so that he looks as though he had been out in the snow. His house is dirty and filled with chips and dust of stones. In speaking of excellent painters and sculptors we may say that just the opposite happens to the painter, since the well-dressed painter sits at great ease in front of his work, and moves a very light brush, which bears attractive colors, and he is adorned with such garments as he pleases.[3] His dwelling is full of fine paintings and is clean and often filled with music, or the sound of different beautiful works being read, which are often heard with great pleasure, unmixed with the pounding of hammers or other noises.

Furthermore, the sculptor in carrying out his work has to make many contours for each figure in the round, so that that figure will look well from all sides.[4] These contours are produced by the meeting of high and low areas of the stone, which he cannot place accurately unless he retires and views it in profile, that is, when the boundaries of concave areas and those in relief are seen in silhouette against the air that touches

1 English translation and reference numbers from Leonardo da Vinci, *Treatise on Painting*, ed. A. Philip McMahon (Princeton: Princeton University Press, 1956), pp. 36-38, 40-43. Reprinted by permission of Princeton University Press. Material in brackets is newly translated by Klein and Zerner.

2 This is the theme developed in this whole section. Physical fatigue characterizes mechanical arts, and mental fatigue, liberal arts.

3 The same argument already appears in Cennini's *Libro dell'arte.*

4 This argument, often used by sculptors, is introduced here by Leonardo who will show that it applies to painting as well.

them. But truly this does not [make the work of the sculptor more diffi-cult], considering that he, as well as the painter, has true knowledge of all the outlines of things seen from any side whatever, a knowledge that is always [virtually present to] the painter as well as the sculptor.

But the sculptor, having to remove stone where he wishes to leave intervals between muscles, and to leave it where he desires to show those muscles in relief, cannot create them with the right shapes, beyond getting their length and breadth, unless he leans across the stone, bending over and raising himself up in such a way that he sees the true height of the muscles and the true depth of intervals between them. These are judged by the sculptor who must place himself in that position, and thus the contours are corrected, otherwise he could never make the contours or the form of his sculpture well.

They say this is a mental fatigue for the sculptor, although his fatigue is only physical. So far as his mind or judgment is concerned, he has only to correct in profile the portions where the muscles project too high. This is the proper and ordinary way for the sculptor to bring his work to completion, and is ordinarily carried out with true knowl-edge of the contours of the figure from every side.

The sculptor says that if he takes off too much of the outer portion of his material, he cannot add to it later as can the painter.[5] The reply to this is that if his art were perfect, through knowledge of the measure-ments, he would have removed just enough and not too much of the covering material. Excessive removal of material arises from his igno-rance, which makes him remove more or less than he should.

But I am not really speaking of such as these, for they are not masters but wasters of marble. Masters do not depend on the judgment of the eye, because it is deceptive, as is proved when one wishes to divide a line into two equal parts by means of the judgment of the eye, and there experience shows it often to be deceptive. Because of this uncer-tainty good judges always fear what the ignorant do not, and therefore they are continually guided by knowledge of the measurement of each dimension, length, and breadth of the limbs, and when they do thus, they do not remove more than they should.[6]

The painter has ten different subjects to consider in carrying his work to completion: light, shadow, color, [volume, outline,] location, distance, nearness, motion, and rest. The sculptor has to consider only [volume, outline,] location, motion, and rest. He does not need to be con-cerned about darkness or light, because nature itself creates these for his

5 See pp. 11-13.

6 Leonardo's confidence in measurements is the consequence of his scientific turn of mind. It explains the excess of his theory of human proportions. Michelangelo and V. Danti were to reply by stressing the importance of the judgment of the eye.

sculpture, and about color there is no concern at all. He concerns himself
moderately about distance and nearness. He employs linear perspective
but not that of color, although at different distances from the eye, color,
and clarity in the contours and forms of figures vary.

Therefore sculpture has fewer matters to consider and consequently
is less fatiguing to the mind than is painting.

A Comparison of Painting and Sculpture

54. *The difference between painting and sculpture.* The first
marvel that appears in painting is that it appears to be detached from
the wall or other flat surface, and deceives those of subtle judgment as
it is really not separated from the surface of the wall. In comparison with
this the sculptor creates his works so that they appear as they are.[7] And
this is the reason that the painter needs to understand the shadows that
go with lights. The sculptor does not need this knowledge, because nature
aids his works, as it does all other objects which are all of the same color
when the light is gone, and . . . when the light is returned, [they are of
different colors, bright and dark].

The painter's second task is to evaluate with care the true qualities
and quantities of shadows and lights. Nature provides these for the sculp-
tor's work.

The third thing is perspective, which is the most subtle discovery
in mathematical studies, for by means of lines it causes to appear distant
that which is near, and large that which is small. Sculpture is aided by
nature in this case, which accomplishes its end without any artifice of
the sculptor.

55. *Comparison of painting and sculpture.* Painting is a matter
of greater mental analysis, of greater skill, and more marvelous [than
sculpture, since necessity compels the mind of the painter to transform
itself into the very mind of nature, to become an interpreter between
nature and art. Painting justifies by reference to nature the reasons of
the pictures which follow its laws: in what ways the images of] objects
before the eye come together in the pupil of the eye; which, among ob-
jects equal in size, looks larger to the eye; which, among equal colors will
look more or less dark or more or less bright; which, among things at
the same depth, looks more or less low; which, among those objects placed
at equal height, will look more or less high, and why, among objects
placed at various distances, one will appear less clear than the other.

This art comprises and includes within itself all visible things such
as colors and their diminution which the poverty of sculpture cannot

[7] The same opposition could lead to the contrary conclusion as in Michelangelo's
letter (cf. pp. 13-14).

include. Painting represents transparent objects but the sculptor will show you the shapes of natural objects without artifice. The painter will show you things at different distances with variation of color due to the air lying between the objects and the eye; he shows you mists through which visual images penetrate with difficulty; he shows you rain which discloses behind it clouds with mountains and valleys; he shows the dust which discloses within it and beyond it the combatants who stirred it up; he shows streams of greater or lesser density; he shows fish playing between the surface of the water and its bottom; he shows the polished pebbles of various colors lying on the washed sand at the bottom of rivers, surrounded by green plants; he shows the stars at various heights above us, and thus he achieves innumerable effects which sculpture cannot attain.[8]

The sculptor says that bas-relief is a kind of painting. This may be accepted in part, insofar as design is concerned, because it shares in perspective. But with regard to shadows and lights, it [is false. The lighting of bas-relief would be false both in sculpture and in painting, because the shadows of bas-relief are of the same nature as those of the full-relief, as seen in the shadows of foreshortenings, which do not occur in the shading of painting and sculpture].[9] This art is a mixture of painting and sculpture.

56. *The painter and the sculptor.* The sculptor says that his art is more worthy than painting, because his work is more enduring, for it has less to fear from humidity, as well as fire, heat, and cold, than does painting.

The reply is that this does not make the sculptor more worthy, because this permanence comes from the material and not from the artist. The same kind of permanence can also be found in painting when it is done in enamel on metals, or terracottas, which are fired in a furnace and then polished with various instruments that give a smooth and lustrous surface. These can be seen in several places in France and Italy, and most of all in Florence among the della Robbia family, who have discovered a way to carry out every kind of great work in painting on terracotta covered with glaze. It is true that this sort of painting is subject to knocks and breaks, as is also sculpture in marble, but not to destruction . . . as are figures in bronze. With regard to durability it is equal to sculpture and surpasses it with regard to beauty, since in it are combined the two perspectives,[10] but in sculpture in the round there is no perspective except that found in nature.

8 This list comprises only transparency or semi-transparency effects; it amounts to saying that sculpture deals with solids and painting with their luminous environment.

9 The text is obscure, probably corrupted, and our translation is conjectural.

10 These are linear perspective and color perspective.

In making a figure in the round, the sculptor makes only two forms, and not an infinite number for the infinite number of points of view from which it can be seen; one of these forms is seen from in front and the other from in back. This is proved to be so, for if you make a figure in bas-relief which is seen from in front, you will never say that you have put more of the work on display than a painter would do with a figure made from the same point of vantage and the same thing happens with a figure seen from the back.

But bas-relief requires incomparably greater thought than that which is wholly in relief and somewhat approaches painting in concept, because it is indebted to perspective. Work wholly in relief is not troubled at all about the problem, because it employs the simple measures that it finds in life, and therefore the painter learns sculpture more quickly than the sculptor does painting.

But to return to the claim of what is called bas-relief, I say that it requires less physical fatigue than work wholly in relief, but far more study, since it requires consideration of the proportion of the distances which lie between the first and the second planes of bodies and those from the second to the third and so forth in succession. If these are being considered by you, master in perspective, you will find no bas-relief which is not full of errors, with regard to the greater or lesser relief required by the parts of the body, in relation to their distance from or proximity to the eye. There is never any error in total relief because nature helps the sculptor, and therefore he who works in total relief is freed of this great difficulty.

There exists a basic enemy of the sculptor who works in the round as well as in bas-relief. His works are worth little if the light in which they are seen is not adjusted so that it is similar to that of the place in which it was made. If the light is from below, the works will appear distorted, and this will be so most of all in bas-relief, because of shadows cast in a direction opposite to that intended, almost eliminating recognition of the work. This cannot happen to the painter who, after having placed the limbs of his figures properly, turns to two functions of nature which are very great, which are the two perspectives, and also to the third great factor which is the brightness and darkness in shadows and lights, of which the sculptor is ignorant and in which he is aided by nature in the way in which it aids other visible things, natural as well as artificial.

Varchi's Inquiry

Following two lectures on the arts delivered in Florence in 1546, Benedetto Varchi (1503-1565), one of the most prominent intellectuals of

the *Medician court, had the idea of making an inquiry among the artists about the* paragone; *he obtained answers from Vasari, Bronzino, Pontormo, Tasso, Francesco da Sangallo, Tribolo, Cellini, and Michelangelo. Almost all apologized for their poor style of writing by calling themselves "only artists." Varchi himself, in his lectures, had given his exposition of the problem, which he concluded tactfully, as he had to, by saying that the figurative arts are essentially identical in that they pursue the same end. Trying to sum up the artist's opposed points of view, one could say that most of them grant the advantage of "reality" (as opposed to appearance) to sculpture, and the merit of skill to painting.*

Although it is incomplete, we have chosen Bronzino's answer because it organizes all the required points with exemplary clarity; conscientiously, Bronzino does not hesitate to present Varchi with the very arguments and counterarguments which he had drawn from the latter's discourse. The most representative defender of sculpture was of course Michelangelo; Cellini, in his passionate reply to the painters, constantly referred to the master's authority and described his workshop habits, though perhaps not accurately. At all events, Michelangelo's own late, short, and grudging answer to Varchi's inquiry leaves no doubt as to his position in the debate.

Bronzino: Answer to Benedetto Varchi [1]

My intention, most able Messer Benedetto, is to be as clear and as short as I can in writing you which of the two most excellent manual arts, i.e., painting and sculpture, holds the first rank. Stating the arguments first in favor of one and then of the other, I shall compare them so that it will be possible to see which of the two should be preferred. And since I intend to take sides, and indeed believe myself to be on the right side, i.e., on the side of painting, I shall now present its defense, stating, nevertheless, the opposite arguments as faithfully as I can. The subject, however, is really very difficult and would need long and careful consideration; therefore I do not promise to discuss it fully, but, as I said, only as clearly and as briefly as I can.

Those who practice sculpture or who take its part, are wont to put forth, among other arguments, that sculpture seems to be more permanent than painting, and for that reason they insist that it is much more beautiful and noble; they argue that, when a work is brought to ultimate perfection after long efforts, it is enjoyable for a longer time, and, therefore, it will for a longer time bring back the memory of those times when or for which it was made; thus, it is more useful than painting. They also say that a statue requires much more effort than a painted

1 Barocchi, *Trattati,* I, 63-67.

figure, because of the very hard material such as marble, porphyry, or other stones. They also add that since [in sculpture] you can not put back something where you have taken something away, so that when you have maimed a figure it can not be mended, while in painting one can remove and rework indefinitely, sculpture requires much greater skill and needs much more judgment and care than painting; it is, therefore, both nobler and worthier. They add this: both arts must imitate and resemble Nature, which is their master, and Nature's works are three-dimensional and can be touched with the hand; painting is only an object of vision and of no other sense, while sculpture exists also in three dimensions in which it resembles Nature, and is an object not only of vision but of touch, too. For that reason, sculpture being known through more senses than painting would be the more universal and superior.

Then they go on to say that, since sculptors must almost always make their statues, whether nude or clothed, in the round, and free on all sides, they must take great care that the work looks well from all views, and if their figure has grace from one view, they must make sure that it is not deficient from the other views, which, when the eye goes around the statue, are infinite in number because such is the nature of the circular form. But this problem does not present itself to the painter, who, in each figure, never gives more than one view, which he chooses the way he wants; since he is satisfied if it is beautiful on the side he shows, he does not care what it would look like from the other view-points which can not be seen. For this reason, also, sculpture would be the more difficult. And following their reasoning, they say that it is far more beautiful and gives greater delight to find in a single figure all the physical attributes of a man, of a woman, or of an animal, such as the face, the chest, and the other parts, and when turning around to find the side and the arm, and what goes with them, and then from the back the spine, and to see how the front parts correspond to the side and the back, and to see how the muscles start and how they end; and to appreciate many beautiful harmonies, and, in sum, moving around a statue, to be totally satisfied with seeing it entirely; for this reason, sculpture would be more enjoyable than painting.

They want, furthermore, to elevate sculpture by saying that it is magnificently effective and a great ornament for cities, because it serves to make colossi and statues, either in bronze, or marble, or other material, that honor illustrious men, and adorn the land, and give those that see them the will to emulate the virtuous actions in order to be honored in the same fashion, whence follows the greatest glory and advantage. And they do not forget to mention that, in sculpture, one has to be very skillful to respect all the measurements, (e.g., of the heads and arms and legs, and all the other parts of the body), because verification is always

at hand and one can not cheat on any of the measurements, as one can in paintings, where there is less possibility of verification; and it is a source of satisfaction no less than of difficulty to find sculptures to be material and measurable at will, which does not always happen with painting. For this reason, sculpture would be less deceptive and more real. They also show that sculpture, besides the greatness of the skill, is of no small utility, since one can use its figures for architectural support instead of columns or corbels, or for water spouts on fountains, for tombs, or for an infinite number of other things that one comes across all the time, while with painting one can only make fictitious things of no utility other than giving pleasure. For this reason sculpture would be the more useful.

On the other hand, on the side of painting, there is no lack of answers to all the arguments brought forth in favor of sculpture; on the contrary, it seems to those who favor painting that there is more to be said for it than for sculpture. Answering the first argument—that sculpture is more durable because it uses a more solid material—they say that this is not to the credit of the art because it is not in its power, but in that of Nature, to make marble, porphyry, or any other stone, and that the art of sculpture is not to be praised for its durable materials any more than it would be if executed in clay, wax, stucco, wood, or any other less durable material, since, as everyone knows, art works only on the surface.[2] To the second argument they answer this way: while sculptors put forward their so much publicized difficulty of not being able to add to the work but only to take away, and what a great effort it is to apply their art because they have hard stone for material, the painters answer that if the sculptors mean the physical effort of chiselling, this does not make their art nobler, but that it rather diminishes its dignity, because the more the arts are exercised with manual and physical exertion, the closer they are to the mechanical crafts, and, consequently, the less noble they are. If it were not so, one would have to praise as beautiful [3] a great many arts that are considered inferior such as ditch-digging or cleaning cloth, or farriery, or others of the same kind. But if one means mental effort, the painters say that painting is not only equal but surpasses sculpture by far, as will be explained below. And as to not being able to put back anything when too much has been taken off, they say that when one speaks of the sculptor or the painter, one implies an accomplished master in either painting or sculpture, because one must not discuss those who were born only to disgrace either art; therefore, we

[2] Theme from Aristotle: Nature shapes its works from the interior, art from the exterior or from the surface.

[3] "Arti belle." The phrase which is rare, is synonymous here with liberal arts and not yet with what we call "fine arts."

ought not to believe that an outstanding sculptor chips off when he should not, because otherwise he would not do what his art requires, but he will make a complete model, where he can add and take off more easily than the painter, and then, transferring this model to the final work with exact measurements, he will not have to add anything for having taken too much away. But if, however, he should desire or need to add something, who is not aware how easily he can do it? Are not colossal statues made of many pieces? And how many statues have their busts, their arms, or whatever is missing remade? Not to mention the plugs that one sees in many statues that come out brand new from the hands of the artists with such patches. The art of sculpture does not consist in avoiding repairs, because when a statue should be made up of an infinite number of pieces, if it is still good, it does not mar the quality of the art.[4]

Answering the third argument, painters say that it is quite true that the purpose of both arts is the imitation of Nature, but which of the two comes closer to this end will be discussed later. Here we shall only say that sculptors do not imitate Nature more because they work in three dimensions, but that in fact they rather take over the object that was already made three-dimensional by Nature; so that rotundity, thickness, or anything else of that kind does not belong to art, because heighth and breadth and all the qualities of solids already existed in the material, but all that belongs to the art are the lines that outline such a body, which are on the surface; therefore, as we said, the three-dimensional existence does not appertain to art but to Nature, and the same objection also applies when they speak of touch, because, as it has already been said, to find that an object is three-dimensional is not a result of art.

UNFINISHED

Michelangelo: Answer to Benedetto Varchi [1]

MESSER BENEDETTO,

So that it may be clear that I have received your little book, which duly reached me, I will make such a reply as I can to what you ask, although I am very ignorant on the subject. I believe that painting is

4 The Medici used to have the ancient works of their collections restored. The colossus made up of many pieces which Bronzino is thinking of is probably the Laocoön. When it was discovered the joints were carefully studied.

1 English translation from Robert W. Carden, *Michelangelo, A Record of His Life as Told in His Own Letters and Papers* (London: Constable & Company, Ltd., 1913). Reprinted by permission of the publisher.

considered excellent in proportion as it approaches the effect of relief, while relief is considered bad in proportion as it approaches the effect of painting.

I used to consider that sculpture was the lantern of painting and that between the two things there was the same difference as that between the sun and the moon. But now that I have read your book, in which, speaking as a philosopher, you say that things which have the same end are themselves the same, I have changed my opinion; [2] and I now consider that painting and sculpture are one and the same thing, unless greater nobility be imparted by the necessity for a better judgment, greater difficulties of execution, stricter limitations and harder work. And to have this admitted no painter ought to do less sculpture than painting and no sculptor less painting then sculpture. By sculpture I mean the sort that is executed by cutting away from the block: the sort that is executed by adding resembles painting.[3]

Suffice that, since one and the other (that is to say, both painting and sculpture) proceed from the same faculty, it would be an easy matter to establish harmony between them and to let such disputes alone, for they occupy more time than the execution of the figures themselves. As to that man who wrote saying that painting was more noble than sculpture,[4] if he had known as much about the other subjects on which he has written, why, my serving-maid would have written better!

I could add an infinite number of things which have not yet been pointed out and which might be said about these arts, but, as I have already said, they would take up too much time and I have very little to spare, seeing that I am old and almost fitted to be numbered among the dead. For this reason I beg of you to excuse me. And I recommend myself to you and send you all possible thanks of the excessive and undeserved honor you do me.

[ROME, 1549]

<div align="right">YOUR MICHELANGELO BUONARROTI IN ROME</div>

Pino's Vindication of Painting

The Dialogo di pittura *by the painter Paolo Pino was published in Venice in 1548, precisely between the date of Varchi's inquiry (1547)*

2 It is quite obvious that Varchi's "philosophical" decision did not impress Michelangelo, who sticks to traditional criteria: the intellectual effort involved, the difficulties to be overcome, etc. This proves that Michelangelo was aware of the main lines of the discussion.

3 Sculpture executed "by adding" is modeling (and consequently also the art of bronze), which is considered inferior to marble sculpture. The distinction between the two methods "by adding" and "by taking away" is classic and can be found in Pliny.

4 Leonardo, of course.

and that of its publication (1549). The few pages where Pino deals with the paragone have, however, a striking resemblance to those of Varchi and his artists, which shows how stereotyped the discussion was.

The dialogue has a sort of good humored naïveté, a tone which distinctly reminds us of Renaissance comedy. In spite of the conventions of the literary genre, and even in its tedious commonplaces, it sometimes expresses an authentic Venetian artistic feeling. We have chosen two passages characteristic of this.

On the author and his book see p. 58.

On the author and his book see p. 58.

From the Dialogue on Painting [1]

Lauro: You should explain which art is nobler: painting or sculpture.
Fabio: All right, but you demand such a pronouncement from me as if I were the Master of the Sentences.[2] Since, however, our honor is at stake in this controversy,[3] I shall make an effort to show you what is obvious; but let it be understood that after this we will put an end to this discourse on painting.
La.: Just as you like.
Fa.: Many people have tackled this problem, and with greater acuteness than mine, and they have always argued that sculpture was nobler.[4] But since none of them was a painter,[5] it is not astonishing if they did not give this question a decisive answer. Since I want to speak about painting, I shall not repeat their arguments, but only defend our art with the arguments in its favor. Painting and sculpture were born together and were both produced by human minds to the same end and for the same purpose: to imitate and simulate natural and artificial objects. We come much closer to such an end than sculptors, in so far as they can only give their figures shape, which is mere being, but we painters, besides giving them shape and being, we adorn them with total existence, and this means that we also simulate the carnal body, where one notices the variety of complexions, the eyes as distinguished from the hair and from other parts, distinguished, that is, not only through shape but also through colors as they are distinguished in life. We can represent dawn, rainy weather, and in the imitation of artefacts we can make you dis-

[1] Barocchi, *Trattati*, I, 127-128 and 131.

[2] Petrus Lombardus. This reference to the medieval theologian, author of the *Book of Sentences*, is one of Pino's usual jokes; he plays on the legal sense of the word sentence.

[3] Both characters in the dialogue are painters and their professional "honor" is at stake.

[4] One year later, and also in Venice, Antonfrancesco Doni will write exactly the contrary in his *Disegno;* but he proposed to defend sculpture.

[5] Probably an allusion to the great many amateurs and wits who mingled in the quarrel. It is unlikely that Pino knew Varchi's inquiry.

tinguish armor, silk cloth from linen, a crimson one from a green one, and so on and so forth. And if you tried to argue that the merit goes to the paints, I would say that it does not because if it is true that green pigment will paint all that is green, it will not give the proper difference between velvet and a woolen cloth, and, therefore, the paints can not produce the effects by themselves if the artist does not contribute his skill.[6] Sculptors lack perfection in that they have no power to imitate a thing exactly, but only through its outlines.

* * *

La.: You have answered me admirably, and if I can remember your reasoning properly, I shall be able to stop the mouths of those who will try to defend sculpture, just as they have been confounded in another way by Giorgione da Castel Franco, our famous painter, who is as worthy of praise as the ancients. For the perpetual shame of sculptors, he painted a full length picture of Saint George in armor, leaning on the broken shaft of a spear, his feet just at the edge of a clear and limpid brook in which the whole figure had its foreshortened reflection up to the top of the head; then, there was a mirror leaning against a tree-trunk in which was reflected the whole figure showing its back and one side. To the side the painter showed another mirror in which one could see entirely the other side of Saint George. He wanted to prove by this picture that a painter can show a figure entirely at one glance, which a sculptor is incapable of. This work, being Giorgione's, was perfectly conceived as to the three parts of painting, i.e., design, invention, and color.[7]

AMATEURS AND COLLECTORS

Baldassare Castiglione: The Courtier and Art

The Courtier, *the main work of Baldassare Castiglione (1478-1529), a famous man of letters and a diplomat, was published in 1527, but it had circulated previously in manuscript for several years; it soon gained an immense authority throughout cultured Europe, and the few pages on art it contains were crucial for fashionable aesthetics in the*

[6] The concern with rendering materials and textures is particularly marked in Venice.

[7] This piece of information was repeated by Vasari (Milanesi ed., I, 101 and IV, 98) but has found no other confirmation. We know of a similar artifice by Savoldo in his portrait of Gaston de Foix, which might have been executed under the influence of the lost Giorgione.

16th century. In particular, it established the main points of the ritual disputation on the paragone, *and once and for all it secured a place for the plastic arts among occupations proper for a gentleman.*

The main sources for the following passage are: Aristotle's Politics *viii, 1338 ab, where the question of the artistic education of free children is posed* ex cathedra; *Philostratus' introduction to his* Eikones *(on the relation between painting and "truth" or science; this is the first formulation of the* paragone); *Pliny, Natural History xxxv, which provides all the historical references and the usual anecdotes; and finally, the contemporary treatises on beauty, love, and grace. It is significant that in his scientific claims for painting, Castiglione agreed with Leonardo.*

Castiglione had great reverence for ancient art. In that field, however, he dwelt mostly on grotesques, which were a preoccupation of contemporary artists. He also mentioned the utility of drawing for civil and military engineers (who were often artists), and he elegantly brought in a compliment to his friend Raphael; all this proved the essentially modern interests of the author.

The question whether the artist is or is not particularly sensitive to feminine beauty, and, therefore, more subject to love than others, was not taken over with the rest by later art treatises. Castiglione borrowed it from his model in Aristotle, but it is characteristic of his social turn of mind that he wanted to combine ideas from theories of art and from treatises on love.

From *The Courtier* [1]

Then said the Count: before we enter into this matter, I will talke of an other thing, which for that it is of importance (in my judgement) I believe our Courtier ought in no wise to leave it out. And that is the cunning in drawing, and the knowledge in the verie arte of painting.

And wonder ye not if I wish this feate in him, which now adayes perhappes is counted an handicraft and full litle to become a gentleman, for I remember I have reade that the men of olde time, and especially in all Greece, would have gentlemens children in the scholes to study painting, as a matter both honest and necessarie. And this was received in the first degree of liberall artes, afterwarde openly enacted not to bee taught to servants and bondmen.[2]

Among the Romanes in like manner it was in verie great reputation,

[1] *The Courtier,* trans. Sir Thomas Hoby (New York: Everyman's Library, 1956), pp. 77-83. The book relates a conversation between several members of the Court of Urbino, about the qualities of the accomplished courtier. The man who speaks is Count Lodovico da Canossa. John Christopher Romano was a sculptor.

[2] Pliny xxxv, 10, 77.

and thereof sprung the sirname of the most noble family of Fabii, for the first Fabius was sirnamed Pictor, because in deed he was a most excellent Painter, and so addicted to painting, that after hee had painted the walles of the temple of Health, hee writte therein his name, thinking with him selfe, that for all he was borne in so noble a familie, which was honoured with so many titles of Consulshippes and triumphes, and other dignities, and was learned and well seene in the law, and reckoned among orators, to give also an increase of brightenesse, and an ornament unto his renowne, by leaving behind him a memorie that he had beene a Painter.[3]

There have not in like manner wanted many other of notable families that have beene renowned in this arte, of the which (beside that in it selfe it is most noble and worthie) there ensue many commodities, and especially in warre, to draw out Countries, Platformes, Rivers, Bridges, Castels, Holdes, Fortresses, and such other matters, the which though a man were able to keepe in minde (and that is a hard matter to doe) yet can he not shew them to others.[4]

And in verie deed who so esteemeth not this arte, is (to my seeming) farre wide from all reason [5] for somuch as the ensigne of the world that we behold with a large skye, so bright with shining starres, and in the middest, the earth, environed with the seas, severed in partes with hilles, dales, and rivers, and so decked with such divers trees, beautifull flowers and herbes, a man may say it to be a noble and great painting, drawne with the hand of nature and of God: the which who can represent in mine opinion he is worthie much commendation. Neither can a man attaine to this, without the knowledge of many thinges as he well knoweth that tryeth it.

Therefore had they of old time in very great estimation, both the arte and the artificers, so that it came to the toppe of all excellencie.

And of this may a man gather a sufficient argument at the auncient Images of Marble and mettall, which at this day are to bee seene. And thought painting bee a diverse matter from sculpture, yet doe they both arise of one selfe fountaine (namely) of a good design.[6]

And even as the statues are divine and excellent, so it is to be thought paintings were also, and so much the more, for that they containe in them a greater workemanship.

Then the Ladie Emilia turning her unto John Christopher Romano, that sate there among the rest, howe thinke you (quoth she) to

[3] Pliny xxxv, 4, 10, and others; Cicero, *Tusc.*, i, 4; Valerius Maximus viii, 14, 6.
[4] Except by drawing. *Mostrare* means both to show and to explain.
[5] Cf. Philostratus, *Images,* introd.
[6] This is among the first examples of the glorification of design (*disegno*) as father of all the visual arts. Gauricus, *De Sculptura,* 1504, attributed a less elaborate form of this typically Florentine idea to Donatello (ed. Brockhaus, 1886, p. 128).

this judgement, will you graunt that painting containeth in it a greater workemanshipe, than sculpture?

John Christopher answered: in my minde sculpture is of more travaile, of more arte, and of more dignitie than painting.

Then saide the Count, Because statues are more durable, perhaps a man may say that they are of a more dignitie. For sith they are made for a memorie, they better satisfie the effect why they be made, than painting.

But beside memorie, both painting and sculpture are made also as ornaments and in this point hath painting a great deale the upper hand, the which though it be not so long lasting (to terme it so) as sculpture is, yet doth it for all that endure a long time, and for the while it lasteth, is much more sightly.

Then answered John Christopher: I believe verily you think not as you speake, and all this doe you for your Raphaelles sake.

And peradventure too, you judge the excellencie you know to bee in him in painting, to be of such perfection, that carving in Marble can not come to that degree. But waigh with your selfe, that this is the prayse of the artificer, and not of the arte.

Then he proceeded: and I judge also both the one and the other, to bee an artificiall imitation of nature. But yet I knowe not how you can say, that the truth and property that nature maketh, can not bee imitated better in a figure of Marble or Mettall, wherein the members are all rounde proporcioned and measured as nature her selfe shapeth them, than in a pannel, where men perceive nothing but the outwarde sight, and those colours that deceive the eyes: and say not to me, that being, is not nigher unto the truth than seeming.

Againe, I judge carving in Marble much harder, because if yee make a faulte, it can not be amended againe, for marble can not be joyned together, but ye must be driven to make a new Image.

The which happeneth not in painting, for a man may alter, put to, and diminish, alwaies making it better.

The Count saide laughing: I speake not for Raphaelles sake, neither ought you to think me so ignorant a person, but I understand the excellencie of Michaelangelo, of you your selfe, and of other men in carving of Marble, but I speake of the arte and not of the Artificers.

And you say well, that both the one and the other is imitation of nature. But for all that, it is not so, that painting appeareth and sculpture is: for although statues are all rounde like the lively model, and painting is onely seene in flat surface, yet want there many things in statues that want not in paintinges, and especially lights and shadowes, for flesh giveth one light, and Marble another, and that doth the Painter

naturally follow with cleare and darke, more and lesse, as he seeth occasion, which the graver in marble can not doe.

And when the Painter maketh not his figure round he maketh the muscules and members in round wise, so that they goe to meete with the partes not seene, after such a manner, that a man may very well gather the Painter hath also a knowledge in them, and understandeth them.[7]

And in this point he must have an other craft that is greater to frame those members, that they may seeme short, and diminish according to the proportion of the sight by the way of prospective, which by force of measured lines, colours, lights, and shadowes, discover unto you also in the outwarde sight of an upright wall the plainesse and fairenesse, more and lesse as pleaseth him.

Thinke you it againe a trifling matter to counterfeite naturall colours, flesh, cloth, and all other coloured thinges.

This can not nowe the graver in marble doe, ne yet expresse the grace of the sight that is in the blacke eyes, or in azure with the shining of those amorous beames.

Hee can not shew the colour of yellow haire, nor the glistring of armor, nor a darke night, nor a sea tempest, nor those twincklings and sparkes, nor the burning of a Citie, nor the rysing of the morning in the colour of Roses, with those beames of purple and golde. Finally hee can not shewe the skye, the sea, the earth, hilles, woodes, meadowes, gardens, rivers, Cities, nor houses, which the Painter doth all.[8]

For this respect (me thinke) painting is more noble, and containeth in it a greater workmanship than graving in Marble. And among them of olde time, I believe it was in as high estimation as other thinges, the which also is to be discerned by certain litle remnants that are to be seene yet, especially in places under ground in Roome.[9]

But much more evidently may a man gather it by olde wrytings, wherein is so famous and so often mention both of the worke and workemen, that by them a man may understande in what high reputation they have beene alwaies with Princes and common weales.

Therefore it is read, that Alexander loved highly Apelles of Ephesus, and so much, that after he had made him draw out a woman of his naked, whome hee loved most dearely, and understanding that this good Painter, for her marvellous beautie was most fervently in love with her, without any more adoe, hee bestowed her upon him. Truely a worthie

[7] Slightly incorrect paraphrase of Pliny xxxv, 10, 67-68 on foreshortening.

[8] These two last paragraphs follow and amplify a passage of Philostratus' introduction to the *Images*.

[9] The *grotte di Roma* were underground Roman ruins like Nero's Golden House, the murals of which were greatly admired and the principal source of Renaissance *grotesques*.

liberallitie of Alexander, not to give onely treasure and states, but also his owne affections and desire, and a token of verie great love towarde Appelles, not regarding (to please him withall) the displeasure of the woman that he highly loved, who it is to be thought was sore agreeved to chaunge so great a king for a painter.

There bee many other signes rehearsed also of Alexanders good will towardes Apelles, but he shewed plainly in what estimation he had him, when hee commanded by open Proclamation no other Painter should bee so hardie to drawe out his picture.[10]

Here could I repeat unto you the contentions of many noble Painters, with the greatest commendation and marvaile (in a manner) in the world.[11]

I coulde tell you with what solemnitie the Emperours of olde time decked out their triumphes with paintinges, and dedicated them up in public places, and how deare it cost them, and that there were some painters that gave their workes freely, seeming unto them no golde nor silver was enough to value them: And how a pannel of Protogenes was of such estimation, that Demetrius lying encamped before Rhodes, where hee might have entred the Citie by setting fire to the place, where hee wist this pannel was, for feare of burning it, stayed to bid them battaile, and so he wunne not the Citie at all.[12]

And how Metrodorus a Philosopher and a most excellent Painter, was send out of Athens to Lucius Paulus, to bring up his children, and to decke out his triumph he had to make.[13]

And also many noble writers have written of this arte, which is a token great inough to declare in what estimation it hath beene. But I will not wee proceede any farther in this communication.

Therefore it sufficeth onely to say that our Courtier ought also to have a knowledge in painting, since it was honest and profitable, and much set by in those dayes when men were of more prowesse than they are now. And though hee never get other profit or delite in it (beside it is a helpe to him to judge of the excellencie of statues both olde and new, of vessels, buildings, old coines, cameos, gravings, and such other matters) it maketh him also understand the beautie of lively bodies, and not onely in the sweetnesse of the Phisiognomie, but in the proportion of all the rest, as well in men as other living creatures.[14]

See then how the knowledge in painting is cause of verie great

10 The anecdotes on Apelles are drawn mostly from Pliny xxxv, 10, 79-97.

11 Famous rivalries: Pliny xxxv, 10, 65 f. and 81 ff.

12 Zeuxis giving his works free: Pliny xxxv, 10, 62; Demetrius renouncing to storm Rhodes: Pliny xxxv, 10, 104.

13 Pliny xxxv, 11, 135.

14 A free paraphrase of Aristotle, *Politics* viii, 1338 ab.

pleasure. And this let them thinke that doe enjoy and view the beautie of a woman so throughly, that they thinke themselves in Paradise, and yet have not the feate of painting: the which if they had, they would conceive a farre greater contentation, for then shoulde they more perfectly understand the beauty that in their brest ingendreth such hearts ease.

Here the Lorde Cesar laughed and saide: I have not the arte of painting, and yet I knowe assuredly I have a farre greater delite in beholding a certain woman, than Apelles himselfe that was so excellent, whom ye named right now, coulde have if he were now in life againe.

The Count answered: this delite of yours proceedeth not wholy of beautie, but of the affection which you perhaps beare unto the woman. And if you will tell the truth, the first time that you beheld that woman, yet felt not the thousandeth part of the delite which you did afterwarde, though her beautie were the verie same.

Therefore you may conceive how affection beareth a greater stroke in your delite than beautie.

I deny not that (quoth the Lord Cesar:) but as delite ariseth of affection, so doth affection arise of beautie, therefore a man may say for all that, that beautie is the cause of delite.

The Count answered: there be many other thinges also, that beside beautie oftentimes inflame our minds as manners, knowledge, speach, gestures, and a thousand moe (which peradventure after a sorte may be called beautie too) and above all, the knowing a mans selfe to be beloved: so that without the beautie you reason of, a man may bee most fervently in love:

But those loves that arise onely of the beautie which we discerne superficially in bodies, without doubt will bring a farre greater delite to him that hath a more skill therein, than to him that hath but a litle.

Therefore returning to our purpose, I believe Apelles conceived a farre greater joye in beholding the beautie of Campaspes, than did Alexander, for a man may easily believe, that the love of them both proceeded only of that beautie, and perhaps also for this respect Alexander determined to bestow her upon him, that (in his mind) could know her more perfectly than he did.

Have you not reade of the five daughters of Croton, which among the rest of that people, Zeusis the Painter chose to make of all five one figure that was most excellent in beautie [15] and were renowned of many Poets, as they that were allowed for beautifull of him that ought to have a most perfect judgement in beautie?

[15] Cicero, *De inventione* ii, 1; Cf. Pliny xxxv, 10, 64.

Sabba di Castiglione: On Collections *

Sabba di Castiglione (1485-1554), a knight of the Order of Rhodes, a lover of art from youth, lived most of his life in a house of the Order in Faenza where he wrote the Ricordi *(1546), a book of moral considerations and advice. The* Ricordo *109 is devoted to the decoration of a gentleman's mansion, and contains a description of the kinds of things collected at a time when there was but a vague distinction between furniture and collections: musical instruments, sculpture, medals, gems, painting and engraving, intarsia, tapestry, arms, and books.*

Sabba di Castiglione: On the Decoration of the House [1]

. . . Others decorate their houses with antiques, such as heads, torsos, busts, ancient marble or bronze statues. But since good ancient works, being scarce, can not be obtained without the greatest difficulty and expense, they decorate it with the works of Donatello, who, for sculpture and casting [bronze] is the peer of any ancient Greek sculptor, be it Phidias or Praxiteles, or a better artist than those and of higher genius, as is proved by his divine and outstanding works in stone and in bronze at Florence, particularly in the gardens of Saint Michael,[2] and his Gattamelata in Padua, which is made with great art. Or they decorate it with the works of Michelangelo, the glory of our time in sculpture and in painting; it is still debated in which of these two he is the more excellent. . . .

Some decorate it with the works of Pietro del Borgo, or of Melozzo da Forli, who for their perspectives and their artistic secrets are perhaps more agreeable for the intellectuals than they are appealing to the eyes of those who understand less. Some decorate it with intarsie by Fra Giovan da Monte Oliveto, or by Fra Rafaello da Brescia, or by the Legnaghi, excellent masters in this kind of work, particularly for perspective views. But above all, those who can obtain them, furnish and decorate their house with the works, more divine than human, of dear Father Fra Damiano da Bergamo of the Dominican order, who, not only in perspective views, like those other fine artists, but in landscapes, in pictures of houses, in distant views, and, what is more, in figures, can do with wood all that the great Apelles could hardly do with the brush. In fact, it seems to me that the colors of those woods are more vivid,

* Cf. Edmond Bonnaffé, *Etudes sur l'art et la curiosité* (Paris, 1902), pp. 13-47.

[1] From *Ricordo* 109, *On the Decoration of the House;* translation from edition of Venice, 1560, fol. 56ro to 60vo.

[2] *Horto di San Michele,* obviously stands for *Or San Michele.*

brighter, and more agreeable than those used by painters, so that these noble works can be called a new sort of painting, excellently painted without paints. It is admirable and also most surprising that, although these works are made of juxtaposed pieces, the more one tries, the less one can see the joints; which stupefies the observers. I believe this good Father will be without equal in centuries to come, as he has been in past ones, for dyeing woods any color, and for imitating spotted and veined stones. Would Our Lord God grant him His grace, because I would like him to put the finishing touches to the work in San Domenico in Bologna, since it is well under way. I believe, in fact I am certain, it will be called the eighth wonder of the world.[3]

<p style="text-align:center">* * *</p>

Others decorate and ornate their halls with hangings of Arras and tapestries of Flanders made with figures, foliage, or greenery; rugs and moquettes from Turkey or Syria,[4] barbaresque carpets and tapestries; painted hangings by good masters; [5] Spanish leather ingeniously wrought; others decorate them with new, fantastic and bizarre, but ingenious things from Levant or from Germany, subtle inventress of beautiful and artistic things. I favor and praise all these ornaments too, because they are a sign of judgment, culture, education and distinction. . . .

I myself, although I am a poor gentleman, I decorate my little studio with a head of St. John the Baptist aged about fourteen, in the round, of Carrara marble, a very beautiful work by Donatello, which is really such that if there were no other works from his hand, this one alone would be enough to make his name eternal and immortal.[6] I decorate it with a figure of St. Jerome, in clay but imitating bronze, almost in full relief, one cubit high,[7] by Alfonso da Ferrara,[8] which can easily compare with all his other most famous works. I decorate it with a little panel and with two [other] intarsia panels of two heads, one of St. Paul, the other of St. John the Baptist, by my Reverend Father Fra

[3] Fra Giovanni da Monte Oliveto is the Olivetan monk Fra Giovanni da Verona (1457-1525), who worked mainly in Verona and Monte Oliveto. Fra Raffaello da Brescia (Roberto Marone, 1479-1539), pupil of Fra Giovanni, was well known for his work in Bologna. Fra Damiano (Damiano Zambelli da Bergamo, before 1490-1549), author of the stalls of San Domenico in Bologna, brought intarsia work closer to painting. Charles V could not believe that the San Domenico stalls were made in intarsia, and a piece of the wood was lifted off to convince him.

[4] *Soria* can mean both Syria and the city of Soria in Spain, which was well known for its fabrics, but not particularly for tapestry.

[5] People used to hang painted cloth with figures; this was called *alla francese.*

[6] The *Saint John*, attributed to Donatello (Faenza, Pinacoteca), is according to Janson "clearly a work of the Antonio Rossellino shop."

[7] *Cubito* is not a usual Italian measure; it can be either another word for *braccio* (in Venice somewhat longer than the Florentine, see p. xviii) or a reminiscence from Vitruvius, who says that a *cubitus* is 1½ feet.

[8] Alfonso Cittadella, called Lombardo da Ferrara (1497-1537), whom Sabba calls his friend, worked mostly in Bologna in a style close to Roman-Florentine classicism.

Damiano da Bergamo, all three of them excellent works. It seems to me, however, that in the head of St. John the Baptist the good Father, surpassing himself, has shown the very limit of his possibilities. I have also decorated it with an ancient urn of oriental alabaster, with some veins of chalcedony; it is certainly not inferior to any vase of alabaster that I have seen to this moment, although I have seen many in Rome and other places; and if these things were not mine, I might praise them at greater length, as they deserve it.[9]

Marcantonio Michiel: Notes of a Connoisseur

Marcantonio Michiel, a Venetian gentleman who died in 1552, is perhaps the most admirable connoisseur of art during the first half of the 16th century. He was a man of extensive culture, whose letters reveal a variety of interests; as a collector himself and the owner of a Giorgione, he planned to write a history of art, which, however, remained unfinished, apparently because of his hearing that Vasari was working on a more complete one. Michiel's notes for this work remained in manuscript; Morelli published these Notizie d'opere del disegno *in 1800 without having identified their author (from this edition came the name* Anonimo Morelliano *by which they were known for a long time).*

Michiel used few printed sources. A friend of his, the philosopher Leonico Tomeo, showed him a letter by Campagnola on Paduan artists; another friend, Pietro Summonte, sent him a long report on Neapolitan art. But most of Michiel's information was first hand: conversations with artists like Riccio, and, above all, visits to monuments and collections. The precision of his descriptions of works of art and the refinement of his judgment, particularly in the famous pages on the Pasqualino collection, are astonishing and give a high opinion of the artistic culture of his environment.

Two Visits to Private Collections [1]

IN THE HOUSE OF MESSER PIETRO BEMBO [2]

The small picture on two panels representing on the one side St. John the Baptist dressed, seated, with a lamb, in a landscape; and on

[9] Fra Damiano's panel and the funeral urn are still kept in the Faenza Pinacoteca. Alfonso Lombardo's *Saint Jerome* is recorded as extant at Faenza in 1929.

[1] English edition *The Anonimo. Notes on Pictures and Works of Art in Italy Made by an Anonymous Writer in the Sixteenth Century,* trans. P. Mussi, ed. G. C. Williamson (London: G. Bell & Sons, Ltd., 1903), pp. 21-28, 93-95, and 115-116. Reprinted by permission of the publisher.

[2] Pietro Bembo, 1470-1547, the well-known writer and poet, was an important figure in the art world, both for his personal acquaintance with artists and for his rôle at courts (Rome, Mantua, Ferrara) and with great patrons. The description of Bembo's collection is dated around 1543.

the other side, Our Lady with the Child, also in a landscape, was painted by John Memlinc, probably about the year 1470.[3]

The small picture on panel, which represents Our Lady holding the Child for Circumcision, with half-length figures, is by Mantegna.[4]

The picture on panel, with the portraits of Navagiero and Beazzano, is by Raphael d'Urbino.[5]

The portrait of Sannazaro was painted by Sebastiano Veneziano from another portrait.[6]

The small portrait of Messer Pietro Bembo himself, when, as a youth, he was staying at the Court of the Duke of Urbino, was drawn by Raphael d'Urbino in pencil.

The portrait, in profile, of the same, when he was eleven years of age, is by Giacometto.[7]

The portrait, in profile, of Gentile da Fabriano, is by Giacomo Bellini.[8]

The portrait of Bertoldo, of the family of the Marquises of Ferrara, if I am not mistaken, is by Giacomo Bellini.[9]

The portraits of Dante, Petrarch and Boccaccio are by. . . .

The portrait of Madonna Laura, Petrarch's lady-love, was painted by . . . , from a picture on a wall in Avignon, representing Ste. Margaret, in which Madonna Laura was portrayed.[10]

The picture, on canvas, representing St. Sebastian, over life size, fastened to a column and shot at with arrows, is by Mantegna.[11]

The two miniatures, on vellum, are by Giulio Campagnola: one represents a woman, nude, lying down with her back turned, and is from a picture by Giorgione; the other represents a woman, nude, who

[3] The *Saint John in the desert* seems to be that in Munich, which bears the false inscription H.v.d.Goes 1472, but is certainly by Memlinc.

[4] There are two versions—both controversial—of this picture by Mantegna in Berlin and Venice (gal. Querini-Stampaglia).

[5] The double portrait extant in Rome (gal. Doria) which represents these two friends of Bembo might be the picture in question.

[6] Unknown. The painter is of course Sebastiano del Piombo.

[7] The two portraits of Bembo are lost. The manuscript says Raphael's was in *m.ta*; Frimmel explains it as *inminiata* (in miniature); the English version more likely supposes *in matita* (in pencil). As for Giacometto, his identity is controversial. Jacopo de Barbari is very unlikely. According to Michiel's notes he seems to have made mostly miniatures and drawings.

[8] Jacopo Bellini was a pupil of Gentile, and once added this title after his signature. The portrait in question has not been identified.

[9] Bertoldo d'Este died in 1463 during the war against the Turks, but his portrait is not known.

[10] There is no authentic portrait of Laura, but imaginary ones were quite numerous, especially in Venice; Giorgione himself painted one.

[11] Still extant in Venice (Cà d'Oro).

is watering a tree, with two little children digging, and is from a picture of Diana.[12]

The small picture divided into several compartments, representing the life of . . . , is by Giacometto.

The small picture, representing the dead Christ supported by two little angels, is by . . . , an assistant of Giulio Campagnola, who helped him in this work.[13]

The portrait of Messer Carlo Bembo, as a baby, was made by Giacometto at birth of the former, Messer Bernardo being then an ambassador at the Court of the Duke Charles, about the year 1472.[14]

The small Jupiter, in bronze, seated, is antique. The small Mercury, in bronze, seated on the mountain with the tortoise at his feet, is also antique.

The little Moon, in bronze, which was on the car, is antique. The marble heads,[15] the earthen vases, the gold, silver and copper medals, as well as the glass vases, are antique. The precious stones, carved and set in rings, are antique.

The marble head of Brutus in the act of delivering a speech is antique.

The heads of Caracalla, Aurelianus, Antinous, Marcellinus [*sic*], Julius Caesar, and Domitian, all in marble, are antique.

The head of Antonius, in copper, is antique.

The marble Cupid, lying down asleep, with a sculptured lizard, is an antique work by Samos,[16] and is different from the one in the possession of Madam of Mantua.[17]

The Book of the Comedies of Terence, written on good paper, in Roman capitals, is an ancient book.

The Virgil also, written on good paper in Roman capitals with the arguments of the books painted at the heading of each of them, is an ancient book, and the figures wear ancient costumes.[18]

[12] Benedetto Diana, c.1460-1525. Giulio Campagnola, 1482-1514, painter, musician, scholar and humanist, celebrated by his contemporaries since his childhood, is known to us as an engraver and designer only; one of his prints (Hind 13) precisely represents Venus in the Giorgionesque attitude described by Michiel.

[13] The only known assistant of Giulio Campagnola was Domenico Veneziano, perhaps the same as Domenico Campagnola, engraver and follower of Titian.

[14] Carlo Bembo was the brother of Pietro. Their father Bernardo actually was Venetian ambassador to Charles the Bold of Burgundy in 1472. The portrait is lost.

[15] Note in the margin of the manuscript: of Caracalla, Antinous, Domitien, Brutus.

[16] *Sic*. Bembo probably believed he owned a work by Theodorus of Samos or Pythagoras of Samos, sculptors known to us through ancient sources.

[17] Isabella d'Este owned two versions, one of which was the fake antique executed by Michelangelo in 1496.

[18] These two famous manuscripts, both written in Roman capitals, are now in the Vatican Library (respectively Lat. 3226 and 3225).

The bronze figure of a kneeling maiden carrying a basket upon her head, used as candlestick, is a modern work by. . . . The bronze statuette, one foot high, representing a draped woman, is antique.

The bronze statuette representing a man, nude, standing and holding a spear with his left hand, is antique.

The bronze statuette, one span high, wrapped in a cloth, is antique.

The small nude statuette is an antique bronze.

The other small nude figure with a short dress, also in bronze, is antique.

All these, together with the Mercury, belong to Messer Bartolommeo.[19]

IN VENICE

IN THE HOUSE OF MESSER ANTONIO PASQUALINO

JANUARY 5TH, 1532

The large picture of the "Last Supper" was painted by Stefano, a pupil of Titian's, and was partly finished by the latter in oil.[20]

The head of the young man holding an arrow in his hand is by Giorgio da Castelfranco, and was obtained from Messer Giovanni Ram, who possesses a copy of it, which he believes to be the original.[21]

The life-size portrait, in profile, of a commonlooking man, with a hood on his head and a black mantle, holding a string of seven large black rosary beads, the lowest and biggest of which is of gilded stucco in relief, was painted by Gentile da Fabriano, and was brought to the aforesaid Messer Antonio Pasqualino by the same Fabriano, together with the following picture: namely, the half-length portrait of a young man in the garb of a priest, with his hair cut short above his ears, dressed in a tight grayish frock, with a black stole gathered round the neck and hanging loose, the sleeves being very large on the shoulders, and very tight at the wrists, also a work of the same Gentile. Both of these portraits have black backgrounds, and both are in profile, and are believed to be father and son; they look at each other, but are in two separate panels. They are alike in the complexion; but, in my opinion, the likeness in the complexion is to be accounted for by the manner of the master, who always used the same pale tint for painting flesh. These two portraits, however,

19 This sentence is added later, obviously after Bembo's death in 1547.

20 Probably Stefano dall'Arzere of Padua, active between 1540-1575.

21 A *Man with an arrow*, close to Giorgione but probably not from his hand, is in the Vienna Museum. One year before his description of Pasqualino's collection Michiel had visited Ram's collection and seen the replica which he himself had taken for the original.

are very bright and full of spirit, highly finished, and shine like oil pictures, and are altogether worthy of praise.[22]

The head of St. James with the staff is either by Giorgio da Castelfranco, or by a pupil of his, copied from the Christ of San Rocco.[23] The half-length figure of Our Lady with the child in her arms, much under life size, in tempera, was painted by Giovanni Bellini and restored by Vincenzo Catena, who painted into it a blue sky instead of a curtain drawn behind the figures. It was executed many years ago, and is clearly modeled by strong lights which do not blend well with the half tints: it is, however, a praiseworthy picture for its graceful expression, the drapery, and other parts.[24]

The two portraits on small panels, under life size, the one representing Messer Alvise Pasqualino, Messer Antonio's father, bare-headed, the black hood being turned down on his shoulder, and dressed in scarlet; the other representing Messer Michele Vianello in a pink dress, with the black hood on his head, were both painted by Antonello da Messina in the year 1475, as appears from the signature. They are painted in oil, in three-quarter view, are highly finished, and have great power and vivacity, especially in the eyes.[25]

The marble head of a woman with her mouth open is by . . . and it was given to the aforesaid Messer Antonio by Messer Gabriel Vendramini in exchange for the antique marble torso.

The numerous drawings are by Giacometto.

In the House of Messer Antonio Pasqualino

1529

The little picture, representing St. Jerome robed as a cardinal and reading in his study, is ascribed by some to Antonello da Messina [26]; some believe that the figure has been repainted by Giacometto Veneziano [27]; but the great majority, with more certainty, ascribe it to John Van Eyck or to Memlinc, old Flemish painters. It really shows their manner, though the face may be finished in the Italian style, and seems to have been painted by Giacometto. The buildings are in the Transalpine style: the

22 Both portraits are lost.
23 The "Christ of Saint-Roch," which Michiel seems to attribute to Giorgione and which is sometimes considered to be by Titian or as a collaboration work, is still in place; nothing is known about the St. James with the Pilgrim's stick.
24 This might be a Virgin in the gal. Querini-Stampaglia of Venice.
25 Alvise's portrait would be in Vienna, Schwarzenberg coll., and Vianello's in Rome, gal. Borghese.
26 London, National Gallery. The attribution to Antonello is no longer questioned.
27 This sentence was added at a later date.

little landscape is natural, very detailed, and highly finished; it is only to be seen through a window and the door of the study. A peacock, a quail, and a barber's basin are represented in it. On the desk is a little label which seems to contain the name of the master, but upon closer examination, one cannot distinguish any letters, as it is all a deception. And it is well in perspective; all the work—its finish, coloring, drawing, strength, and relief—is perfect.

Francesco Albertini: The Cathedral of Florence

We owe the first artistic guidebook of Florence to Francesco Albertini, a Florentine priest who died in Rome in 1520. The Memoriale di molte statue e pitture che sono nell'inclyta ciptà di Florentia, *1510, is a superficial and rather poor piece of writing, the source value of which is at best second rate. It is, however, an interesting document on the pride and historical consciousness of the Florentines as regards their art, and on the state of mind of moderately cultured amateurs.*

Albertini has also written the eulogy of some cities and a guidebook of Rome which marks the transition between the old pilgrims' manuals and the modern descriptions of the city's artistic treasures.

From the Guidebook of Florence [1]

The cathedral church of Sancta Maria del Fiore, popularly called Sancta Reparata: I will not write how stupendous and admirable this church is because someone who has not seen all its particulars would not believe it; and it is continually worked on; and up to now it has cost two millions in gold and more than six hundred thousand florins. This sumptuous building is all of cut stone and has a perimeter of seven hundred eighty two and $\frac{2}{3}$ braces. The length of the church is two hundred sixty braces. On the outside it is entirely inlaid with various marbles, richly decorated with marble and porphyry statues by noble sculptors. In particular, there is the first giant by Donatello, near the door with the marble Assumption by Nanni di Banco, above the Annunciation in mosaic by Domenico Ghirlandajo.[2] On the main façade there is a seated

[1] Translated from the facsimile edition by Herbert Horne, Letchworth, 1909, p. 2.

[2] Donatello's *primo gigante* is probably the terracotta *Joshua*, 1410-11, which topped the buttress at the angle made by the north façade of the Cathedral with the transept; it is lost. Nanni di Banco's *Assumption,* or *Miracle of the Belt,* is still in place, as well as Ghirlandaio's mosaic *Annunciation* (1490).

evangelist and a statue of a bowing man and in the corner an old man, all executed by Donatello.[3]

But to tell you the truth, that façade, which Lorenzo de Medici wanted to build and to finish, seems to me without order and measure; and before I leave Florence, God willing, I shall show you a model of my invention for it, which I believe will not displease you.[4] But if I did it for nothing else, at least I would make many people talk and particularly those invidious who say: *Quomodo hic litteras scit, cum non didiscerit?* [5] We, however, know who speaks so. One does not get rich by sleeping and loitering on benches. They do not know that for many years I heard public lectures by Politian and Landino and Lippo, men of great learning; [6] and also in Bologna for six months I did not waste my time at court, and I have even seen something of Vitruvius and Leon Battista Alberti's *De Architectura,* and in the Pope's Palace there is even a door designed by me. Let them talk, I shall act. Who brings up private matter into the public eye must be able to stand up with strength.[7]

Let us turn back to architecture and in particular to that of the cathedral of Florence, which is all decorated with various marble pavements which are in progress.[8] In the church there are two sacristies with two organ lofts. The ornamentation of the one is by Donatello, who has done the marble wash basin in the sacristy, and the bronze shrine in the chapel of San Zenobio.[9] Luca della Robbia has decorated the other, and has done the door of the new sacristy.[10] I pass in silence over the Crucifix of the choir, and the marble head of Giotto by Benedetto da Majano,

[3] The seated Evangelist is Donatello's *St. John,* 1408-15, in the Museo dell'Opera; it was part of an ensemble with other evangelists by Niccolo Lamberti, Nanni di Banco, and Bernardo Ciuffagni. The "bowing man" is probably Nanni di Banco's *Isaiah,* formerly called Daniel, and the old man must be the so-called *Poggio Bracciolini* of which the attribution to Donatello is now rejected.

[4] The competition for the façade of the Cathedral, instituted by Lorenzo (1489-91), engaged Giuliano and Benedetto da Majano, Francesco di Giorgio, Filippino Lippi, Verrocchio, Pollaiuolo, and Francesco Ferrucci; but no decision was taken. Several instances are recorded of private Florentine citizens without any architectural training who bothered the architects with their plans for churches.

[5] How can he read, if he has not learned?

[6] Cristoforo Landino and Politian gave public lectures at the Florence Studio; Lippo is probably Filippo Beroaldo the Elder who lectured at Bologna.

[7] The idea is expressed in the text by a combination of proverbial phrases: *ma chi fa la casa in piazza, bisogna rigar dritto ben sua mazza.*

[8] Cronaca was working on it in 1502-6.

[9] Donatello's famous *Cantoria* (1433-39) is in the Museo dell'Opera; the wash basins of the two sacristies are by Buggiano who started them in 1440 and 1442 respectively, probably on Brunelleschi's design. The shrine of San Zenobio is evidently Ghiberti's, 1432-1442.

[10] Luca della Robbia's *Cantoria,* 1432-38, is in the Museo dell'Opera. Luca had an important part in creating the bronze doors of the old (but not the new) sacristy.

and the equestrian figure in green earth by Paolo Uccello, and the white one by Andreino,[11] and the silver crosses and candlesticks, and the beautiful vases by excellent artists, and the four books with silver binding.

The height of the dome and double cupola is of 154 braces [12] without the marble ornaments, which measure 36 braces, with the sphere of gilt brass, 4½ braces high, an extraordinary thing. It is decorated with various friezes and beautiful statues, among which the four tall ones towards the square and two towards the door of the canons are by Donatello.[13]

CLASSICAL TASTE

Raphael Sanzio: Letter to Count Baldassare Castiglione *

This famous letter to the author of The Courtier *must date from 1514. It contains one of the earliest and most striking expressions of classical idealism: the beauty of actual things can never do more than approximate the "ideal" beauty of their different species, which the artist must try to reach by going beyond experience. But while orthodox Neoplatonism proposed to transcend experience by following inspiration, the Roman classicizing milieu established a connection between this idealization and good taste or connoisseurship.*

SIGNOR CONTE,[1]

I have made drawings of various types based on Your Lordship's indications, and unless everybody is flattering me, I have satisfied everybody; but I do not satisfy my own judgment, because I am afraid of not

[11] The giant Crucifix in the choir is by Benedetto da Majano (c. 1490; bought in 1509 and painted the following year by Lorenzo di Credi). Uccello's horse (monument of Hawkwood, 1436), "Andreino" del Castagno's monument of Niccolo da Tolentino (1456), and B. da Majano's half length medallion of Giotto (1490) could not be omitted from any guide.

[12] The number is not clearly readable in the copy used; we interpret it as closely as possible to the real dimensions, supposing that the "marble ornament" mentioned below is the lantern.

[13] The four statues on the west side are the so-called *John the Baptist*, the *Zuccone*, the so-called *Jeremiah*, and *Obadiah;* Donatello executed the second and third; the *Saint John* is a false attribution. Toward the Canons' door, i.e., on the east side, there are four statues: two *Prophets*, *Abraham and Isaac*, and a third *Prophet*. Only the second prophet is not Donatello's; for the other figures Janson admits some collaboration by Nanni di Bartolo (documented for *Abraham and Isaac*).

* See Panofsky, *Idea* (Leipzig: Studien der Bibliothek Warburg, 1927), p. 32 f.

[1] Often reprinted since Bernardino Pino, *Nuova Scelta di Lettere*, Venezia 1582, p. 249. English translation from Robert Goldwater and Marco Treves, *Artists on Art* (New York: Random House, Inc., 1945). Reproduced by permission of Random House, Inc.

satisfying yours. I am sending these drawings to you. Your Lordship may choose any of them, if you think any worthy of your choice.

The Holy Father, in honoring me, has laid a heavy burden upon my shoulders: the direction of the work at St. Peter's. I hope, indeed, I shall not sink under it; the more so, as the model I have made for it pleases His Holiness and has been praised by many connoisseurs. But my thoughts rise still higher. I should like to revive the handsome forms of the buildings of the ancients. Nor do I know whether my flight will be a flight of Icarus. Vitruvius affords me much light, but not sufficient.

As for the Galatea, I should consider myself a great master if it had half the merits you mention in your letter. However, I perceive in your words the love you bear me; and I add that in order to paint a fair one, I should need to see several fair ones, with the proviso that Your Lordship will be with me to select the best.[2] But as there is a shortage both of good judges and of beautiful women, I am making use of some sort of idea which comes into my mind. Whether this idea has any artistic excellence in itself, I do not know. But I do strive to attain it.

Michelangelo on Flemish Art

The Portuguese painter Francisco de Hollanda (c.1517-1584) was sent during his youth to Italy to study military architecture (1537-40). On his return from this journey, with a good pension but unemployed, he laid down his experiences in theoretical works which were published only long after his death.

His Four dialogues *in appendix to his* Tractado de Pintura antigua *(written 1547-49) report conversations with Roman friends among whom appear Michelangelo and Vittoria Colonna. The authenticity of this report has been strongly challenged, although all circumstances that could be checked turned out to be correct. But it is obvious that Francisco often used Michelangelo's authority to strengthen his own position. This comes through clearly in his pages on Flemish art, which must be understood in the light of the opposition between partisans of Flemish and of Italian art in his own country. The condemnation of landscape and the conviction that non-Italian national styles are not eradicable, are familiar traits of the classical Italian doctrine.*

The very special religious accent, the disdain for sentimental devotion, and the idealism which binds artistic perfection to true piety are not commonplaces of Italian artistic opinion and fit well enough within Michelangelo's personality to be considered authentic.

2 Allusion to the anecdote of Zeuxis in Crotona.

From Francisco de Hollanda's *Four Dialogues* [1]

And Michelangelo said: Your Excellency [2] has only to ask for something that I can give and it is yours.

And smiling she said: I much wish to know, since we are on the subject, what Flemish painting may be and whom it pleases, for it seems to me more devout than that in the Italian manner.

Flemish painting, slowly answered the painter, will, generally speaking, Signora, please the devout better than any painting of Italy, which will never cause him to shed a tear, whereas that of Flanders will cause him to shed many; and that not through the vigour and goodness of the painting but owing to the goodness of the devout person. It will appeal to women, especially to the very old and the very young, and also to monks and nuns and to certain noblemen who have no sense of true harmony.[3] In Flanders they paint, with a view to deceiving sensual vision, such things as may cheer you and of which you cannot speak ill, as for example saints and prophets. They paint stuffs and masonry, the green grass of the fields, the shadow of trees, and rivers and bridges, which they call landscapes, with many figures on this side and many figures on that.[4] And all this, though it pleases some persons, is done without reason or art, without symmetry or proportion, without skillful selection [5] or boldness and, finally, without substance or vigor. Nevertheless there are countries where they paint worse than in Flanders. And I do not speak so ill of Flemish painting because it is all bad but because it attempts to do so many things well (each one of which would suffice for greatness) that it does none well.

It is practically only the work done in Italy that we can call true painting, and that is why we call good painting Italian; were it produced elsewhere we should give it the name of that country or region. And at its best nothing is more noble or devout, since with discreet persons nothing so calls forth and fosters devotion as the difficult perfection which approaches and nearly equals the divine. For good painting is nothing but a copy of the perfections of God and a recollection of His painting; [6] it

[1] From Francisco de Hollanda, *Four Dialogues on Painting,* trans. Aubrey F. G. Bell (London, 1928), pp. 15-18.

[2] Vittoria Colonna.

[3] In Portuguese: *desmusicos da verdadeira harmonia.* This learned phrase, imitated from the Greek, is coined by the author.

[4] The same objections to landscape had already been made by Botticelli according to Leonardo's notes. Michelangelo surely shared this opinion and Vasari had to admit that this showed some one-sidedness in Michelangelo and his followers (cf. p. 90).

[5] Ideal beauty was obtained through selection (p. 33 and note 2).

[6] "The painting of God" is the Creation.

is a music and a melody which only intellect can understand, and that with great difficulty.[7] And that is why painting of this kind is so rare that no man may attain it.

And further I say (and he who notes this will appreciate it): There is no clime or country lit by sun or moon outside Italy where one can paint well. It is almost impossible to paint well elsewhere, even were other regions to produce men of greater genius, were that possible; and this for the following reasons: Take a great man of another country and bid him paint whatever he wish or best can, and let him do it; and take a bad Italian apprentice and order him to make a drawing or to paint something at your bidding, and let him do it; you will find, if you have understanding in the matter, that the drawing of the apprentice, so far as concerns art, has more substance in it than the drawing of the master, and that what he attempted to do is of more worth than all that the other did. Bid a great master, not an Italian, even if it be Albert [Dürer], who is a delicate painter in his way, that in order to deceive me or Francisco de Hollanda, he attempt to make a painting that will seem one of an Italian, if not an excellent painting, a reasonably good one or even a bad one; and I assure you that it will be seen at once that it has not been painted in Italy nor by an Italian. Therefore I declare that no nation or people (I except one or two Spaniards) can perfectly attain or imitate the Italian manner of painting (which is that of ancient Greece) in such a way that it will not immediately be seen to be foreign, however much they may strive and toil. And if by some great miracle one of them attains excellence in painting, then, even though his aim were not to imitate Italy, we say merely that he has painted as an Italian. Thus we give the name of Italian painting not necessarily to painting done in Italy but to all good and right painting; and because Italy produces more masterly works of splendid painting and more nobly than any other region, we call good painting Italian, and if good painting be produced in Flanders or in Spain (which has most affinity with us) it will still be Italian painting. For this most noble science belongs to no country; it came down from heaven; yet from of old it has always remained in our Italy more than in any other country on earth, and so I think it will be to the end.[8]

[7] A characteristic proposition of Florentine Neoplatonism.

[8] The contradictions of this whole passage can be explained by the fact that Francisco is torn between his desire to enhance the Italian manner and his fear of discrediting himself along with all non-Italians.

2

Documents
on Art and Artists
(First Half
of the 16 th Century)

INTRODUCTION

This chapter is a collection of a few documents chosen, if not at random, at least in a great variety of contexts and forms. Such documents should speak for themselves, for they are not only useful as sources of precise information, but also evocative of people's outlook and of their relations to one another.

The Installation of Michelangelo's David

The reunion of experts called by the Opera [1] *to decide the future location of Michelangelo's David is one of the many consultations typical of the Florentine democratic regime, which was anxious to conciliate public opinion in all fields, those of art and architecture in particular. One will notice, however, that while most members of the committee voted for the Loggia de' Lanzi, the statue was installed in a much more honorific place: in front of the Old Palace in the place of Donatello's Judith, a solution that only the Herald of the Signoria had dared to propose, but which must, as Tolnay suggests, have had Michelangelo's support.*

The description of the installation of the David is taken out of Luca Landucci's Journal, one of the most interesting documents on Florentine life at the time; it is very rich in information about art, although written by a simple dealer in spices and drugs (1450-1519). The act of vandalism mentioned by Landucci may have been prompted by political considerations because Donatello's Judith, which was to be dethroned, was particularly dear to the radical Republicans of the old school.

On the minutes of the reunion of experts and on all the other documents concerning the installation of the David, see Tolnay, The Youth of Michelangelo *(Princeton: Princeton University Press, 1947), pp. 96-98 and 151-153.*

Deliberation on the Location of Michelangelo's *David* [1]

JANUARY 25, 1503

Considering that the statue of David is almost finished, and wishing to install it and find for it a convenient and suitable location, and a suitable time for the installation; (the place having to be sound and consoli-

[1] The *Opera del Duomo* was the name given to the board of directors of the Cathedral works, as well as to the workshops and other establishments attached to these constructions.

[1] Published by Gaye, *Carteggio inedito d'artisti dei sec. XIV, XV, XVI* (Florence, 1839-40), II, 454-463.

dated in agreement both with the instructions of Michelangelo, the artist who made the aforesaid giant, and of the consuls of the *Arte della lana;* [2]) and wishing to have some advice as to the above mentioned matter etc., the consuls decided to call together, to decide on this, the masters, men and architects whose names are written down in Italian, and to write down their opinion word for word:

Andrea della Robbia	Lorenzo della Golpaia
Giovanni Cornuola	Salvestro, *jeweller*
Vante, *miniature painter*	Michelangelo [Viviani], *goldsmith*
the Herald of the Palace	Cosimo Rosselli
Giovanni, *fifer-player*	Chimenti del Tasso
Francesco d'Andrea Granacci	Sandro di Botticelli, *painter*
Biagio, *painter*	Giovanni, called Giuliano and
Piero di Cosimo, *painter*	Antonio da Sto. Gallo
Guasparre, *goldsmith*	Andrea da Monte a Santo Sovino,
Ludovico, *goldsmith and*	*painter* (in the margin: *is in*
bronze-caster	*Genova*)
Riccio, *goldsmith*	Lionardo da Vinci
Gallieno, *embroiderer*	Pietro Perugino in the via Pinti,
Davit, *painter*	*painter*
Simone del Pollaiuolo	Lorenzo di Credi, *painter*
Philippo di Philippo, *painter*	Bernardo della Ciecha, *woodcarver* [3]

All those mentioned above came to the office of the Opera del Duomo, and as they were asked and summoned by two members of the Opera, to give and lay down their opinion etc. and to indicate the place where the statue should be installed. And from the beginning we shall take

2 *L'Arte della lana* was one of Florence's great corporations, and the consuls were its elected leaders.

3 Some of the characters on this list are difficult to identify, others are well known. The following seem to ask for some explanations:

Giovanni Cornuola or delle Corniuole, engraver on hard stones, c.1470-1516; we know a head of Savonarola carved by him in carnelian.

Vante the miniaturist is Attavante, 1482-1517, who worked for Lorenzo de Medici and was a friend of Leonardo.

Giovanni the fifer-player is B. Cellini's father; see the latter's *Vita*, I, 5.

Francesco Granacci, 1477-1543, is the well-known painter, a friend of Michelangelo's youth.

Davit the painter must be Ghirlandaio.

Simone del Pollaiuolo: this is the real name of the architect Cronaca.

Filippo di Filippo is Filippino Lippi.

Lorenzo della Golpaia built a famous astronomic clock described by Politian.

Michelangelo the goldsmith is, according to Gaye, Michelangelo Viviani, father of Bandinelli.

There were two Chimenti del Tasso, the uncle, 1430-1516, and the nephew, d. 1525. Both were wood sculptors and makers of intarsia.

Bernardo della Cecca, called Bernardo di Marcho below, is Bernardo di Marco Renzi, pupil of the cabinet maker and wood sculptor Fr. d'Angelo, called la Cecca.

It is hard to understand why Andrea Sansovino is called a painter.

down word for word just what they said as it came out of their mouth in Italian.

Messer Francesco The Herald of the Palace: I have turned over in my mind those suggestions which my judgment could afford me. You have two places where the statue may be set up: the first, where the Judith stands; the second, in the middle of the courtyard where the David is.[4] The first might be selected because the Judith is an omen of evil, and no fit object where it stands, as we have the cross and lily for our emblems; besides, it is not proper that the woman should kill the male; and, above all, this statue was erected under an evil star, as you have gone continually from bad to worse since then. Even Pisa has been lost. The David of the courtyard is an imperfect statue because the leg thrust backwards is poor; and so I should advise you to put the Giant in one of these places, but I give preference myself to that of the Judith.[5]

Francesco Monciatto, carpenter [6]: I answer and say: I believe everything made is made for a certain purpose; and I believe so because it [the statue] was made to be placed above the pilasters or buttresses around the church: [7] why one should not want to put it there, I do not know; and it seems to me that it would have stood there as a fine ornament for the church and for the consuls, and the place has been changed. My advice is that since you changed the first project, it would be very well either in the Palace or around the church. Since I have not quite made up my mind, I shall yield to what others say, because by lack of time I have not given enough thought to what place would be most suitable.

Cosimo Rosselli: Both Messer Francesco [the herald] and Francesco [the carpenter] were right that it would be fine around the Palace. I also thought of placing it on the steps of the church to the right, with a pedestal on the corner of those steps, with a high base and ornament, and that's where it should go in my opinion.

Sandro Botticello: Cosimo has said exactly where I feel [it should go] to be seen by the passers-by with a Judith on the other corner; the *loggia dei Signori* is also possible, but on the corner of the church is better. I believe it would stand there best and it would be the best place. . . .[8]

4 Donatello's bronze *David*, formerly owned by the Medici, was set up by the Republic in the courtyard of the Old Palace.

5 This is the opinion which prevailed. Donatello's *Judith* was stationed in front of the Old Palace, and was considered a symbol of Florentine freedom and of the Republic (this is what the Herald protests against when he says "as we have the cross and the lily for emblems").

6 Francesco Monciatto was, together with Cronaca, the architect of the Council Hall, 1495-1497.

7 The buttresses of the Cathedral's tribune were supposed to be crowned by statues; the marble allotted to Michelangelo, which two or three sculptors successively had started and worked on, was originally planned for that place.

8 There follows the word *dalorini,* the meaning of which is dubious; perhaps for *dall'orini.*

Giuliano da Sangallo: I was much inclined to chose the corner of the church, like Cosimo, which is seen by the passers-by; but since it is exposed to the public, in view of the imperfection of the marble which is soft and spoiled by having remained in the open,[9] I do not think it would last. For that reason I decided that it would be well placed in the central bay of the *loggia dei Signori,* either in the middle of the vault so that one could walk around it, or further inside near the wall in the middle, with a black niche behind it like a little chapel. Because if it is put in the open it will soon be destroyed, and it has to be covered.

The Second Herald (nephew of Messer Francesco, the first speaker): I can see what they all mean, and everyone is right in a different way. And looking for a place, because of frost and cold I concluded that it must be sheltered, and that its place is in the foresaid loggia and in the bay near the Palace; there it would be sheltered and honored by the proximity of the Palace; but if it were placed in the central bay, it would interfere with the ceremonies performed there by the Signoria and other magistrates, and before Your Honors decide where it belongs, you should check with the Signori, because some of them are very clever.

Andrea called Il Riccio, goldsmith *(This was added after everyone had spoken):* I agree with what Messer Francesco the herald said, that there it would be well sheltered, and it would be better appreciated and its conservation would be better taken care of, and it would be better if it were sheltered; passers-by would go and see it, and a thing like this would not have to go and meet the passers-by; it is for us and the passers-by to go and see it and not for the statue to come and see us.

Lorenzo della Golpaia: I agree with the Herald, Riccio, and Giuliano da S. Gallo.

Biagio, painter: I think that this is wisely spoken, and I am of the opinion that it would stand best where Giuliano has said, if set far back so as not to hamper the ceremonies of state which take place in the Loggia. Or, if not there, then on the stairs.

Bernardo di Marcho: I agree with Giuliano da S. Gallo; I think he is right, and I subscribe to the arguments Giuliano has brought up.

Leonardo di Ser Pietro da Vinci: I agree it should be in the Loggia, where Giuliano has said, on the parapet where they hang the tapestries on the side of the wall; with appropriate ornament and in a way that does not interfere with the ceremonies of state.

Salvestro: We have considered and discussed all the places where such a work can be displayed, and I believe that he who has made it should give it the best location. As for myself I think it would be best next to the palace. Nevertheless, as I said, the man who made it would know

better than anyone else the place fit for the appearance and the conception of the statue.

Philippo di Philippo: You have all spoken very well and I believe the artist has considered the location better and at greater length, and let us hear his opinion, and I approve of all that has been said, for it has been said wisely.

Gallieno, embroiderer: As I see it, and in view of the quality of the statue, I believe it would be well where the lion sits on the square,[10] with a base as ornament. This place is suitable for such a statue and the lion could be put at the side of the gate of the palace on the corner of the parapet.

Davit, painter: It seems to me Gallieno has pointed out as worthy a place as any, and this is the suitable and convenient location, and put the lion where he said, or in another place, wherever it would be decided best.

Antonio, carpenter of S. Gallo: If the marble were not fragile, the place of the lion would be fine. But I don't think it would last there very long. Therefore, since the marble is fragile, I would install it in the Loggia, and if it is not quite on the street, the passers-by will put up with going to see it there.

Michelangelo, goldsmith: These wise men have well spoken, and best of all Giuliano da S. Gallo; it seems to me that the location in the loggia is fine, and if this is not approved, then the middle of the Council Hall.

Giovanni, fifer-player: Since I see your opinion, I would agree with Giuliano if it could be seen complete, but it can not be seen complete; one must think of the purpose of the work, the climate, the opening [of the loggia], of the wall, and of the roof; it would be necessary to walk around it, and on the other hand some wretch might hurt it with a bar. I think it would be well in the courtyard of the palace, as Messer Francesco the herald proposed, and this would be very agreeable to the creator, since such a place is worthy of such a sculpture.

Giovanni Cornuola: I was inclined to put it where the lion is, but I had not thought that marble was fragile and would be necessarily damaged by water and cold; therefore I think it would be well in the loggia as Giuliano da S. Gallo has said.

Guasparre di Simone: I had thought of putting it on the Piazza di S. Giovanni, but I think the loggia is a more suitable location, since it is fragile.

Piero di Cosimo, painter: I agree with Giuliano da S. Gallo, and even more that the man who made it should give his agreement, because he knows best how it should be located.

[10] This figure, now lost, was in approximately the same spot in front of the Palace that is occupied today by a replica of Donatello's *Marzocco*.

The answers of the other gentlemen who were named and whose opinion was asked have not been written down for the sake of brevity. But their opinion was to agree with those above, one to this, one to the other without difference.

<div align="right">APRIL 1ST, 1504</div>

After deliberation they contracted Simone del Pollaiuolo to transport the marble statue to the Palace of the Signori, in the presence and with the approval of Michelangelo Buonarroti, sculptor. It must be transported by the 25th of this month.

FROM THE DIARY OF LUCA LANDUCCI [11]

On the 14th of May 1504, the marble Giant was taken from the *Opera*. It came out at 24 o'clock, and they broke the wall above the gateway enough to let it pass. That night some stones were thrown at the colossus to harm it. Watch had to be kept at night; and it made way very slowly, bound as it was upright, suspended in the air with enormous beams and a complicated mechanism of ropes. It took four days to reach the Piazza, arriving on the 18th at the hour of 12. More than forty men were employed to make it go; and there were fourteen rollers joined beneath it, which were progressively transferred.[12] Afterwards, they worked until the 8th of June 1504, to place it on the platform where the Judith used to stand. The Judith was removed and set up upon the ground within the Palace. The said Giant was the work of Michelangelo Buonarroti.

Appointment of Raphael as Inspector of Antiquities in Rome

On August 1, 1514, Raphael was appointed chief architect of Saint Peter's. The papal brief which made the appointment specified that Bramante had named his successor to the office before dying. Raphael certainly considered this his most onerous duty (see p. 33). The other letter of nomination which we translate here is intended to facilitate Raphael's work on Saint Peter's by providing stone from the Roman ruins. Using ancient materials for building was current practice through the 16th century (Sixtus V had the Septizonium, one of Rome's most famous ancient ruins, destroyed for this purpose). Yet, the terms of Raphael's appointment showed an advance over previous practice in that it made an effort to avoid outrageous destructions. In this context one will notice the humanist attitude which gave precedence to inscriptions rather than reliefs.

[11] *Life of Michelangelo,* English trans. Symonds (London, 1899), pp. 96 f.
[12] As the statue was moving, one took the logs from behind and placed them in front so that the *David* continued to roll on them.

To Raphael of Urbino [1]

It is of the utmost importance for the work on the Roman temple of the Prince of the Apostles [St. Peter's], that the stones and marble, of which a great quantity are needed, be easily obtained in the neighborhood rather than imported from afar. And since we know that the Roman ruins provide them abundantly, and that all sorts of stone are found by almost anybody who starts to build in or around Rome, or digs up the ground for some other reason, we create you, because we have entrusted you with the direction of the work, inspector in chief for all the marble and all the stone which will be excavated from now on within Rome or within ten miles around it, so that you can purchase them if they are useful for the work on the temple. Hence we order everyone, of high, modest, and low origin and rank, that they should first of all inform you, in your position as head superviser, of all the marble and stones of all kinds discovered in the above-mentioned precincts. Whoever will not have complied within three days will be punishable by a 100 to 300 gold ducats fine, as you should decide. Since we have been informed that masons unheedingly cut and use ancient pieces of marble and stone that bear inscriptions or other remains which often contain things memorable, and which deserve to be preserved for the progress of classical studies and the elegance of the Latin tongue, but that get lost in this fashion, we order all stone quarries of Rome not to break or saw stones bearing inscriptions without your order and permission, liable to the same fine if they disobey our orders.

ROME, AUGUST 27, IN THE 3RD YEAR OF OUR PONTIFICATE [1518]

Commission of a Group of Statues to Andrea Sansovino

We know of several instances where artists, anxious to obtain a commission, left the price up to the patron's discretion. In this case, Sansovino did not risk much in making such an offer to the Calimala, or Merchants' Guild of Florence, which, in order to enhance its prestige, had assumed the cost of all the works on the Baptistry. The Calimala furnished the marble; Andrea, according to customs, had to give a warranter. The statues remained unfinished and were finally completed by Vincenzo Danti. They were installed over the eastern portal, and not the southern one as originally planned.

[1] Translated from Passavant, *Raphael et son Père G. Santi* (Paris, 1860), p. 506. First published in P. Bembo's collected Latin letters, Lyon ed., p. 246.

From the Deliberations of the Council of the Calimala
(Merchant's Guild of Florence) [1]

28TH OF APRIL, 1502

There came to the attention of our honorable Consuls [2] that there is a sculptor called Andrea dal Monte San Savino, who offers to make a figure in marble of our Lord and of St. John the Baptist baptising Him, to be placed above the baptismal door of the church of St. John the Baptist in Florence, facing the Misericordia.[3] For the moment, he wants only the marble needed to execute them, and then he will work on them. When they are finished, he wants for his labor and for his mastery whatever is decided by the Consuls and the Officers of the Fabric [4] or by two thirds of those then in office in the said Fabric; and he leaves it to their discretion, because he hopes to make them so fine and beautiful that he believes he will have a fair price for them. Our said honorable Consuls consider that the [extant] figures above the door are so clumsy that it is a disgrace that they should be seen and remain on a temple of the distinction of the said church of St. John; also they are so damaged that they have already begun partly to fall down, and what remains shows signs of ruin; and since they understand that the said artist is apt and fully competent, and that the figures being thus done would be an ornament for the said church; for these reasons, by the present document it is deliberated, decided and ordered, that the said honorable Consuls now in office and their successors or the two thirds of them have the right and the power to commission the said figures from the said Andrea, and to give him the necessary marble and to agree with him that, once the said statues are completed, the price he could ask for them would be left to the decision and discretion of the Consuls and Officers of the Fabric or the two thirds of them then in office; and that they should do what is necessary and fit to this purpose; and what will be ordered by the said Consuls and Officers of the Fabric will be recognized as valid and executed by who ought and is expected to do so.

Titian Applies to the Council of the Ten *

This letter, of December 1515 or January 1516, is Titian's last offer in a long conflict during which he opposed not so much the Council of the Ten as Giovanni Bellini. In May 1513 Titian had obtained the com-

[1] Published in 1860 by Gaetano Milanesi in *Giornale Storico degli Archivi Toscani*, IV, 66-67, from the minutes of the deliberations of the Calimala.

[2] The consuls are the chief executives of the Guild.

[3] Called today Loggia del Bigallo, South of the Baptistry.

[4] *Arte del Musaico.* This was the name of the Opera of the Baptistry, because of the important mosaics on the ceiling.

* Cf. Crowe and Cavalcaselle, *Titian, His Life and Times* (London, 1877), 2 vol.

mission for a painting in the Great Council Hall, accompanied by privileges that encroached upon Bellini's primacy; the latter protested, and the privileges were partly cancelled. Propositions, counterpropositions, and resolutions followed one another until a report, established on the Ten's order, exposed the poor management of the funds for painting the Hall. Titian then made his definitive offer, reprinted here, which is considerably more modest than his previous propositions. This served as a basis for the final agreement. The picture, representing the Battle of Cadore, *was finished only in 1538, and burned with the Hall in 1577.*

Titian: Letter to the Doge of Venice [1]

Having understood, Your Highness, that you have decided to let those canvases in the Great Council Hall be painted, and since I, Titian, servant of Your Highness, should like to display such a canvas painted in this fashion from my hand, and have actually started on one two years ago, and it is not the most difficult and laborious to do for this Hall,[2] I bind myself by my own will to finish it as it ought to be, at my own expense; nor do I want any other payment before the completion of the work, except only for ten ducats' worth of paints, and three ounces of that blue which is kept in the Salt Office; and I want one of the two young men that will help me to be paid for me as an advance on my account, which only amounts to 4 ducats a month, while I bind myself to pay another out of my pocket, and to take charge of any other expenditure that will be required by the painting; Your Highness would make the Salt Office promise me that when the work was completed, they would pay me half of that which was once promised to Perugino, who was supposed to paint this canvas, which would come to 400 ducats, since he would not do it for 800, and that in time [3] I should get the office of broker of the Association of German Merchants,[4] as was decided in the Most Illustrious Council of November 28, 1514.

Tommasso Vincidor's Report to the Pope *

The following piece is a very interesting but difficult document. The name of the author of the letter nowhere appears on it, but all scholars have accepted E. Müntz's attribution to Tommaso Vincidor, a student of

1 From G. Gaye, *Carteggio inedito d'artisti dei secoli XIV, XV, XVI* (Florence, 1839-1840), II, 142-43.

2 This was said to assure the Ten that the execution of the work would be speedy. In fact, Titian completed it only 24 years later, under menace of having to give back the whole advance.

3 I.e., after Bellini's death.

4 *Sanseria del Fondaco dei Tedeschi* was an office held by Giovanni Bellini at that time, and which obliged the beneficiary to paint portraits of the Doges.

* Cf. Pouncey and Gere, *Raphael and His Circle* (London, 1962), for previous literature.

Raphael and a member of his studio, who was sent to Flanders to super-vise the weaving of tapestries. The text is hard to read at points and some of our readings and interpretations are conjectural, but there is no seri-ous question as to what Vincidor meant. However, the question of his re-sponsibility in the creation of the tapestries with playing children (some of which are preserved in the Louvre) is a much harder one. It was a series of 20 pieces which Vasari (ed. Milanesi, VI, 555) described and assigned to Giovanni da Udine without mentioning Tommaso Vincidor. On the basis of letters printed herein, E. Müntz, R. Förster and O. Fischel have accepted Vincidor's full authorship. But Diez, Pouncey and Gere are probably right in supposing that Vincidor relied without mentioning it on G. da Udine's compositions, since Vincidor also did not mention in his letter that for the bed hanging (lost, but known through a drawing in the Louvre) he used a composition by Raphael almost without alteration.

This difference of opinion is a good example of how cautious one must be in using even the best and most direct sources.

Letter of Tommaso Vincidor to Leo X [1]

Most Blessed Father, I begin by kissing your foot and paying you my due reverence. This will be a faithful recital of Your Holiness's busi-ness. Although I have informed Your Beatitude by many letters, I do not know whether they have not come into the hands of some people who have not delivered them; therefore I have given these to the Papal Nuncio who stays at the King's Court; I have explained to him how your work is proceeding; he had no time, being ready to leave Brussels to go to Ant-werp; very busy, he had not slept all night, and had spent the day writ-ing; nevertheless, when he returns to Brussels I shall show him all the models (*patroni*) I have made, that is, the cartoons; Your Holiness will understand all in a few words. I have made twenty cartoons for twenty pieces [of tapestry] which will go around the room that is being painted by my companions, that is, Giulio [and] Gianfrancesco.[2] Holy Father, you can expect to see in this the most beautiful hanging ever seen, the gayest and richest in gold. I have varied all the inventions of the middle, fantasies with little putti, something gay, fitting to all your devices, as rich as possible. True that they could not be executed entirely by me. I have designed the whole arrangement and done most of it with zeal to do Your Holiness honor. I have also begun the pictures for the bed. I know they will please you because of the compositions that I have made; in

[1] First published by E. Müntz in *The Athenaeum*, July 11, 1896, p. 73, from which it is translated.

[2] Giulio Romano and Gianfrancesco Penni, as heirs to Raphael, were engaged in painting the decoration of the Sala di Costantino in the Vatican. The tapestries of playing children were to go below the frescoes.

these pieces there will be the portrait of Your Holiness in the presence of God who is bestowing upon You the grace of the Holy Ghost, [with] the most Reverend Monsignor de Medici, [and] Monsignor Cibo.[3] I beseech Your Holiness to remember my letters only because I ask the Most Reverend Monsignor de Medici to have a reduced copy made of two portraits owned by His Lordship in an oil painting from the hand of my master, which painting is in Florence.[4] Let these two heads, one of Your Holiness, the other of Monsignor de Medici, be sent with a letter, so that I can portray them better. I have asked for this in many letters of mine; the bed would be already done.

I beg Your Holiness for a very small intervention. Do not allow to be taken away from me a poor office which Monsignor Medici gave me, at least as long as I am in Your service; it is not worth more than one ducat a month.

Nothing more, most Blessed Father, to tell you in this letter: wherever I am they say *leo est bonus pastor*.[5]

P.S. Most Blessed Father, I beg Your Holiness to recommend me to my patron, who treats me like a son; when one asks him for something he is a good man, looks after your business, and puts himself to great trouble, [but] he is always away, and we are in the hands of his intendants. I have much to bear away among foreign barbarians.

The Death of Giulio Romano *

Cardinal Ercole Gonzaga, brother of Federigo II, governed Mantua at the latter's death in 1540 because Federigo's children were still very young. This new patron, a leader of the Council of Trent, was a very different figure from his famous libertine brother for whom Giulio Romano had worked for 15 years. The new patron and the artist became, however, deeply attached to each other, and the Cardinal's letter to his brother Ferrante two days after Giulio's death is a striking and moving witness of this relation.

Ercole Gonzaga to His Brother Ferrante [1]

We lost our Giulio Romano with so much displeasure that in truth it seems to me that I have lost my right hand. I did not want to inform

[3] The tapestry is lost but Vincidor's drawing is in the Louvre. It repeats a drawing by Raphael with the sole addition of the portraits mentioned.

[4] Raphael's *Portrait of Leo X and the Cardinals Giulio de' Medici and Luigi Rossi*, today in Florence, Pitti.

[5] "The Lion is a good shepherd." A flattering pun on the Pope's name.

* Cf. Frederick Hartt, *Giulio Romano* (New Haven: Yale University Press, 1958), I, 255.

[1] Translated from Gaye, *Carteggio inedito*, II, 501.

you of this at once, as I thought that the later you would hear of such a great loss, the less it would affect you, especially since you are taking your water cure. Like those who from evil try always to extract some good, I try and convince myself that the death of this rare man will at least have succeeded in taking away my appetite for building, for silverware, for paintings, etc., for in fact I would not have the heart to do any of these things without the design of this beautiful mind; therefore, when these few are done, whose designs I have with me, I think I shall bury with him all my desires as I have said. God give him peace; which I hope well is certain, for I have known him as an honest man and pure toward the world, and I hope also toward God. I cannot have enough of talking about him with tears in my eyes, yet I must end, since it has pleased Him who governs all to end his life.

FROM MANTUA, NOVEMBER 7, 1546

3

Mid-Century
Venetian Art Criticism

INTRODUCTION

In the middle of the century, the Venetians had, one might say, invented art criticism which they wrote in a fashionably colloquial form. This is not astonishing, considering the milieu we have seen described by Michiel (p. 25).

The first in time of these critics, Pietro Aretino, dealt with art in his letters which he himself published. Tuscan by birth and Roman by his first artistic education, he was able to adopt Venetian taste and to express it sometimes magnificently. But he was an art broker, a collector, and a propagandist before being a critic, and one often feels him to be hampered by the interests which dictated his epistles (p. 51). His friend Dolce's dialogue titled Aretino, *intended to give a systematic expression to its hero's ideas, has therefore more coherence and contains some pages of a by no means impartial, but sometimes surprisingly closely knit, criticism (p. 60).*

The Venice-Florence opposition, stressed by Dolce in his implicit polemic against Vasari, dominates all Venetian literature on art; it appears in P. Pino's dialogue on painting (p. 58), a modest piece of writing in a popular tone, where one feels the envy of a poor Venetian painter for the Tuscan artists so richly endowed by their patrons. A dialogue by Anton Francesco Doni, a Florentine established in Venice (Il Disegno, 1549), is a rather disparaging answer to Pino; the author resolves the para-gone in favor of sculpture and writes a eulogy of his friend Bandinelli.

Only one minor piece of Venetian writing on art—the Della nobilissima pittura *(1549) by Michelangelo Biondo, physician and polygraph—is merely rhetoric and didactic. In general, the Venetians were progressive and pragmatic, and abandoned generalizations à la Castiglione for a circumstantial criticism of works and styles.*

Aretino: Letters to Artists *

Sovereigns and other important people commissioned and bought works of art for reasons of prestige, and these Maecenases were always glad to see their acquisitions publicly talked about and their artists praised. The famous writer Pietro Aretino (1492-1556), the "scourge of princes" and friend of Titian and Sansovino, took advantage of the situation systematically; his letters, brilliant and full of zest, although at times tedious by their rant and stylistic mannerisms, could be either helpful for both artists and patrons, or dangerous through their power of ridi-

* Cf. L'Aretino, *Lettere sull'arte*, ed. Flora, Pertile, and Camesasca (Milan, 1957-1960), 4 vol.

cule. Aretino asked for payment from both parties, in money and in works of art, and was thus able to acquire a handsome collection.

As an art critic, he indisputably had his own doctrine, the same one that he preached in literature: naturalness, spontaneity, and the appearance of life are the supreme values. His temperament reveals itself in his letter to Titian, reprinted below (pp. 54-55). He was sensitive to colors and even more so to light; and he was enough of a connoisseur to see nature through art, and to use the metaphors of painting to describe a real scene almost unaffectedly.

His letter to Schiavone (pp. 55-56), which is beautifully written in the tradition of the younger Pliny—a translation cannot do justice to the original—illustrates his behavior with artists: a mixture of flattery and menace, tied to a commonplace of criticism delivered in a peremptory tone, all leading to the final and open request for one of the artist's works. In his first approach to Michelangelo, Aretino tried to be more discreet than usual, asking for nothing openly, and made a literary effort, inventing a project for the Last Judgment. *His advice would be hard to follow for a painter; one will notice the abundance of allegories and the insistence on pathetic effects. There is no question that a picture of the Last Judgment as proposed by Aretino would have pleased a Counter Reformatory critic like Gilio better than Michelangelo's. On the later development of the relations between Aretino and Michelangelo, see below p. 122.*

To Titian [1]

Signor compare,[2] having, contrary to my custom, dined alone, or rather in the company of the discomforts of that quartan fever which never lets me enjoy the taste of food any longer, I walked up from the table sated with the same despair with which I had sat down to it. And then, leaning my arms, my chest, and almost my whole body against the window sill, I started to look at the admirable spectacle made by the innumerable barges which, laden with foreigners as well as natives, entertained not only the onlookers but the Grand Canal itself, that entertainer of all who plough its waves. And as soon as it offered the diversion of two gondolas with famous gondoliers having a race, it was a great pleasure to watch the crowd of people who had stopped, to look at the regatta, on the Rialto Bridge, on the Riva dei Camerlinghi, in the Fish Market, on the landing-stage of Saint-Sophia, and in the Casa da Mosto. When these crowds had gone on their way with joyful applauses, then, like a man

1 Aretino, *op. cit.,* II, 16-18.
2 Titian, Sansovino, and Aretino formed a sort of informal academy, and called each other *compare.*

bored with himself who does not know what to do with his mind or his thoughts, I turned my eyes towards the sky; this had never since God's creation shown such a beautiful picture of shadows and light. And it was such as those who envy you, because they cannot approach you, would like to render. You should see, by means of my description, first the buildings which, although of real stone, seemed made of some unreal material. And then, imagine the sky, which I perceived in some places pure and bright, in others dim and livid. Think also how I marvelled at the clouds of condensed humidity; in the principal view they were partly close to the roofs of the buildings, partly receding far back [to the left], for the right hand side was all veiled with a darkish gray. I was really amazed by the various colors which they showed; the closest were burning with the flames of the sun's fire; and the farthest were red with a less burning vermilion. Oh, with what beautiful strokes the brushes of Nature pushed the azure into the distance, setting it back from the buildings the same way that Titian does in his landscapes! In some places there appeared a green-blue and in others a blue-green which really seemed as if mixed by the errant fancies of nature, master of the masters. With lights and shadows she hollowed and swelled whatever she wanted to swell and hollow; so that I, who know that your brush is the very soul of her soul, burst out three or four times with: "Oh, Titian, where are you now?"

On my honor, if you had painted what I described, you would amaze people as I was amazed; but while watching what I have described to you, I had to fill my soul with it since the splendor of a painting of this kind was not to last.

<div align="right">In Venice, May 1544</div>

To Messer Andrea Schiavone [1]

It is a cruelty by no means different from that which a son shows his father when he forgets the latter's love, that you do not come any longer as you used to before when you never painted anything lascivious or religious without having it brought to my house to show it to me; and the admirable Titian—no less dear to Charles V than Apelles to Alexander—knows how I have always praised the consummate quickness of your intelligent handling. Even that worthy painter was almost baffled by the experience which you display in brushing the sketches of your compositions, which are so intelligent and well organized that, if the haste of the sketching was changed into care for finishing the works, you too would confirm the excellence of my judgment. Only your imagination in the arrangement of figures deserves unrestricted praise,

[1] Aretino, *op. cit.*, II, 221.

because, where that quality is lacking there is little expertness to be found in your painting. But I pass over all that I could tell you for your improvement, so as not to deprive Time of his rights; it is his office to teach the young how to mend their shortcomings; with growing years, the young grow in discretion, which changes thoughtlessness into experience. I pass over all that, as I said, and beseech you to come here again with some painting, the granting of which would cheer me both with your presence and your art.

<div align="right">IN VENICE, APRIL 1548</div>

To Michelangelo [1]

Venerable man, just as it is a blemish on reputation and a sin of the soul to forget God, in the same way it is a flaw in one's worth and a debasement of intelligence (for whoever has worth and intelligence) not to revere you who are a target for marvels in which the stars, competing in their favors, have cast all the arrows of their gifts. Thus in your hands there lives hidden the idea of a new nature,[2] so that the difficulty of out-lines—the ultimate science in the subtleties of painting—is so easy for you that you bind within the outlines of the bodies the end of art, a thing which art itself confesses to be impossible to achieve perfectly, because the outline (as you know) should appear to fold back and so define the object, so that, by showing what it does not show,[3] it suggests just that which is suggested by the figures of the Sistine Chapel to him who knows how to understand them and not look at them merely to see them.

Now I, who with praise and censure have exposed the greater part of the merits and faults of others, in order not to efface the little that I am, I pay you my respect. I should not venture to address you, had not my name, accepted by the ears of every prince in Europe, outworn much of its native indignity. And it is but meet that I should approach you with this reverence, for the world has many kings, and only one Michel-angelo. Strange miracle, that Nature, who cannot place aught so high but that you explore it with your art, should be impotent to stamp upon her works that majesty which is contained within the immense power of your

1 Aretino, *op. cit.,* I, 64-66.

2 This much admired formula is really a happy characterization of Michel-angelo's genius; Aretino himself must have been quite pleased with it for he has used it again several times, but applying it to Titian.

3 Open allusion ("as you know") to a well-known and obscure passage in Pliny on Parrhasius: *extrema corporum facere et desinantis picturae modum includere rarum in successu artis invenitur. Ambire enim se ipsa debet extremitas et sic desinere, ut promittat alia et post se ostendatque etiam quae occultat. (Nat. Hist., XXXV,* 10, 67-68). Below, there seems to be a further allusion to a passage which comes soon after in Pliny *(ibid.,* 74) on Timanthes: *Atque in unius huius operibus intelligitur plus semper quam pingitur.*

style and your chisel! Wherefore, when we gaze on you, we no longer regret that we may not meet with Pheidias, Apelles, or Vitruvius, whose spirits were but the shadow of your spirit. But I consider it fortunate for Parrhasius and the other ancient painters that Time has not consented to let their manner be seen today: for this reason, we, giving credit to their praise as proclaimed by the documents, must suspend granting you that palm which, if they came to the tribunal of our eyes, they should have to give to you, calling you unique sculptor, unique painter, and unique architect. But if it is so, why are you not satisfied with the glory you have already won? I think that you should be content to have surpassed all the others with your previous works; but I feel that with the end of the universe, which you are painting now, you intend to surpass the creation of the world, which you have painted already, so that your paintings defeating your own paintings, you should win a triumph over yourself.

Now, who would not quake with terror while dipping his brush into the dreadful theme? I behold Antichrist in the midst of thronging multitudes, with an aspect such as only you could limn. I behold affright upon the forehead of the living; I see signs of the extinction of the sun, the moon, the stars; I see the breath of life exhaling from fire, air, earth, water; I see Nature abandoned and apart, reduced to barrenness, crouching in her decrepitude; I see Time sapless and trembling, for his end has come, and he is seated on an arid throne; and while I hear the trumpets of the angels with their thunder shake the hearts of all, I see both Life and Death convulsed with horrid confusion, the one striving to resuscitate the dead, the other using all his might to slay the living; [4] I see Hope and Despair guiding the squadrons of the good and the cohorts of the wicked; I see the theatre of clouds, blazing with rays that issue from the purest fires of heaven, upon which Christ sits among his hosts, ringed round with splendors and with terrors; I see the radiance of his face, coruscating flames of light both joyful and terrible, filling the blessed with joy, the damned with fear intolerable. Then I behold the satellites of the abyss, who with horrid gestures, to the glory of the saints and martyrs, deride Caesar and the Alexanders; for it is one thing to have trampled on the world, but more to have mastered oneself. I see Fame with her crowns and palms trodden under foot, cast out among the wheels of her own chariots.[5] And to conclude all, I see the dread sentence issue from the mouth of the Son of God. I see it in the form of two darts, the one of salvation, the other of damnation; and as they speed downward, I hear the fury of its

[4] On the day of Doom, those who will be alive will die to be instantaneously resurrected in the valley of Jehoshaphat.

[5] Fame triumphs over Death, but is itself defeated when the Last Judgment ends time. This conception derives from Petrarch's *Triumphs*.

onset shock the elemental frame of things, and, with tremendous fracas, smash it to fragments. I see the vault of ether merged in gloom, illuminated only by the lights of Paradise and the furnaces of hell. My thoughts, excited by this vision of the Day of Doom, whisper: "If we quake in terror before the work of Buonarroti, how shall we shake and shrink affrighted when He who shall judge passes sentence on our souls?"

But does Your Lordship believe that the vow I have made never to see Rome again should be broken by my wish to see such a picture? I would rather belie my decision than prejudice your worthiness, which I beg to be pleased with the desire I have to proclaim it.

VENICE, SEPTEMBER 16, 1537

Paolo Pino: Charm and Speed in Painting

Paolo Pino's Dialogo di Pittura *is the first in a series of theoretical works written in Venice around the middle of the century. Pino's attitude is still close to Castiglione's urban manner of considering art theory as a succession of traditional controversies about a certain number of famous questions (the* paragone, *the comparison between inspiration and study, etc.). But he has the true Venetian approach, the kind of art criticism which tries to understand the real value of the works and the origin of the pleasure they give. What distinguished Pino from Castiglione as well as from Dolce is his less intellectual manner (although he has read and used Alberti, Gauricus, and Dürer), his lack of literary culture, and his love for the concrete.*

Pino was a painter, a pupil of Savoldo; as Pallucchini has shown, Pino's taste was reactionary at a time when Titian was at the height of his power and Tintoretto was already a rising star. Pino's lack of professional success was the cause for some meaningful remarks on the financial difficulties of mediocre painters and on their relation with the public.

Of the two speakers, Lauro is the needy Venetian; the other, Fabio, is the more successful Tuscan, who gives lessons to the former and is used by the author as the critical spokesman.

From the *Dialogue on Painting* [1]

Lauro: Just a moment! How do you like a charming painter? [2]
Fabio: He pleases me most, and I tell you that charm is the relish of our works. I do not, however, mean by charm the ultramarine blue at

[1] Translated from Barocchi, *Trattatisti,* I, 94-139 (see pp. 118-120).

[2] *Il pittore vago.* Vaghezza, or sensory attractiveness, generally assimilated with the pleasure given by colors, was opposed to the more intellectual values of good design, anatomical science, perspective, and the beauty of proportions. For true Tuscans, an excess of *vaghezza* would bring a kind of discredit to the painter.

sixty scudi an ounce or fine lacquer, because paints are also beautiful by themselves in their boxes, and a painter can not be praised as charming for giving pink cheeks and blond hair to all his figures, for making serene expressions, or for coating the earth with beautiful green; but true charm is nothing else than grace, which comes from a harmony or just proportion of things, so that, while the pictures have decorum, they also have charm and bring honor to the master.

Lauro: How badly off I would be, if they did not sell those beautiful paints, which bring me credit and profit!

Fabio: This just dazzles the ignoramuses. I do not blame you for using beautiful colors in your work, but I would like *you* to enhance the colors, and not the colors to serve you.

Lauro: This is your wish and my desire, but we do not know how. Please, tell me: how do you like one who paints fast? [3]

Fabio: Promptness is successful in all things, but speed in a man is a natural disposition and almost an imperfection. The artist does not deserve any praise for it, because it was not acquired by him, but given to him by Nature. Besides, in our art one does not judge by the time spent on one work, but only the perfection of that work, through which one can tell the master from the hack. It is true that both extremes are to be blamed, and, for example, we are told that Apelles scolded himself because he was too diligent and never stopped searching and perfecting his works, which is very harmful to one's intellectual power.[4] And the contrary is told about another painter who showed a work of his to Apelles, boasting that he had done it very fast; whereupon Apelles answered: "You do not have to tell me, the work itself shows it." [5] And also, this practice of smearing, as does your Andrea Schiavone, is a shameful thing, and painters like that show how little they know, since they don't reproduce but only vaguely suggest the effect of life, and for that reason they don't have to take much care, because they do not care to spend much time. On the other hand, ancient artists—and this should be practiced as a good method—used to put aside all their pictures when they were finished, and after a while they would look at them again and they would improve them. This method is used by writers for their compositions [6] and it is very useful.

3 This second traditional question touches on a related problem: inspiration and virtuosity are incompatible with the patient study of nature. This is the type controversy around Tintoretto.

4 Pliny, XXXV, 80.

5 Plutarch, *De educatione puerorum*, 9. Pino has taken the anecdote from Alberti; it became particularly famous when Apelles' saying was attributed to Michelangelo, who would have directed it against Vasari (Lomazzo, *Trattato* (1584), III, 466 of the 1844 ed.).

6 Horace, *Ars poetica*, pp. 386-390.

Lauro: And when would we get paid? Poverty is murderous, I tell you; and one work is not paid enough for the money to last until the next is completed. One goes as fast as one can, and, worse, sometimes one has to paint even furniture, not being able to keep oneself busy with the other application, because our art is not of vital use.[7]

Fabio: And why don't you paint pictures, and not such hackwork which with us is considered shameful and improper?

Lauro: Because if a Titian were offered for sale they would say it is cheap stuff; [8] and to our confusion they would offer us ten farthings or worse, for each house has its painter; and if I waited to be asked, I would paint less often than I see comets.

Fabio: To tell you the truth, I think you are trying to fool me. And because I am as soft as wax, you think you can easily print with the seal of disfavor on me, in order to clear the scene, fearing that I might steal your trade away. I believe so, because all these Venetian lords seem munificent to me, and partial to men of talent.

Dolce: Raphael and Michelangelo

The Dialogo della pittura intitolato l'Aretino *(Venice, 1557) is a manifesto expressing the critical conceptions of Aretino's Venetian circle. The attack on Michelangelo's* Last Judgment, *the near-defense of the* Sonnetti lussuriosi *and of the pictures they accompany, and the dithyrambic praise of Titian as a finale, all encourage us to believe that the whole* Dialogue *was written out of complaisance by one of Aretino's friends.*

Lodovico Dolce, one of many Venetian polygraphs, does not seem to have been particularly interested in art, although he expressed the essence of his ideas on the relation between Michelangelo and Raphael in a much earlier letter (to Ballini, 1544, printed in Bottari-Ticozzi, Lettere pittoriche, *V, 169 f). In the dialogue here excerpted, the arguments that Aretino used to confound the Tuscan Michelangelo apologist Fabbrini are of a rather general nature and remind us, in their naïvely systematic succession, of the previous generation's amateurism. But it was the first time that the merits and weaknesses of a living artist were discussed so thoroughly and that the styles of two masters were compared in this way. Dolce's criteria were those of classicism (Raphael, and not Titian, was set up against Michelangelo), but there is no doubt that Venetian taste dictated the main character of his real preferences: here*

[7] There was nothing more debasing for a painter than to paint furniture.

[8] A work of art should never be offered for sale in public, but should always be commissioned. The custom of exhibiting pictures in public, on a square, was introduced precisely in Venice by unemployed painters.

*is an agreeable, rich, and harmonious art, set up against a learned art
confined to the dryness of* disegno *and to an unreal and monotonous
manner.*

*The booklet had a lasting success and it was imitated and trans-
lated in several languages. Lessing attacked its conception of* ut pictura
poesis *at length.*

From *The Aretine* [1]

Aretin: Upon recollecting, therefore, all the parts which are required
in a good painter, we shall find that Michelangelo possesses one alone,
Design; and that Raphael possesses them all, or at least (as a man cannot
attain the independence of a God, to whom nothing is wanting) the
greater part; and if he was deficient in any, it was such as was of little
moment.

Fabrini: To the proof.

Aretin: First, as to Invention, whoever pays good attention, and
minutely considers the paintings of one and the other, will find Raphael
to have most admirably observed every thing relative to this part, and
Michelangelo little or nothing.

Fabrini: This seems to me a great partiality in the parallel.

Aretin: I say nothing more than truth: Hear me with patience. To leave
apart all that respects History (in which Raphael imitated the writers
in such a manner, that frequently the judgment of the observer is led to
believe that the painter has represented things more justly in his pictures
than they in their writings, or at least was on equal terms with them),
and proceeding to Propriety,[2] from this Raphael never departed, but
made his children really children, that is soft and tender, his men robust,
and his women with that delicacy which belongs to their sex.

Fabrini: Has not the great Michelangelo also preserved this propriety?

Aretin: If I would please you, and his other favorers, I should say yes;
but if I am to speak truth, I must say no: for although we may observe
in the pictures of Michelangelo, the general distinctions of age and sex
(which every painter knows), yet you cannot find it in the distribution
of the muscles. I shall not stop to examine his particular works, both
through the respect I bear him, and which ought to be had to such a
man, as also because it is unnecessary. But what think you with regard
to modesty? Does it appear to you proper that the painter, for the sake
of showing the difficulties of the art, should exhibit what shame and
modesty conceal, without any regard either to the sanctity of the persons
whom he represents, or to the place where they are painted?

[1] *Dialogo della pittura intitolato l'Aretino* (Venice, 1557); we use the anonymous
English translation: *Aretin: A Dialogue on Painting* (London, 1770), pp. 171-218.

[2] *convenevolezza,* the classical criterion by excellence.

Fabrini: You are too rigid and scrupulous.

Aretin: Who will be daring enough to affirm that it is proper, that in Rome, in the church of St. Peter, the chief of the apostles; in Rome, where all the world assembles, in the chapel of that high priest, who (as Bembo says) is the representative of God upon earth, figures should be seen, who immodestly discover what decency conceals? A thing, in truth, (speaking with submission) utterly unworthy of that most holy place. The laws prohibit the printing of immodest books: how much more should they prohibit such pictures? Does it appear to you, that they excite the mind to devotion? or raise it to the contemplation of divine subjects? But let us yield to Michelangelo on account of his great merit, what we should not allow to any one else. But let us also freely speak truth: If that is not permitted, I would I had not said this, because I do not say it for the sake of carping at his merits, nor to make a vain parade of extraordinary knowledge.

Fabrini: Sound eyes, my friends, are incorrupt and unoffended by seeing natural objects. Those which are infirm see nothing with a just mind; and you may with truth suppose, that if this were really so bad an example as you think it, it would not be suffered. But as you weigh these things with the severity of a Socrates, I ask you, Whether you think that Raphael acted consistently with modesty when he designed, and caused to be engraved by Marc Antonio, those men and women in loose and immodest embraces?

Aretin: I might answer to you, that Raphael was not the inventor of it, but Julio Romano, his disciple and heir. But allowing that he had designed the whole or part of it, he did not expose it in the public squares, or in the churches; but they came by chance into the hands of Marc Antonio, who for his own profit engraved them for Bavier; and Marc Antonio, if I had not interposed, would have met with a punishment from Pope Leo worthy of his deserts.[3]

Fabrini: This is merely a covering of fine sugar over aloes.

Aretin: I do not vary in the least from truth, nor is it utterly prohibited to the painter sometimes to do such things by way of pastime; as some of the ancient poets trifled lasciviously for Maecenas's diversion upon the image of Priapus, to celebrate that minister's gardens.[4] But in public, especially in sacred places, and on divine subjects, modesty should always be regarded: and it would be much better that these figures had been

3 Marcantonio's series of *Positions (I Modi)* were published along with Aretino's *Sonetti Lussuriosi.* The clumsily artificial manner in which this passage is inserted proves that Dolce was very anxious to introduce this apology of his friend. In a letter to Battista Zatti (d. 1537), Aretino brags of having obtained the engraver's pardon from the Pope (Clement VII, of course, and not Leo X). Baviera is a member of Raphael's studio, who printed and sold Marcantonio's engravings.

4 The *Priapea*, a 1st century B.C. collection.

more modest, even if they had been less perfect in design, than as we see them most perfect, but most immodest. But the virtuous Raphael always observed this modesty in all his works; insomuch that though he generally gave to his figures a soft and elegant air, which charmed and inflamed the mind; nevertheless, in the faces of his saints, and particularly of the Virgin Mother of our Lord, he always observed I know not what of sanctity and divinity, (and not only in the faces, but also in all their motions) which seems to repress every vicious thought in the spectator's mind. Wherefore in this part of invention, both with regard to the history and to propriety, Raphael is superior.

Fabrini: I do not know that Michelangelo yields to Raphael for the composition of history; on the contrary, I hold the opposite opinion, that he far exceeds him. For I dare aver, that in the order of his stupendous Judgment many most profound allegorical sentiments are contained, which are understood by only a few.

Aretin: In this he might merit praise, as imitating those great philosophers who hid under the veil of poetry the greatest mysteries of human and divine philosophy, that they might not be understood by the vulgar, because they would not cast their pearl before swine. And this I would believe to be the meaning of Michelangelo, were there not some things in that Judgment quite ridiculous.[5]

* * *

. . . We have considered Michelangelo in sacred history: Let us a little consider Raphael in profane; for when we find him most accurate and modest in this, we may conceive that he is not less so in the other.

Fabrini: I hear you.

Aretin: I do not know whether you have seen at our friend Dolce's, the picture of Roxana painted by Raphael, which has been since engraved on copper.[6]

Fabrini: I do not remember it.

Aretin: It is a wash drawing heightened with white in which is represented the coronation of Roxana, who being a most beautiful woman, was much beloved by Alexander the Great. Alexander is likewise represented in the picture standing near Roxana, and presenting the crown to her; and she sits on one side of a bed in a timid and reverential attitude, entirely naked, except that, for the sake of modesty, a slight drapery is thrown over her. It is impossible to conceive an air more gentle, or a body more delicate, with a proper fulness of flesh, and a

5 Here follow arguments of the type later used by Gilio, augmented with attacks against the painter's pretentious obscurity.

6 The engraving is by Agostino Veneziano.

stature not too long, but with an agreeable ease. There is a naked boy with wings undressing her feet; another above arranges her hair: a little farther off there is a youth entirely naked representing Hymen who points out Roxana to Alexander with his finger, as inviting him to the sacrifices of Venus or Juno; and also a man bearing a torch. In another part there is a group of children, some of which bear the shield of Alexander, showing the force and vivaciousness agreeable to their age, and another bearing his lance. There is a third, who having got on his cuirass, not being able to support its weight, has fallen down and seems crying. All these figures have the most elegant airs, and various attitudes. In this composition Raphael has preserved history, propriety, and modesty: and besides this (as a mute Poet,) he has from his own conceptions imagined Hymen and the Boys.

Fabrini: I think I have read this invention in Lucian.[7]

Aretin: Be that as it may, it is so happily expressed, that it would seem doubtful whether Raphael had taken it from the works of Lucian, or Lucian from the picture of Raphael, had not Lucian lived some ages before. But what of that? So Virgil described his Laocoön, such as he had before seen him, in the statue formed by three Rhodian artists, which now is seen in Rome, the wonder of every one. The liberty is mutual, that painters frequently receive their ideas from the poets, and poets from the painters. The same may be said of his Galatea which contends with Politian's beautiful poem,[8] and of many other of his elegant inventions. But it would make my discourse too long; and you may have seen them at several times, and can see them whenever you please in Rome; leaving apart the number of beautiful designs of his engraved by the no less skillful than diligent Marc Antonio, and those also in the possession of different persons, which are almost innumerable; a striking evidence of the fertility of his genius, in all of which are admirable inventions, with all the circumstances which I have mentioned to you. And on sacred subjects, the picture of St. Cecilia, with the organ, which is in the church of St. John of the Mountain, at Bologna, may suffice, and that of the Transfiguration of Christ upon Mount Tabor, which is in St. Peter Montorio's church in Rome; without mentioning an infinite number of pictures which may be seen throughout Italy, all beautiful, and truly divine.

Fabrini: I have, indeed, seen many works of Raphael in Rome and other places; and I assure you, I esteem them almost miraculous, and for invention, equal if not superior: but in design, how can you compare him to Michelangelo?

Aretin: I will always leave you, Fabrini, in full possession of your own

7 In *Herodotus or Aetion.*
8 *Stanze per la Giostra,* I, strophe 118. In fact, the model is a poem by Navagero.

opinion, not being able to do otherwise, since reason has not the power of conviction to all. This arises either from obstinacy, ignorance, or affection. In you, whose good sense excludes the two former causes, the third takes place, which is a pardonable defect, and, as I before said,

Spesso occhio ben san sa veder torto.[9]

—often turns ascant the nicest eye.

But as to design, which is the second part, since we must consider man naked and cloathed, I agree with you, that in the nude Michelangelo is stupendous, truly miraculous, and more than human. No master ever excelled him. But only in one species, viz. a muscular body strongly marked with violent foreshortenings and action, which show every difficulty of the art, and every part of the body; in these he has such excellence, that I dare affirm, not only no master can execute, but even that none can conceive any thing more perfect. But in every other species, he is not only inferior to himself, but even to others; because he either does not know, or will not observe those differences between ages and sexes, which are mentioned above, and in which Raphael is so admirable. To conclude, whoever sees one figure of Michelangelo's, sees all.[10] But we must observe, that Michelangelo, has chosen the most elaborate and impressive aspect of the nude and Raphael the pleasing and graceful: Whence some have compared Michelangelo to Dante, and Raphael to Petrarca.[11]

Fabrini: Do not seek to bewilder me in such comparisons, though they make for my cause; for in Dante there is substance and learning, in Petrarca only elegance of style and poetical ornaments. I remember a Cordelier who preached some years ago at Venice, quoting frequently these two poets, used to call Dante September, and Petrarca May; alluding to the seasons, one full of fruit, the other of flowers. But take together a nude by Michelangelo and another by Raphael, and having fully considered them both, decide which of the two is the more perfect.

Aretin: I answer, that Raphael excelled in every kind of nude, and Michelangelo succeeded only in one; and that the nudes of Raphael excel his in promoting pleasure. I will not say, what was observed of a fine genius, that Michelangelo has painted only boors, and Raphael gentlemen: but, as I before observed, Raphael succeeds in every part,

[9] Petrarch, *Canzoniere,* sonnet 244, l. 11.

[10] This charge of monotony, the only one which could weaken the uncontested credit of *disegno,* is equivalent to the charge of working *di maniera* (see below, p. 67 and note 16). All Michelangelo's opponents reproached him with his "manner."

[11] The double comparison had just been launched (P. Barocchi quotes a text by Carlo Lenzoni, 1557) and enjoyed enduring favor.

the delicate, terrible, and sophisticated, but always with soft and temperate action. He was naturally fond of politeness and delicacy, as he was himself remarkably polite and gentle in his manners, insomuch that he himself was not less beloved than his paintings were agreeable.

Fabrini: It is not sufficient to say this nude is as beautiful and perfect as that, but the assertion must be proved.

Aretin: Answer me first: Are the nudes of Raphael, lame, dwarfish, too fleshy? Are they dry? Have they the muscles out of their proper places, or other defects?

Fabrini: I have heard it as the general opinion, that they are well painted, but that they do not contain so great a degree of art as those of Michelangelo.

Aretin: What is that art?

Fabrini: They have not the elegant contours that the figures of the other have.

Aretin: What are these elegant contours?

Fabrini: Those which form such beautiful legs, hands, backs, breasts, and all other parts.

Aretin: Does it not then appear to you, and to the other favorers of Michelangelo, that the nudes of Raphael have these parts also beautiful?

Fabrini: I say not merely beautiful, but extremely so; but yet not in the perfection that the nudes of Michelangelo have them.

Aretin: Whence do you deduce the rule for judging of this beauty?

Fabrini: I think it should be taken (as you have already said) from life, and from the statues of the ancients.

Aretin: You confess then, that the nudes of Raphael have every beautiful and perfect part; for he seldom did any thing in which he did not imitate either the one or the other: whence we see in his figures, heads, legs, turns of the body, arms, feet, and hands, that are wonderful.

Fabrini: He did not mark the bones, muscles, and certain little nerves and minutiae, so strongly as Michelangelo has.

Aretin: He has marked those parts sufficiently strong, which required to be so marked, and Michelangelo (be it said without offence) sometimes more so than was proper. This is so clear, that there is no need to exemplify it farther. I must put you in mind that I have said, it is of greater importance to clothe the bones with plump soft flesh, than to make an *écorché;* and as a proof of this truth, I add, that the ancients have, for the most part, made their figures tender, and with few parts strongly marked.[12] Yet Raphael has not always stopped at delicacy: he has,

12 The objection to *écorchés* and overstressed muscles without regard to the movement represented is usual. It occurs in Leonardo who does not name the artist he means, and in Gauricus who directs it against Verrocchio; it reappears again in Armenini.

as I have said before, for the sake of varying his figures, made some nudes strongly marked, as he found occasion; as may be seen in his battle, in the old man carried by his son,[13] and in many others. But he was not extremely fond of this manner,[14] because he placed his principal end in pleasing, (as really being the principal part of painting) seeking rather the name of elegant than terrible: and he acquired another, being generally called graceful; for besides invention, design, variety, and the effect which all his works have on the spectator's mind, there are found in them that which Pliny says characterized the figures of Apelles, that *venustas*, that *je ne sais quoi*, which uses to charm so much in painting as well as poetry; insomuch that it fills the mind of the spectator or reader with infinite delight, without our knowing what gives us pleasure; which consideration caused Petrarca (that admirable and elegant painter of the beauties and virtues of Madonna Laura) to sing thus:

> *"E un non so che ne gli occhi, che in un punto*
> *"Po far chiara la notte, oscuro il giorno,*
> *"E'l mel' amaro, et addolcir l'ascentio."* [15]

> *A certain something in her eye is seen,*
> *Which causes night to shine like day serene,*
> *Or veil the day, when shining clear and bright*
> *At once with all the clouds and shades of night,*
> *In honey wormwoods bitter can create,*
> *And gives to bitters all the honey's sweet.*

Fabrini: This which you call *venustas*, is called by the Greeks χαϱις, which I would always translate by the word grace.

Aretin: The great Raphael knew also perfectly well how to foreshorten figures when he pleased. Besides, I again repeat to you, that in all his works he had a variety so admirable, that no one figure resembles another, either in air or motion; so that there is not the least shadow of that which is called by painters "manner" in the bad sense of the word, that is, bad practice, in which you constantly see forms and faces resembling one another.[16] And as Michelangelo in his works always sought after difficulty, so, on the contrary, Raphael sought ease; a part, as I before observed, difficult to obtain; and he obtained it in such a manner, that his works seem to be done naturally and by no means labored; which is a mark of the greatest perfection. So also among writers, the

13 The *Battle of Constantine* and the group of fleeing people in the *Incendio del Borgo*, both in the Vatican.

14 Allusion to Raphael's Michelangelesque period.

15 *Canzoniere*, sonnet 215, l. 12-14.

16 This is one definition of *maniera*; the other stresses free invention and antinatural idealism.

best in the esteem of the learned are the easiest; as Virgil and Cicero in the Roman language, and in ours Petrarca and Ariosto. As to expression of the passions, I shall add nothing to what I have said before, which I touched upon, only lest you should say that his figures failed in this part.
Fabrini: This I do not deny. But what say you of the figures of Michelangelo?
Aretin: I will not say any thing concerning them, because it is a part of which all are capable of judging; nor would I choose to offend him by what I should say.
Fabrini: Proceed then to coloring.
Aretin: It is necessary that we should first consider the man when clothed.
Fabrini: Of this you need not say any more: I know that the drapery of Raphael is more commended than that of Michelangelo; perhaps because Raphael studied more of the manner of dressing figures, and Michelangelo the nude.
Aretin: Rather, Raphael studied both one and the other, and Michelangelo the latter only: We may therefore determine, that as to design they were equal, or rather that Raphael was superior, as his talents were more various and universal; as he has better preserved the distinctions of sexes and ages; and as his pictures abound more in grace and beauty, insomuch that there never was any but received pleasure from them. . . . As to coloring . . .
Fabrini: Thus far I agree with you; pray proceed. . . .
Aretin: In coloring the graceful Raphael excelled all his predecessors in painting, whether in oil or in fresco; but still more remarkably in the latter; insomuch that I have heard many say, and I dare affirm to you, that the paintings of Raphael in fresco exceed in coloring the works of the best masters in oil. They are soft and united with the most beautiful modeling and with every perfection art can produce. Santo Zago,[17] a painter, who himself was excellent, particularly in painting in fresco; also studious in collecting antiques, of which he has a great number, extremely fond of reading, and well versed in history and poetry; used to expatiate upon Raphael's excellence in this point in all companies. I shall not speak of Michelangelo's coloring, because every one knows that he took little care in this article, and you give it up to me. But Raphael knew the art, by the means of colorings, to produce flesh, drapery, landscape, and whatever else is objective to the art of the painter. He also sometimes painted portraits from nature; amongst others Pope Julius the Second, Pope Leo the Tenth, and many other great personages, which are all esteemed divine. He was also a great architect; for

17 A Venetian fresco painter, active from 1530 and dead before 1568, whose works are mostly lost.

which reason, after the death of Bramante, he was entrusted with the building of St. Peter and the Palace by the same Pope Leo; whence we frequently see in his pictures buildings drawn perfectly just as to the architecture and perspective. His early death was a very great loss to painting: He left his name behind him illustrious throughout Europe, and lived during the few years of his life, (as I can assure you of my own knowledge, and as Vasari has justly written) not like a private man, but like a prince,[18] being liberal of his knowledge and fortune to such students in his art as needed the assistance of either. It was universally believed that the Pope intended to give him a Cardinal's Hat: For beside all his excellence as a painter, Raphael possessed every virtue, excellence of morals, and elegance of manners, that become a gentleman. These excellent qualities induced the Cardinal Bibiena to press him, contrary to his own will, to marry his niece. Raphael delayed the time of consummating the marriage, expecting that the Pope (who had intimated his intention to him) would make him a Cardinal. The same Pope had given him a little while before his death the office of Chamberlain, an appointment both of honor and profit. After all I have said, you may rest assured, that Raphael was not only equal, but superior to Michelangelo in painting. In Sculpture Michelangelo stands alone, divine, and equal to the ancients; nor in this has he need of my or any other's praises; nor can he be excelled by any except by himself.

<p style="text-align:center">* * *</p>

[18] Vasari, in the first edition of the *Vite,* 1550 (the only one that Dolce could know), p. 671. All the information that follows is drawn from Vasari.

4

Vasari

INTRODUCTION

The publication of Vasari's ample history in the middle of the 16th century (Vite de' piu eccellenti architetti, pittori et scultori italiani (Florence, 1550) 2nd ed. considerably enlarged, and with a slightly different title, Florence, 1568) was a momentous event, and the work remains not only our main source of information about Italian art, but also a great monument of art historical writing.

It was the first time that a whole book was entirely dedicated to artists' biographies; the idea was prevalent, but only less ambitious works had been attempted. At once Vasari set out to write not just a history of artists, but a history of art, something particularly difficult if one considers the traditional pattern with which he was working: biographies of famous men. His borrowing of ideas developed and elaborated for the history of literature and of science contributed to his success. He used in particular the concepts of a "Renaissance" as a return to nature and to antiquity, and of technical and artistic progress. This progress did not entail a steady improvement but a succession of changes in style and taste which allowed the delimitation of periods (see p. 74). In addition, the existence of local schools and traditions, sometimes brilliantly characterized, offers Vasari an empirical system of classification.

Thoroughly conscious of the difference between the history of art and the other domains of historiography, Vasari did not let himself be entirely enslaved by the historian's traditional tasks. He treated his subject as a general introduction to art, for the use of amateurs and even of artists; critical judgment and technical information were often interwoven in the narration of facts. This aspect of Vasari's writing is particularly interesting as it marks a transition between the age of cultured amateurs and that of doctrinaire academicians.

A recent and convenient edition in Italian is that published by the Club del libro (Milan, 1962).

The Rise of the High Renaissance

The importance of the famous preface to the third part of the Lives is double: it reveals both Vasari's critical and historical systems.

To establish the first, Vasari chose five criteria which define artistic value; then he distinguishes two levels of accomplishment: the inferior, where one works within objective, formulable, and teachable norms derived from the criteria mentioned above; the superior, where one transcends these norms by some imponderable perfection. This attempt at schematization, if not very successful, clearly showed, as Sir Anthony

Blunt has observed, that Vasari had audaciously taken grace and some related notions (naturalness, facility, delicacy) as the central values of his criticism.

The connection with the historical scheme is insured by a rather brutal thesis: the passage from the second period (the Quattrocento), to the third (inaugurated by Leonardo) corresponds to a rise from the inferior to the superior level. With this system Vasari ran into difficulties which partially distorted his characterization of some artists (e.g. Michelangelo); nonetheless, he has remarkably grasped the origin and core of the new style.

Preface to the Third Part [1]

Truly great was the advancement conferred on the arts of architecture, painting, and sculpture by those excellent masters of whom we have written hitherto, in the Second Part of these Lives, for to the achievements of the early masters they added rule, order, proportion, draughtsmanship, and manner [2]; not, indeed, in complete perfection, but with so near an approach to the truth that their light enabled the masters of the third age, of whom we are henceforward to speak, to aspire still higher and attain to that supreme perfection which we see in our highly prized and most celebrated modern works. But to the end that the nature of the improvement brought about by the aforesaid artists may be even more clearly understood, it will certainly not be out of place to explain in a few words the five improvements mentioned above, and to give a succinct account of the origin of that true excellence which, having surpassed the age of the ancients, makes the modern so glorious.

Rule, then, in architecture, was the process of taking measurements from antiquities and studying the ground-plans of ancient edifices for the construction of modern buildings. Order was the separating of one style from another, so that each body should receive its proper members, with no more interchanging between Doric, Ionic, Corinthian, and Tuscan. Proportion was the universal law applying both to architecture and to sculpture, that all bodies should be made correct and true, with the members in proper harmony; and so, also, in painting. Draughtsmanship was the imitation of the most beautiful parts of nature in all figures, whether in sculpture or in painting; and for this it is necessary

1 G. Vasari, *Lives of the Most Eminent Painters, Sculptors and Architects*, trans. G. du C. de Vere (London, 1912), IV, 79-85. Reprinted with the permission of The Medici Society Ltd.

2 *Regola, ordine, misura, disegno, maniera.* The definitions given by Vasari further down are rather confused. One can admit, for clarity's sake, that *regola* means the basic principle, *ordine* the coherence in its application (lack of disparate mixtures), *misura* mathematical harmony, *disegno* the artificial imitation of nature, and *maniera* idealization or style.

to have a hand and a brain able to reproduce with absolute accuracy and precision, on a level surface—whether by drawing on paper, or on panel, or on some other level surface—everything that the eye sees; and the same is true of relief in sculpture. Manner then attained to the greatest beauty from the practice which arose of constantly copying the most beautiful objects, and joining together these most beautiful things, hands, heads, bodies, and legs, so as to make a figure of the greatest possible beauty. This practice was carried out in every work for all figures, and for that reason it is called the beautiful manner.

These things had not been done by Giotto or by the other early artists, although they had discovered the rudiments of all these difficulties, and had touched them on the surface; as in their drawing, which was sounder and more true to nature than it had been before, and likewise in harmony of coloring and in the grouping of figures in scenes, and in many other respects of which enough has been said. Now although the masters of the second age improved our arts greatly with regard to all the qualities mentioned above, yet these were not made by them so perfect as to succeed in attaining to complete perfection, for there was wanting in their rule a certain freedom which, without being of the rule, might be directed by the rule and might be able to exist without causing confusion or spoiling the order; which order had need of an invention abundant in every respect, and of a certain beauty maintained in every least detail, so as to reveal all that order with more adornment. In proportion there was wanting a certain correctness of judgment, by means of which their figures, without having been measured, might have, in due relation to their dimensions, a grace exceeding measurement. In their drawing there was not the perfection of finish, because, although they made an arm round and a leg straight, the muscles in these were not nuanced with that sweet and facile grace which hovers midway between the seen and the unseen, as is the case with the flesh of living figures; nay, they were crude and excoriated, which made them displeasing to the eye and gave hardness to the manner. This last was wanting in the delicacy that comes from making all figures light and graceful, particularly those of women and children, with the limbs true to nature, as in the case of men, but veiled with a plumpness and fleshiness that should not be awkward, as they are in nature, but refined by draughtsmanship and judgment.[3] They also lacked our abundance of beautiful costumes, our great number and variety of bizarre fancies, loveliness of coloring, wide range of buildings, and distance and variety

[3] This page is written with some affectation—thus almost each passage on one criterion ends with an allusion to the next one. The general idea is that the supreme degree of perfection consists in a motivated deviation from the norm, or a voluntary ambiguity: the artist's freedom, above criteria, will add grace to the rule.

in landscapes. And although many of them, such as Andrea Verrocchio and Antonio del Pollaiuolo, and many others more modern, began to seek to make their figures with more study, so as to reveal in them better draughtsmanship, with a degree of imitation more correct and truer to nature, nevertheless the whole was not yet there, even though they had one very certain assurance, that they were advancing towards the good, namely, that their figures were approved according to the standard of the works of the ancients, as was seen when Andrea Verrocchio restored in marble the legs and arms of the Marsyas in the house of the Medici in Florence. But they lacked a certain finish and last perfection in the feet, hands, hair, and beards, although the limbs as a whole are in accordance with the antique and have a certain correct harmony in the proportions. Now if they had had that minuteness of finish which is the perfection and bloom of art, they would also have had a resolute boldness in their works; and from this there would have followed delicacy, elegance, and supreme grace, which are the qualities produced by the perfection of art in beautiful figures, whether in relief or in painting; but these qualities they did not have, in spite of their laborious application. That finish, and that certain something that they lacked, they could not achieve so readily, seeing that study, when it is used in that way to obtain finish, gives dryness to the manner.

After them, indeed, their successors were enabled to attain to it through seeing excavated out of the earth certain antiquities cited by Pliny as amongst the most famous, such as the Laocoön, the Hercules, the Great Torso of the Belvedere, and likewise the Venus, the Cleopatra, the Apollo, and an endless number of others, which, both with their sweetness and their severity, with their fleshy roundness copied from the greatest beauties of nature, and with certain attitudes which involve no distortion of the whole figure but only a movement of certain parts, and are revealed with a most perfect grace, brought about the disappearance of a certain dryness, hardness, and sharpness of manner, which had been left to our art by the excessive study of Piero della Francesca, Lazzaro Vasari, Alesso Baldovinetti, Andrea dal Castagno, Pesello, Ercole Ferrarese, Giovanni Bellini, Cosimo Rosselli, the Abbot of S. Clemente,[4] Domenico del Ghirlandaio, Sandro Botticelli, Andrea Mantegna, Filippo, and Luca Signorelli. These masters sought with great efforts to do the impossible in art by means of labor, particularly in foreshortenings and in things unpleasant to the eye, which were as painful to see as they were difficult for them to execute. And although their works were for the most part well drawn and free from errors, yet there was wanting

4 Bartolomeo della Gatta.

a certain resolute spirit which was never seen in them, and that sweet harmony of coloring which the Bolognese Francia and Pietro Perugino first began to show in their works; at the sight of which people ran like madmen to this new and more lifelike beauty, for it seemed to them quite certain that nothing better could ever be done. But their error was afterwards clearly proved by the works of Leonardo da Vinci, who, giving a beginning to that third manner which we propose to call the modern—besides the force and boldness of his drawing, and the extreme subtlety wherewith he counterfeited all the minutenesses of nature exactly as they are—with good rule, better order, right proportion, perfect drawing, and divine grace, abounding in resources and having a most profound knowledge of art, may be truly said to have endowed his figures with motion and breath.

There followed after him, although at some distance, Giorgione da Castelfranco, who obtained soft modeling in his pictures, and gave striking relief to his works by means of a certain darkness of shadow, very well conceived; and not inferior to him in giving force, relief, sweetness and grace of color to his pictures, was Fra Bartolommeo di San Marco. But more than all did the most gracious Raffaello da Urbino, who, studying the labors of the old masters and those of the modern, took the best from them, and, having gathered it together, enriched the art of painting with that complete perfection which was shown in ancient times by the figures of Apelles and Zeuxis; nay, even more, if we may make bold to say it, as might be proved if we could compare their works with his. Wherefore nature was left vanquished by his colors; and his invention was facile and peculiar to himself, as may be perceived by all who see his painted stories, which are like written narrations, for in them he showed us places and buildings faithfully, and the features and costumes both of our own people and of strangers, with full command; not to mention his gift of imparting grace to the heads of young men, old men, and women, reserving modesty for the modest, wantonness for the wanton, and for children now charm in their eyes,[5] now playfulness in their attitudes; and the folds of his draperies, also, are neither too simple nor too intricate, but of such a kind that they appear real.

In the same manner, but sweeter in coloring and not so bold, there followed Andrea del Sarto, who may be called a rare painter, for his works are free from errors. Nor is it possible to describe the charming vivacity seen in the works of Antonio da Correggio, who brushed hair, not in the precise manner used by the masters before him, which was constrained, sharp, and dry, but soft and feathery, so that you could

[5] The Italian edition has *vizi*, which we correct to *vezzi*.

feel the hairs, such was his facility in making them; and they seemed like gold and more beautiful than real hair, which is surpassed by that which he painted.

The same did Francesco Mazzuoli of Parma, who excelled him in many respects in grace, adornment, and beauty of manner, as may be seen in many of his pictures, in which the faces are smiling; their eyes appear to see with great vivaciousness and one can feel their pulse beat, according as it best pleased his brush. But whosoever shall consider the mural paintings of Polidoro and Maturino, will see figures in attitudes that seem beyond the bounds of possibility, and he will wonder with amazement how it can be possible, not to describe with the tongue, which is easy, but to express with the brush the tremendous conceptions which they put into execution with such mastery and dexterity, in representing the deeds of the Romans exactly as they were.

And how many there are who, having given life to their figures with their colors, are now dead, such as Il Rosso, Fra Sebastiano, Giulio Romano, and Perino del Vaga! For of the living, who are known to all through their own efforts, there is no need to speak here. But the most important thing for art is that they have now brought it to such perfection, and made it so easy for him who possesses draughtsmanship, invention, and coloring, that, whereas those early masters took six years to paint one panel, our modern masters can paint six in one year, as I can testify with the greatest confidence both from seeing and from doing; and our pictures are clearly much more highly finished and perfect than those executed in former times by masters of account.

But he who bears the palm from both the living and the dead, transcending and eclipsing all others, is the divine Michelangelo Buonarroti, who holds the sovereignty not merely of one of these arts, but of all three together. This master surpasses and excels not only all those moderns who have almost vanquished nature, but even those most famous ancients who without a doubt did so gloriously surpass her; and he alone triumphs over moderns, ancients, and nature, who could scarcely conceive anything so strange and so difficult that he would not be able, by the force of his most divine intellect and by means of his industry, draughtsmanship, art, judgment, and grace, to excel it by a great measure; and that not only in painting and in the use of color, under which title are comprised all forms, and all bodies upright or not upright, palpable or impalpable, visible or invisible, but also in the highest perfection of bodies in the round, with the point of his chisel. And from a plant so beautiful and so fruitful, through his labors, there have already spread branches so many and so noble, that, besides having filled the world in such unwonted profusion with the most luscious fruits, they have also given the final form to these three most noble arts.

And so great and so marvelous is his perfection, that it may be safely and surely said that his statues are in all their parts much more beautiful than the ancient; for if we compare the heads, hands, arms, and feet shaped by the one with those of the others, we see in his a greater depth and solidity, a grace more completely graceful, and a much more absolute perfection, accomplished with a manner so facile in the overcoming of difficulties, that it is not possible ever to see anything better. And the same may be believed of his pictures, which, if we chanced to have some by the most famous Greeks and Romans, so that we might compare them face to face, would prove to be as much higher in value and more noble as his sculptures are clearly superior to all those of the ancients.

But if we admire so greatly those most famous masters [6] who, spurred by such extraordinary rewards and by such good-fortune, gave life to their works, how much more should we not celebrate and exalt to the heavens those rare intellects who, not only without reward, but in miserable poverty, bring forth fruits so precious? We must believe and declare, then, that if, in this our age, there were a due meed of remuneration, there would be without a doubt works greater and much better than were ever wrought by the ancients. But the fact that they have to grapple more with famine than with fame, keeps our hapless intellects submerged, and, to the shame and disgrace of those who could raise them up but give no thought to it, prevents them from becoming known.

And let this be enough to have said on this subject; for it is now time to return to the Lives, and to treat in detail of all those who have executed famous works in this third manner, the creator of which was Leonardo da Vinci, with whom we will now begin.

Pontormo's Madness

Vasari was always embarrassed when dealing with neurotic artists. He disapproved of their neglect of art and of patrons, but he could excuse them as colleagues and victims of the difficulties of art.

Pontormo's mental illness is known to us through the impressive Diary *of his last years. Vasari knew the artist well, and was the friend of his pupil Bronzino; the biographer does not allow himself the picturesque details that the lives of Piero di Cosimo or Parmigianino are literally stuffed with, but considers the matter from a professional point of view. In the pages preceding the extract, a long critical digression on young Pontormo's purely artistic "madness," his mania of imitating Dürer, sets the tone: "Did not Pontormo know, then, that these Germans and Flemings came to these parts to learn the Italian manner, which he with such effort sought to abandon as if it were bad?"*

6 The Ancients.

From the *Life of Pontormo* [1]

The occasion having thus presented itself to Pontormo, thanks to this money, to set his hand to the fitting up of his house, he made a beginning with his building, but did nothing of much importance. Indeed, although some persons declare that he had it in mind to spend largely, according to his position, and to make a commodious dwelling and one that might have some design, it is nevertheless evident that what he did, whether this came from his not having the means to spend or from some other reason, has rather the appearance of a building erected by an eccentric and solitary creature than of a well-ordered habitation, for the reason that to the room where he used to sleep and at times to work, he had to climb by a wooden ladder, which, after he had gone in, he would draw up with a pulley, to the end that no one might go up to him without his wish or knowledge. But that which most displeased other men in him was that he would not work save when and for whom he pleased, and after his own fancy; wherefore on many occasions, being sought out by noblemen who desired to have some of his work, and once in particular by the Magnificent Ottaviano de' Medici, he would not serve them; and then he would set himself to do anything in the world for some low and common fellow, at a miserable price. Thus the mason Rossino, a person of no small ingenuity considering his profession, by playing the simpleton, received from him in payment for having paved certain rooms with bricks, and for having done other mason's work, a most beautiful picture of Our Lady, in executing which Jacopo toiled and labored as much as the mason did in his building. And so well did the exquisite Rossino contrive to manage his business, that, in addition to the above-named picture, he got from the hands of Jacopo a most beautiful portrait of Cardinal Giulio de' Medici, copied from one by the hand of Raffaello, and, into the bargain, a very beautiful little picture of a Christ Crucified, which, although the above-mentioned Magnificent Ottaviano bought it from the mason Rossino as a work by the hand of Jacopo, nevertheless is known for certain to be by the hand of Bronzino, who executed it all by himself while he was working with Jacopo at the Certosa,[2] although it afterwards remained, I know not why, in the possession of Pontormo. All these three pictures, won by the industry of the mason from the hands of Jacopo, are now in the house of M. Alessandro de' Medici, the son of the above-named Ottaviano.

Now, although this procedure of Jacopo's and his living solitary

[1] Vasari, *Lives, op. cit.*, VII, 174-75, and 178-82.
[2] The Certosa di Galluzzo, where Pontormo worked during the plague of 1522-1524, and again later.

and after his own fashion were not much commended, that does not mean that if anyone wished to excuse him he would not be able, considering that we should be thankful for those works that he did and for those that he did not choose to do we should not blame or censure him. No artist is obliged to work save when and for whom he pleases; and, if he suffered thereby, the loss was his. As for solitude, I have always heard say that it is the greatest friend of study; and, even if it were not so, I do not believe that much blame is due to him who lives in his own fashion without offence to God or to his neighbor, dwelling and employing his time as best suits his nature.

Now his Excellency,[3] following in the footsteps of his ancestors, has always thought to embellish and adorn his city; and he had the idea and decided to cause to be painted all the choir of the magnificent Temple of San Lorenzo, formerly built by the great Cosimo de' Medici, the elder. Whereupon he gave the charge of this to Jacopo da Pontormo, either of his own accord, or, as was said, at the instance of Messer Pier Francesco Ricci, his majordomo; and Jacopo was very glad of that favor, for the reason that, although the greatness of the work, he being well advanced in years, gave him food for thought and perhaps dismayed him, on the other hand he reflected how, in a work of such magnitude, he had a fair field to show his ability and worth. Some say that Jacopo, finding that the work had been allotted to him notwithstanding that Francesco Salviati, a painter of great fame, was in Florence and had brought to a happy conclusion the painting of that hall in the Palace which was once the audience-chamber of the Signoria, came to say that he would show the world how to draw and paint, and how to work in fresco, and, besides this, that the other painters were but ordinary hacks, with other words equally insolent and overbearing. But I myself always knew Jacopo as a modest person, who spoke of everyone honorably and in a manner proper to an orderly and virtuous artist, such as he was, and I believe that these words were imputed to him falsely, and that he never let slip from his mouth any such boastings, which are for the most part the marks of vain men who presume too much upon their merits, in which manner of men there is no place for virtue or good breeding. And, although I might have kept silent about these matters, I have not chosen to do so, because to proceed as I have done appears to me the office of a faithful and veracious historian; it is enough that, although these rumors went around, and particularly among our artists, nevertheless I have a firm belief that they were the words of malicious persons, Jacopo having always been in the experience of everyone modest and well-behaved in his every action.

[3] The Grand Duke Cosimo.

Having then closed up that chapel with walls, screens of planks, and curtains, and having given himself over to complete solitude, he kept it for a period of eleven years so well sealed up, that excepting himself not a living soul entered it, neither friend nor any other. It is true, indeed, that certain lads who were drawing in the sacristy of Michelangelo, as young men will do, climbed by its spiral staircase on to the roof of the church, and, removing some tiles and the plank of one of the gilded rosettes that are there, saw everything. This having come to his attention, Jacopo took it very ill, but took no further notice beyond closing up everything with greater care; although some say that he persecuted those young men sorely, and sought to make them regret it.

Imagining, then, that in this work he would surpass all other painters, and perchance, so it was said, even Michelangelo, he painted in the upper part, in a number of scenes, the Creation of Adam and Eve, the Eating of the Forbidden Fruit, their Expulsion from Paradise, the Tilling of the Earth, the Sacrifice of Abel, the Death of Cain, the Blessing of the Seed of Noah, and the same Noah designing the plan and the measurements of the Ark. Next, on one of the lower walls, each of which is fifteen braccia in each direction, he painted the inundation of the Deluge, in which is a mass of dead and drowned bodies, and Noah speaking with God. On the other wall is painted the Universal Resurrection of the Dead, which has to take place on the last and final day; with such extraordinary confusion, that the real resurrection will perhaps not be more confused, or, so to say, livelier than Pontormo painted it. Opposite to the altar and between the windows—that is, on the central wall—there is on either side a row of nude figures, who, clinging to each other's bodies with hands and legs, form a ladder wherewith to ascend to Paradise, rising from the earth; there are many dead in company with them, and at the end, on either side, are two dead bodies clothed with the exception of the legs and also the arms, with which they are holding two lighted torches. At the top, in the center of the wall, above the windows, he painted in the middle Christ on high in His Majesty, who, surrounded by many Angels, all nude, is raising those dead in order to judge them.[4]

But I have never been able to understand the significance of this scene, although I know that Jacopo had wit enough for himself, and also associated with learned and lettered persons; I mean, what he could have intended to signify in that part where there is Christ on high, raising the dead, and below His feet is God the Father, who is creating Adam and Eve. Besides this, in one of the corners, where are the four Evangelists, nude, with books in their hands, it does not seem to me that in a single place did he give a thought to any order of composition, or meas-

4 The fresco was whitewashed in 1742. Cf. Ch. de Tolnay's reconstruction in *Critica d'Arte* (1950-1951), IX, 38-52.

urement, or time, or variety in the heads, or diversity in the flesh-colors, or, in a word, to any rule, proportion, or law of perspective; for the whole work is full of nude figures with an order, design, invention, composition, coloring, and painting contrived after his own fashion, and with such uneasiness and so little satisfaction for him who beholds the work, that I am determined, since I myself do not understand it, although I am a painter, to leave all who may see it to form their own judgment, for the reason that I believe that I would drive myself mad with it and would lose myself, even as it appears to me that Jacopo in the period of eleven years that he spent upon it sought to lose himself and all who might see the painting, among all those extraordinary figures. And although there may be seen in this work some bit of a torso with the back turned or facing to the front and some attachments of flanks, executed with marvelous care and great labor by Jacopo, who made finished models of clay in the round for almost all the figures, nevertheless the work as a whole is foreign to his manner, and, as it appears to almost every man, without proportion, the torsi for the most part being large and the legs and arms small, to say nothing of the heads, in which there is not a trace to be seen of that singular excellence and grace that he used to give to them, so greatly to the satisfaction of those who examine his other pictures. Wherefore it appears that in this work he paid no attention to anything save certain parts, and of the other more important parts he took no account whatever. In a word, whereas he had thought in this work to surpass all existing paintings, he failed by a great measure to equal his own works that he had executed in the past; whence it is evident that he who seeks to strive beyond his strength and, as it were, to force nature, ruins the good qualities with which he may have been liberally endowed by her. But what can we or ought we to do save have compassion upon him, seeing that the men of our arts are as much liable to error as others? And the good Homer, so it is said, even he sometimes nods; nor shall it ever be said that there is a single work of Jacopo's, however he may have striven to force his nature, in which there is not something good and worthy of praise.

He died shortly before finishing the work, and some therefore declare that he died of grief, remaining, at last, very much dissatisfied with himself; but the truth is that, being old and much exhausted by making portraits and models in clay and laboring so much in fresco, he sank into a dropsy, which finally killed him at the age of sixty-five. After his death there were found in his house many designs, cartoons, and models in clay, all very beautiful, and a picture of Our Lady executed by him excellently well and in a lovely manner, to all appearance many years before, which was sold by his heirs to Piero Salviati. Jacopo was buried in the first cloister of the Church of the Servite Friars, beneath the scene of the

Visitation that he had formerly painted there; and he was followed to the grave by an honorable company of the painters, sculptors, and architects.

Jacopo was a frugal and sober man, and in his dress and manner of life he was rather miserly than moderate; and he lived almost always by himself, without desiring that anyone should serve him or cook for him. In his last years, indeed, he kept in his house, as it were to bring him up, Battista Naldini, a good natured young man, who took such care of Jacopo's life as Jacopo would allow him to take; and under his master's discipline he made no little proficiency in design, and became such, indeed, that a very happy result is looked for from him. Among Pontormo's friends, particularly in this last period of his life, were Pier Francesco Vernacci and Don Vincenzio Borghini, with whom he took his recreation, sometimes eating with them, but rarely. But above all others, and always supremely beloved by him, was Bronzino, who loved him as dearly, being grateful and thankful for the benefits that he had received from him.

Pontormo had very beautiful manners, and he was so afraid of death, that he would not even hear it spoken of, and avoided having to meet dead bodies. He never went to festivals or to any other places where people gathered together, so as not to be caught in the press; and he was solitary beyond all belief. At times, going out to work, he set himself to think so profoundly on what he was to do, that he went away without having done any other thing all day but stand thinking. And that this happened to him times without number in the work of S. Lorenzo may readily be believed, for the reason that when he was determined, like an able and well-practiced artist, he had no difficulty in doing what he desired and had resolved to put into execution.

Raphael's Development

The digression on Raphael's manners is intended, as Vasari himself tells us, for specialists; it is too difficult an exercise in criticism for those who look to art for entertainment only.

Some chronological confusion is amply compensated for by the excellent characterization not only of Raphael's stages of development, but of his whole artistic personality as both receptive and controlled ("a man of supreme judgment"). With the greatest objectivity he could muster, Vasari distributed respectful reproofs equitably: to Michelangelo for his singlemindedness, to Raphael for having tried to "overdo." And since the moral conclusion is rarely missing in Vasari, the finale is that each artist must follow his particular genius.

From the *Life of Raphael* [1]

Now, having described the works of this most excellent artist, before I come to relate other particulars of his life and death, I do not wish to grudge the labor of saying something, for the benefit of the men of our arts, about the various manners of Raffaello. He, then, after having imitated in his boyhood the manner of his master, Pietro Perugino, which he made much better in draughtsmanship, coloring, and invention, believed that he had done enough; but he recognized, when he had reached a riper age, that he was still too far from the truth. For, after seeing the works of Leonardo da Vinci, who had no peer in the expressions of heads both of men and of women, and surpassed all other painters in giving grace and movement to his figures, he was left marveling and amazed; and in a word, the manner of Leonardo pleasing him more than any other that he had ever seen, he set himself to study it, and abandoning little by little, although with great difficulty, the manner of Pietro, he sought to the best of his power and knowledge to imitate that of Leonardo. But for all his diligence and study, in certain difficulties he was never able to surpass Leonardo; and although it appears to many that he did surpass him in sweetness and in a kind of natural facility, nevertheless he was by no means superior to him in that sublime groundwork of conceptions and that grandeur of art in which few have been the peers of Leonardo. Yet Raffaello came very near to him, more than any other painter, and above all in grace of coloring. But to return to Raffaello himself; in time he found himself very much hindered and impeded by the manner that he had adopted from Pietro when he was quite young, which he acquired with ease, since it was overprecise, dry, and feeble in draughtsmanship. His being unable to forget it was the reason that he had great difficulty in learning the beauties of the nude and the methods of difficult foreshortenings from the cartoon that Michelangelo Buonarroti made for the Council Hall in Florence; and another might have lost heart, believing that he had been previously wasting his time, and would never have achieved, however lofty his genius, what Raffaello accomplished. But he, having purged himself of Pietro's manner, and having thoroughly freed himself of it, in order to learn the manner of Michelangelo, so full of difficulties in every part, was changed, as it were, from a master once again into a disciple; and he forced himself with incredible study, when already a man, to do in a few months what might have called for the tender age at which all things are best acquired, and for a space of many years. For in truth he who does not learn in good time

[1] Vasari, *Lives, op. cit.,* IV, 241-46.

right principles and the manner that he wishes to follow, and does not proceed little by little to solve the difficulties of the arts by means of experience, seeking to understand every part, and to put it into practice, can scarcely ever become perfect; and even if he does, that can only be after a longer space of time and much greater labor.

When Raffaello resolved to set himself to change and improve his manner, he had never given his attention to nudes with that zealous study which is necessary, and had only drawn them from life in the manner that he had seen practiced by his master Pietro, imparting to them the grace that he had from nature. He then devoted himself to studying the nude and to comparing the muscles of anatomical subjects and of flayed human bodies with those of the living, which, being covered with skin, are not clearly defined, as they are when the skin has been removed; and going on to observe in what way they acquire the softness of flesh in the proper places, and how certain graceful flexures are produced by twisting the body from one view to another, and also the effect of inflating, lowering, or raising either a limb or the whole person, and likewise the concatenation of the bones, nerves, and veins, he became excellent in all the points that are looked for in a painter of eminence. Knowing, however, that in this respect he could never attain to the perfection of Michelangelo, he reflected, like a man of supreme judgment, that painting does not consist only in representing the nude human form, but has a wider field; that one can enumerate among the perfect painters those who express historical inventions well and with facility, and who show fine judgment in their fancies; and that he who, in the composition of scenes, can make them neither confused with too much detail nor poor with too little, but distributed with beautiful invention and order, may also be called an able and judicious artist.[2] To this, as Raffaello was well aware, may be added the enriching those scenes with a bizarre variety of perspectives, buildings, and landscapes, the method of clothing figures gracefully, the making them fade away sometimes in the shadows, and sometimes come forward into the light, the imparting of life and beauty to the heads of women, children, young men and old, and the giving them movement and boldness, according to necessity. He considered, also, how important is the furious flight of horses in battles, fierceness in soldiers, the knowledge how to depict all the sorts of animals, and above all the power to give such resemblance to portraits that they seem to be alive, and that it is known whom they represent; with an endless number of other things, such as the adornment of draperies, footwear, helmets, armor, women's head-dresses, hair, beards, vases, trees, grottoes, rocks,

2 This indirect criticism of Michelangelo as a painter of historical subjects is taken over from Dolce (see pp. 61-69); the whole passage on Raphael's manners is added in the 1568 edition.

fires, skies turbid or serene, clouds, rain, lightning, clear weather, night, the light of the moon, the splendor of the sun, and innumerable other things, which are called for every moment by the requirements of the art of painting. Pondering over these things, I say, Raffaello resolved, since he could not approach Michelangelo in that branch of art to which he had set his hand, to seek to equal, and perchance to surpass him, in these others; and he devoted himself, therefore, not to imitating the manner of that master, but to the attainment of a catholic excellence in the other fields of art that have been described. And if the same had been done by many artists of our own age, who, having determined to pursue the study of Michelangelo's works alone, have failed to imitate him and have not been able to reach his extraordinary perfection, they would not have labored in vain nor acquired a manner so hard, so full of difficulty, wanting in beauty and coloring, and poor in invention, but would have been able, by aiming at catholicity and at imitation in the other fields of art, to render service both to themselves and to the world.

Raffaello, then, having made this resolution, and having recognized that Fra Bartolommeo di San Marco had a passing good method of painting, well-grounded draughtsmanship, and a pleasing manner of coloring, although at times, in order to obtain stronger relief, he made too much use of darks, took from him what appeared to him to suit his need and his vision—namely, a middle course, both in drawing and in coloring; and mingling with that method certain others selected from the best work of other masters, out of many manners he made one, which was looked upon ever afterwards as his own, and which was and always will be vastly esteemed by all artists. This was then seen perfected in the Sibyls and Prophets of the work that he executed, as has been related, in S. Maria della Pace; in the carrying out of which work he was greatly assisted by having seen the paintings of Michelangelo in the Chapel of the Pope. And if Raffaello had remained content with this same manner, and had not sought to give it more grandeur and variety in order to prove that he had as good a knowledge of the nude as Michelangelo, he would not have lost a part of the good name that he had acquired; but the nudes that he made in that apartment of the Borgia Tower where there is the Burning of the Borgo, although they are fine, are not in every way excellent. In like manner, those that were painted by him on the ceiling of the Palace of Agostino Chigi in the Trastevere did not give complete satisfaction, for they are wanting in that grace and sweetness which were peculiar to Raffaello; the reason of which, in great part, was the circumstance that he had them colored by others after his design. However, repenting of this error, like a man of judgment, he resolved afterwards to execute by himself, without assistance from others, the panel picture of the Transfiguration of Christ that is in S. Pietro a Montorio, wherein

are all those qualities which, as has already been described, are looked
for and required in a good picture. And if he had not employed in this
work, as it were from caprice, printer's smokeblack, the nature of which,
as has been remarked many times, is to become ever darker with time, to
the injury of the other colors with which it is mixed, I believe that the
picture would still be as fresh as when he painted it; whereas it now ap-
pears to be rather a mass of shadows than aught else.

I have thought fit, almost at the close of this Life, to make this dis-
course, in order to show with what labor, study, and diligence this
honored artist always pursued his art; and even more for the sake of other
painters, to the end that they may learn how to avoid those hindrances
from which the wisdom and genius of Raffaello were able to deliver him.
I must add this as well, that every man should be satisfied and contented
with doing that work to which he feels himself drawn by a natural in-
clination, and should not seek, out of emulation, to put his hand to that
for which nature has not adapted him; for otherwise he will labor in vain,
and often to his own shame and loss. Moreover, where doing is enough,
no man should aim at overdoing merely in order to surpass those who,
by some great gift of nature, or by some special grace bestowed on them
by God, have performed or are performing miracles in art; for the reason
that he who is not suited to one particular work, can never reach, let him
labor as he may, the goal to which another, with the assistance af nature,
has attained with ease. Of this, among the old artists, we may see an
example in Paolo Uccello, who, striving against the limitations of his
powers, in order to advance, did nothing but go backwards. The same
has been done in our own day, no long time since, by Jacopo da Pon-
tormo, and it has been proved by the experience of many others, as we
have shown before and will point out yet again. And this, perchance,
happens, to the end that every man may rest content with his lot, because
it is Heaven that distributes gifts.

Views on Contemporary Art

Vasari's critical judgment of the art of the past was obviously clas-
sical: he appreciated reason, verisimilitude, regularity, harmonious beauty
and grace; he seemed rather firmly on the side of Tuscan modeling as
against Venetian taste.

Upon judging contemporary art, Vasari revealed his mannerist
sensibility. The page on Michelangelo's architecture at San Lorenzo
(p. 89) may be the most definite praise of pure caprice, of the arbitrary
as opposed to classical rules, written till that time. Michelangelo the
painter, although deserving superlative praise, left something to be de-
sired in the eyes of an accomplished mannerist: he rejected minor elab-

orate effects, the bizarre inventions and the precious refinements which charmed the Florentine court (p. 90).

Faced with Tintoretto's art, Vasari had mixed feelings. He favored, in principle, a quickness of execution (p. 91) as well as what he called "extravagance"; he could but admire these qualities in the Venetian. What he reprehended, when calling Tintoretto a manual laborer without learning, was his lack of "idealism" in the mannerist sense of the word: Tintoretto was not concerned with the concetto, and if he deviated from the model, it was solely in search of pictorial effects.

Wilfulness in Architecture [1]

Michelangelo departed for Rome in haste, harassed once again by Francesco Maria, Duke of Urbino, the nephew of Pope Julius, who complained of him, saying that he had received sixteen thousand crowns for the above-named tomb, yet was living a life of pleasure in Florence; and he threatened in his anger that, if Michelangelo did not give his attention to the work, he would make him rue it. Having arrived in Rome, Pope Clement, who wished to make use of him, advised him to draw up his accounts with the agents of the Duke, believing that after all that he had done he must be their creditor rather than their debtor; and so the matter rested. After discussing many things together, they resolved to finish completely the library and new sacristy of S. Lorenzo in Florence. Michelangelo therefore departed from Rome, and raised the cupola that is now to be seen,[2] causing it to be wrought on a novel design; and he had a ball with seventy-two faces made by the goldsmith Piloto, which is very beautiful. It happened, while Michelangelo was raising the cupola, that he was asked by some friends, "Should you not make your lantern very different from that of Filippo Brunelleschi?" And he answered them, "Different it can be made with ease, but better, no." He made four tombs in that sacristy, to adorn the walls and to contain the bodies of the fathers of the two Popes, the elder Lorenzo and his brother Giuliano, and those of Giuliano, the brother of Leo, and of Duke Lorenzo, his nephew.[3] And since he wished to execute the work in imitation of the old sacristy that Filippo Brunelleschi had built, but with another manner of ornamentation, he made in it an ornamentation conceived in a more unusual and more original manner than any other master at any time, whether ancient or modern, had been able to achieve, for in the novelty of the beautiful cornices, capitals, bases, doors, tabernacles, and tombs, he departed not a little from the work regulated by measure, order, and rule,

[1] From the Life of Michelangelo, *Lives, op. cit.,* IX, 33-34.
[2] The cupola of the New Sacristy above the Medici tombs.
[3] This is, of course, only the first project.

which other men did according to a common use and after Vitruvius and the antiquities, to which he would not conform. That licence has done much to give courage to those who have seen his methods to set themselves to imitate him, and new fantasies have since been seen which have more of the grotesque than of reason or rule in their ornamentation. Wherefore the artists owe him an infinite and everlasting obligation, he having broken the bonds and chains by reason of which they had always followed a beaten path in the execution of their works. And even more did he demonstrate and seek to make known such a method afterwards in the library of S. Lorenzo, at the same place; in the beautiful distribution of the windows, in the pattern of the ceiling, and in the marvelous entrance of the vestibule. Nor was there ever seen a more natural strength, both in the whole and in the parts, as in the consoles, tabernacles, and cornices, nor any staircase more commodious; in which last he made such bizarre breaks in the outlines of the steps, and departed so much from the common use of others, that everyone was amazed.

The Limits of Michelangelo's Art [1]

But I will not go into the particulars of the invention and composition of this scene,[2] because so many copies of it, both large and small, have been printed, that it does not seem necessary to lose time in describing it. It is enough for us to perceive that the intention of this extraordinary man has been to refuse to paint anything but the human body in its best proportioned and most perfect forms and in the greatest variety of attitudes, and not this only, but likewise the play of the passions and joys, being satisfied to be accomplished in that field in which he was superior to all his fellow artists, and to lay open the way of the grand manner in the painting of nudes, and his great knowledge in the difficulties of design; and, finally, he opened out the way to facility in this art in its principal province, which is the human body, and, attending to this single object, he left aside the charms of coloring and the caprices and new fantasies of certain minute and delicate refinements which many other painters, perhaps not without some show of reason, have not entirely neglected. For some, not so well grounded in design, have sought with variety of tints and shades of coloring, with various new and bizarre inventions, and, in short, with the other method, to win themselves a place among the first masters; but Michelangelo, standing always firmly rooted in his profound knowledge of art, has shown to those who know enough how they should attain to perfection.

1 From the Life of Michelangelo, *Lives, op. cit.,* IX, 56-57.
2 The *Last Judgment* in the Sistine Chapel.

On Tintoretto [1]

In the same city of Venice and about the same time there lived, as he still does, a painter called Jacopo Tintoretto, who has delighted in all the arts, and particularly in playing various musical instruments, besides being agreeable in his every action, but in the matter of painting swift, resolute, fantastic, and extravagant, and the most terrific brain that the art of painting has ever produced, as may be seen from all his works and from his imaginary narrative compositions, executed by him in a fashion of his own and contrary to the use of other painters. Indeed, he has surpassed even the limits of extravagance with the new and fanciful inventions and the strange vagaries of his intellect, working at haphazard and without design, as if to prove that art is but a jest. This master at times has left as finished works sketches still so rough that the brush-strokes may be seen, done more by chance and vehemence than with judgment and design. He has painted almost every kind of picture in fresco and in oils, with portraits from life, and at every price [2] to the point that with these methods he has executed, as he still does, the greater part of the pictures painted in Venice. And since in his youth he proved himself by many beautiful works a man of great judgment, if only he had recognized how great an advantage he had from nature, and had improved it by reasonable study, as has been done by those who have followed the beautiful manners of his predecessors, and had not dashed his work off by mere skill of hand, he would have been one of the greatest painters that Venice has ever had. Not that this prevents him from being a bold and able painter, and delicate, fanciful, and alert in spirit.

[1] From the Life of Battista Franco, *Lives*, VIII, 101-102.
[2] That is, good or poor pictures according to what he was paid.

5

Art Theory
in the Second Half
of the Century

INTRODUCTION

General discussion on art modeled on that in Castiglione's Courtier *had taught the public to approach art with specific criteria. Considering this point as settled, the second half of the century showed a return to the concrete; art theory was now to deal with actual problems of artistic conception and execution. Hence it resumed, on a higher level, the task of medieval books of advice, which is to teach what one should do in actual cases to obtain specific results. But there is no question, of course, of a mere return to the craftsman's mentality; the background is no longer corporative but academic.*

Everyone accepted the ancient and medieval tradition which distinguishes two successive steps of a different nature in artistic creation: conception and execution. This clear distinction brought about a philosophy of art which found its classic formulation in one of Michelangelo's sonnets commented upon by Varchi: Non ha l'ottimo artista alcun concetto . . . *(see p. 97).*

If advice for execution had once seemed sufficient, the intellectual dignity of art now also demanded rules for conception or invention, and, above all, for the coordination of the two stages. From this came the importance given to the concepts of decorum, verisimilitude, and historical or poetic truth, concepts which were at one and the same time norms for invention and principles ruling the adaptation of each work to its actual destination.

Invention was standardized by means of numerous iconographical handbooks. Three very important mythological works with allegorical commentaries appeared around the middle of the century, Gregorio Gyraldi's (1548), Natale Conti's (1551), and Vincenzo Cartari's. The last, called Le imagini degli dei *was by far the most important and popular, as it was conceived for the practical use of artists and was the first to be illustrated. Finally, an even richer collection, C. Ripa's* Iconologia, *superseded Cartari in the artists' favor. A more subtle stimulation of invention was the crystallization of many distinct genres all well schematized as to subject matter and style.*

The precepts of art as science lost their strict application and were adapted to the specific purpose of each work. In the case of perspective, for instance, the problem was no longer how to suggest depth, but how to choose the viewing point according to the location of the painting and its decorum (see Bassi, pp. 105-111); the canon of proportions of the human body was no longer defined mathematically once and for all, but either diversified (Lomazzo, following Dürer) or even turned into a qualitative rule of adaptation of the organs to their function (Danti, p. 100); the

study of light was not, as for Leonardo, a question of geometric optics and physiology: one realizes that scientific statements serve only as preparation for a stylistic choice among several possibilities (Lomazzo, p. 111).

A second important consequence of the distinction between two steps of artistic creation—conception and execution—was the doctrine of mannerist idealism (cf. Panofsky, Idea, Leipzig-Berlin, 1924). The theory of imitation was largely shattered by the assumption that the execution of a work of art followed not a natural model, but the "idea conceived in the intellect." Some said that nature had to be corrected by the idea (this is Raphael's classical version, p. 33); some thought that the idea is an archetype which nature vainly longs to realize (Danti, p. 182); some thought that nature was no more than a causa occasionalis *which called forth the ideas virtually contained in the intellect (Zuccaro). This idealism, sometimes formulated in extravagant systems (Zuccaro, Lomazzo), had a direct impact on the actuality of art: the neglect of "servile" imitation by Michelangelists, the extraordinary vogue of intricate symbolism, the cultivation of gratuitous fancy.*

Thirdly, the theoreticians' fundamental axiom had a serious and purely negative consequence for the criticism and understanding of art: if execution follows faithfully but imperfectly the preconceived idea, it is impossible to appreciate positively the stylistic value of handling (ma-niera). Thus also grace, the je ne sais quoi, *which, by definition, escapes the idea, must be put aside as a simple "weakness of the hand." This conclusion was obviously absurd and, starting with Vasari, one tried to escape it by identifying these two unaccountable values (maniera and grazia) with facility or even quickness of execution, considered as proofs that the hand obeyed the inspired mind without hindrance. This solution was inadequate and did not allow any effective fusion between the criticism, the history, and the theory of art. One would have had, like Giordano Bruno, to recognize expression as an independent artistic value (see Bruno, pp. 184-189). But for this, one had to renounce the conception-execution dualism accepted by all mannerist theoreticians.*

Michelangelo: Sonnet

This sonnet is known only through a transcription made by Varchi, who dedicated a public lecture at the Florentine University to it (1547).

It was generally accepted that the best artist was the one who realized the work in the passive matter exactly as he had conceived it in his mind; if he did not succeed, and especially if his figures resembled him, he was a poor artist. (Leonardo, applying the criterion of universality, considered a personal manner as "the painters' greatest shortcoming," Cod. Urb. 1270, f°44 r°.) Here, Michelangelo adapted this idea to a lov-

er's complaint: the melancholy sculptor is only able to extract from his material, i.e. Vittoria Colonna's soul, the image of death.

Sonnet [1]

The best of artists never has a concept
A single marble block does not contain
Inside its husk, but to it may attain
Only if hand follows the intellect.

The good I pledge myself, bad I reject,
Hide, O my Lady, beautiful, proud, divine,
Just thus in you, but now my life must end,
Since my skill works against the wished effect.

It is not love then, fortune, or your beauty,
Or your hardness and scorn, in all my ill
That are to blame, neither my luck nor fate,

If at the same time both death and pity
Are present in your heart, and my low skill,
Burning, can grasp nothing but death from it.

Cellini: A New Method of Teaching

Cellini's short and incomplete treatise Del modo d'imparare l'arte del disegno *was published for the first time by Carlo Milanesi as an appendix to his edition of* Due trattati *(Florence: 1857). The method proposed by Cellini is interesting for its relation to V. Danti's ideas on organic beauty (see pp. 100-105); it is as if Cellini proposed a concrete application of them.*

The concern with teaching was widespread in artistic circles at a transitory period when the apprenticeship of the botteghe *(the painters' shops) had become insufficient and the academies had not yet taken their place. Several artists opened something like schools for the young who were not their apprentices.*

From the Discourse on the Teaching of the Art of Design [1]

. . . You Princes and Gentlemen who take pleasure in the arts, and you outstanding artists, and you young men who want to learn the arts, undoubtedly you know that the most beautiful animal that human nature has ever made is man, and the most beautiful part of man is the

[1] Sonnet No. 149 in *Complete Poems and Selected Letters of Michelangelo,* trans. and notes by Creighton Gilbert (New York: Random House, Inc., 1963), p. 100. Reprinted by permission of the publisher.

[1] Translated from Cellini *I trattati dell' oreficeria e della scultura,* ed. Carlo Milanesi (Florence: 1857), pp. 234-45.

head, and the most beautiful and admirable thing in the head is the eye. If man, therefore, wants to imitate the eyes, since they are what we said, it will be much more difficult work than imitating other parts of the body. This is why I believe, from my experience, that the method used up to now has been very inconvenient. The teachers would put a human eye in front of those poor and most tender youths as their first step in imitating and portraying; this is what happened to me in my childhood, and probably happened to others as well. I am convinced that this is a poor method, as I have explained, and that the better method would be to give them simpler things, which would not be only easier but more useful than it is to draw an eye. I am quite sure that some pedant or some trouble-maker will raise the objection that a good fencing master puts the heaviest weapons first in the hands of his pupils, so that afterwards the others seem lighter: I could make an elaborate answer . . . but I shall only say that my method is easier than drawing an eye, and infinitely more useful. Now, since the important thing in these arts is to draw a nude man and a nude woman well, and to remember them securely, one must go to the foundation of such nudes, which is their bones; so that when you will have memorized a skeleton, you can never make a mistake when drawing a figure, either nude or clothed; and this is saying a lot. I do not say, however, that you will be sure of drawing your figure more or less gracefully, but only of drawing it without error, and this I can promise. Now consider whether it is easier to start by drawing one single bone or a human eye. I want you to start by drawing the first bone of the leg, called the tibia, which is such that if you give it to a young boy to start drawing, it is certain that it will seem to him like drawing a short stick. Since, in all the noblest arts, the most important thing in mastering and dominating them is to gain confidence, there will not be so timorous a child that, when he starts drawing such a little stick of a bone, he will not promise himself to do it, if not the first, at least the second time very well. This would not happen if you gave him an eye to draw. Afterwards you will add the other bone of the leg which has less than half the thickness of the first, and you will put them together with the articulation in the right place. . . .

[Then Cellini proceeds to build up the skeleton in detail.] At the same time as you go on measuring these bones you will make an exact drawing of the skeleton as if it were a living man; I mean that you will arrange it standing in such a way that you can see in what way and how deeply the leg which bears the weight enters into the hip and which way it turns in it; then you will arrange the skeleton erect, standing on both legs set apart, turning the head, and you will also give a position to the arms; afterwards you will arrange it sitting high, then low, making it turn

in different positions. By doing this you will have constituted for your-self a marvelous basis which will facilitate all the great difficulties of our divine art. . . .

Cellini: On the Technique of Etching

Cellini's Due trattati (l'uno intorno alle otto principali arti dell' oreficeria, l'altro in materia dell'arte della scultura, *Florence: 1568) coin-cide rather closely, as to content, with the* Schedula artium *by the monk Theophilus. The tone, however, is strikingly different: Cellini starts with an historical section about the development of the craft of the goldsmith; he constantly enlivens his descriptions with anecdotes and particularly with references to his own works, his inventions and experiences. Thus, besides its great value as a source of technical information, the book of-fers a rich harvest of historical details about a wide range of subjects.*

We reprint the first description of the technique of etching. Intaglio printing was connected with the craft of the goldsmith from the start (niello). *One will note that Cellini still considers etching as an inferior replacement for burin engraving. Although there had been some remark-able etchers previously (Parmigianino), it is around the middle of the cen-tury that etching became widespread throughout Europe and a little later in Italy.*

How to Prepare Two Kinds of Aqua Fortis, i.e., for Dissolving and for Etching [1]

First, we shall treat of that used to engrave copper plates instead of using a burin; one has invented the following easy and marvelous method.

The aqua fortis for etching is prepared as follows: take ½ oz. of sublimate, 1 oz. of vitriol, ½ oz. of alum, ½ oz. of verdigris, 6 lemons; and in the juice of the said lemons mix the aforementioned things, mak-ing sure in advance that they were properly reduced to powder; and you will boil the whole only a little so that it would not evaporate too much. Boil it in a glazed pot, and if you do not have lemons, take some strong vinegar which will make the same effect.

When your copper plate is well planed, take common varnish, i.e., that used to varnish sword hilts and other metallic objects, and you will heat it gently and melt some wax with it; this is done so that when one draws on it the varnish should not chip. Then, when you lay it on your

[1] B. Cellini, *Due trattati*, ed. Carlo Milanesi (Florence: 1857), I, ch. 24, 155-56.

copper plate, make sure that it be not overcooked; then, when you have done the engraving,[2] and you want to put the aqua fortis, you will edge the plate with wax. When you apply the aqua fortis, do not leave it more than half an hour. And if you feel it is not deep enough, put it in again; and then, having poured it out, wipe it well with a sponge.

One draws on the varnish with a stiletto of tempered steel, i.e., a sharp instrument, which technically is called style. One takes the varnish off the plate with hot oil and a sponge, gently so as not to dull the cuts.

Then one uses the plate, printing with it on paper the same way as with those engraved with a burin. But it is true that if this technique is very easy it is all the less satisfactory than burin engraving.

Vincenzo Danti: A Functional Conception of Proportions

Vincenzo Danti (1530-1576) was a prominent representative of Michelangelesque mannerism in Florentine sculpture. His Primo libro del trattato delle perfette proporzioni di tutte le cose, che imitare o ritrarre si possono con l'arte del disegno *appeared in Florence in 1567 as the introduction to a work which was to comprise fifteen books.*

Danti started from a few sayings of Michelangelo and opinions common among Michelangelists (that one must have "mental compasses," that one must not copy things as they are, and that anatomy is the basic science of art) which he combined with ideas from Aristotle's biological works, as Paola Barocchi has shown. Danti rejected the painstaking methods of prevalent idealism (study of the arithmetic proportions of the perfect body, and the selective process attributed to Zeuxis), and adopted a solution which he called qualitative: organic beauty expresses the adaptation of the body to its function, and proportions should be determined in relation to this function.

From Vincenzo Danti, The Treatise on Perfect Proportions [1]

Ch. XI: *That the operations in the arts of design do not fall perfectly under any quantitative measurement as some would have it. And that ordinarily, neither the human figure nor any other natural or artificial object can be portrayed with perfection exactly as it is seen.*

Having, up to now, shown that *order* is the true means of attaining perfect compositions, as it is the cause of proportion; how it exists in

[2] Cellini used the word "engraved" (*intagliato*) for the drawing on the varnish with the needle. The method he described to apply the acid is slightly different from the one generally used today. One usually protects the back of the plate with wax and dips the plate into a container of acid; Cellini surrounded the recto of the plate with a ridge of wax, thus making a shallow receptacle into which the acid was poured.

[1] Translated from ed. Barocchi *Trattatisti*, I, 235-41.

divine, natural, and artificial products; that it can be easy, difficult, and impossible in its compounds; that the most difficult among the natural ones is the compound of man; that beauty is born from the purpose for which the human members are destined; that grace depends on inner corporeal beauty; that, to attain to the knowledge of perfect and imperfect compounds of the human body, anatomy is necessary; finally, having seen how order is changed into proportion,[2] we will now show more generally that the same proportional order makes the same effect in all the other compounds that are the subject of our arts, which will not only confirm our meaning, but will also show others the way in which they must portray and imitate each of the said things.

There is no doubt that the art of design, with painting, sculpture, and architecture, can imitate and truly portray all things that can be seen; and not only celestial and natural things, but also artefacts of whatever kind they may be; and, what is more, it can make new compounds and things that seem sometimes almost invented by art itself: such as chimeras, which in their entirety are not imitated from nature, but composed partly of this, partly of that natural thing, making up a whole which itself is new. I mean here by chimeras a genus which comprises all sorts of grotesques, foliage, ornaments of all kinds created by architecture, and an infinity of other things made by art, which, as I said above, in their totality do not reproduce anything created by nature, but which in their several parts imitate this or that natural thing. One must know that from such a method of imitating,[3] even if it has been applied by other arts, nothing has drawn such utility, charm, and beauty for the world in general and for men in particular as the things that are born from architecture. This is amply proved by an infinite number of beautiful cities and fortresses which architecture has built and surrounded with walls for the common good; and in particular the very beautiful houses, palaces, temples, and other buildings that can be seen. And who can deny that all the other creations of art are inferior to these? Therefore, one has to admit that most arts have taken example from architecture, as from their principal model. The art of design deserves, therefore, to be considered as noble not only because it is the most artificious of all the arts, but also because its results are more stable and permanent than those of the other arts, besides the fact that its works are mostly made as an ornament and as a perpetual memory of the illustrious deeds of outstanding men, and not out of necessity; which necessity tends to diminish nobility in great part.[4]

2 Summary of Chapters 1 to 10. *Order* is the structure of the beautiful object, *proportion* is the sensible and measurable effect of *order*.

3 The method of inventing imaginary compounds.

4 The praise of architecture is here in relation to its organic character.

The art of design, I say, is that which, like a genus, comprises under itself the three noblest arts: architecture, sculpture, and painting, each of which is itself like a species of the first, although through design each one pursues its own end. One of them can be practiced without the others, but not perfectly, because in general a man will practice each art much better and with much greater perfection if he happens to be proficient in the others; because each serves the other reciprocally: architecture is necessary to painting, painting to architecture, and sculpture to painting.[5] But even if painting is not necessary to sculpture, nor sculpture to architecture, it does not follow that they are not advantageous to one another. For this reason, I do not believe it is at all easy to decide which of the three arts can really be called the noblest; it could be that whoever wants to practice one of them to perfection must necessarily draw upon the other two. And even if there are several differences between them as to the practice itself, it is of little importance because the aim of each is the same as that of the others, since the aim of painting and of sculpture is to imitate all the things that can be seen. And if their means are different, I do not believe that it makes much difference as to their respective nobility. It is true, as I said, that architecture, because it composes objects as it pleases, i.e., it does not imitate as the two other arts, seems of much greater artifice and perfection. However, this is not true nowadays when it is reduced to so many rules, orders, and measurements which make it extremely easy to practice. Of the ancient and original inventors of so many beautiful orders, with so many beautiful ornaments and so much convenience, it can be said that they had the greatest inventiveness and judgment and that then architecture was most noble and creative through its executants. But, as I said, these days almost anybody who can draw two lines can become an architect, because of the rules I mentioned above.[6] This, however, does not apply to sculpture and to painting, for which no one has ever been able to find any rule that could really facilitate imitation, most of all the imitation of the figure of man which we have seen to be such a difficult compound.

It is true that ancients and moderns have written with great care about the portrayal of the human body; but it has obviously turned out to be of no use, because they wished to create a rule by means of quantitatively fixed measurements, which measurements do not apply exactly to the human body, because it is changeable throughout its life, i.e. it does not have stable proportions. Because, as I said in the chapter on beauty, childhood and adolescence grow continuously in proportion until youth,

[5] Fresco painting supposes walls; architecture supposes the drawing of plans and details; good painters use clay or wax puppets to study shadows, foreshortening, and drapery. The question of the comparative dignity of the arts is no longer considered with general arguments but in regard to their practical relationships.

[6] This was a current attack on Serlio.

and afterwards, more often than not, they diminish until old age in such a way that the size of the limbs is not fixed; so that childhood requires other proportions than adolescence, adolescence others than youth, and so on as we have seen in the same chapter. Because of this change, the quantitative measurements do not happen to be stable or precise as they would have to be. It is, however, true that if the said measurements could be perfect for one of those ages, one could claim that it is possible to assign a particular measure to all the ages of man. But, in fact, it can be applied to none of them either perfectly or approximately: because, granted that it would assign a measurement to all the limbs, to each one in itself and to all of them as a whole (which, however, can be denied), I will say that all the principal limbs vary both in length and width when they move, as anyone can easily observe for himself. So that, since we must show the human body now in one position and now in another, because of this variation we can not use such a quantitatively expressed measure. Moreover, as I have said, one can deny that any member can be measured precisely, because an object, to be measured, must have either a point or a line; this can not be found precisely in any part of the human body, as is obvious. If, for instance, we have to measure an arm, and as a subsection of this the hand, and as a subsection of the hand the fingers, where in all this, will be the precise limit where we shall correctly apply the point of the compasses? Certainly, one can see that it must be done by arbitrary decision rather than by measurement. Thus, it becomes clear that with this method one can not compose a well proportioned figure. But, on the other hand, we shall see that by intellectual measurement the accomplished proportion of the human compound can be measured perfectly, as we said before. In architecture, it was easy to draw up rules and devise different orders through measurement, because, its application to buildings is by points and lines which make measuring easy. But so far, it has not been possible to give any rule which would apply perfectly to painting and sculpture because they do not admit of precise measurement.[7]

But the sort of method which I intend to establish now on this subject will clearly define a measure of judgement, which can be found proportionate in all the parts of the body;[8] and this measure depends upon quality. This method will prove to be the best means for obtaining a

[7] This lengthy attack on the arithmetic theory of proportions is justified by its great prestige (Leonardo, Dürer, and many others from Vitruvius to Lomazzo had taken it very seriously).

[8] This "measure of judgment" derives from Michelangelo's famous opposition of the "compasses of judgment" to the traditional arithmetic and geometric rules of perspective and proportion. The method announced by Danti consists in deducing the shape and dimensions of each organ from its particular function in the individual body in a given attitude; since this is only an introduction to a book planned on a very large scale, he does not go into further detail.

perfect representation of the human body of any age in any attitude, position, or movement. One could say in contradiction to this: "If we see those two arts imitate nature by portraying, or rather copying its objects, is it not sufficient if a man, for instance, must be portrayed, to see him posing in front of us and to represent him precisely as nature has made him? And if this is sufficient, are not the other rules superfluous?" if, as I said, someone should say this, I would answer that Nature, because of many accidents, almost never brings its products, and man in particular, to total perfection, or even to a greater degree of beauty than ugliness, as I have explained in my second chapter. And I do not know whether all the beauty that a human body can possess has ever been seen all together in one man; but one might well say that we can see one part in this man and another in that other, and that, scattered among many men, we can find it in its entirety. So that, since we want to imitate nature in the figure of man, and since it is almost impossible to find perfect beauty in a single one, as we said, Art, conscious of its power to comprehend all that beauty in a single man, tries through imitation to include in the composition of one figure all the beauty which is divided among many men. Because Art knows that Nature has not brought the human product to full perfection, i.e. apt to attain its own end, through which it becomes absolutely beautiful. Art achieves that by avoiding imperfection and by pursuing perfect things.

This has not only been known to Michelangelo, who has thought about it more than any other, but a great many others have tried to apply it in our arts: i.e. they tried (as we would say) to help Nature by observing several men in each of whom there is some different kind of beauty. And taking one thing from one man and something else from another they have composed their figure with all possible perfection. This way and method of working is very difficult and wearisome; therefore, many help themselves with figures made by others, either ancient or modern, setting up their own manner by constantly copying one work of art or another. But Michelangelo, who has executed works of greater perfection than all the others, has very well noticed that this method was not the true and right one. Because he knew that even if it were easy to put together different aspects of beauty to compose one single beauty portrayed and copied from several men, these could never have been of accordable proportions. Because, having experienced that beauty changes with the growing and declining years of man, it would be necessary that all those from whom the different aspects of beauty were taken were of the same age, which seems very difficult and, indeed, almost impossible. These arguments will answer the contradiction mentioned above. Still another negative argument could be brought up: that several men of the same age do

not have the same proportions of beauty, although sometimes they seem identical to us, so that when put together there would always remain some discordance between the different parts. It is perhaps because of these difficulties (which, through the careful study of anatomy, are almost impossibilities) that our Michelangelo turned to the method that I shall propose, because one reads that Michelangelo worked on anatomy for twelve continuous years, and, I believe, it is by his meditating and reasoning upon it, that this method of work which I speak of could come into his mind. And I believe that it is with this method that he created the beautiful proportions of his figures. If someone should want to contradict me, I would prove by Michelangelo's manner that this method has in itself the faculty of realizing his beautiful proportions and all his beautiful poses, along with everything else that pertains to the beauty of his art.[9] For this reason, then, I should not be very disturbed if somebody would attack without proof that which can be defended as achieving what it sets out to do.

A Dispute about Perspective

Martino Bassi's Dispareri *(Brescia, 1572) contains the first example, after Varchi, of a collection of authorized opinions on a specific artistic question. The occasion was a quarrel between Bassi, architect for the Milan cathedral, and Pellegrino Tibaldi, chief director of the work.*

Bassi, not without reason, objected to the way Tibaldi meant to alter the tympanum of one of the portals of the cathedral.[1] He was not listened to and decided to appeal to public opinion by a letter in which he added a few other complaints and which he sent to four prominent architects interested in theory: Palladio, Vignola, Bertano, and Vasari. The last added to his answer that of an anonymous academician.

We print here the letter in which Bassi stated the case.[2] The answers were unanimous in condemning Tibaldi; Palladio and Vignola were favorable to Bassi's second project (Fig. 4); Vasari was rather favorable to the original unorthodox solution (Fig. 1), feeling that one must please the eye rather than observe rules; and Bertano, imbued with the authority of the ancients, rejected the whole "lie" of perspective in relief.

[9] The art of Michelangelo was commonly considered as pure heroic idealization of nature, or as pure virtuosity and art for art's sake. Danti is the only one who made a more congenial attempt to account for Michelangelo's manner.
[1] At the entrance of the Lady Chapel. The door was soon blocked up by the archbishop's order, and the tympanum was carried to Sta Maria de Campo Santo.
[2] Pages 37-39 of the original edition.

Martino Bassi: From the Controversies Concerning Architecture and Perspective [1]

. . . Two architects, at different times, have designed projects for a large piece of marble sculpture for a church in Milan. Their conceptions and ideas are laid down in the drawings attached; in these I added the [*reference*] letters and the apparent and constructive lines, making them as clear and intelligible as I could.

In this aforementioned sculpture, one of the architects had at the time executed the Annunciation of God's Word, i.e., the Angel and the Madonna, in relief so high that it was almost detached from the stone, to be raised into place high above the ground, as I shall show later. He set the principal vanishing point on one side (A), in order to show more of the simulated architecture he made on the other side, as can be seen in Fig. 1. He took his distance point at 16 braces; the distance line being lettered B, which because of the size of the paper could not be drawn more exactly. He foreshortened the plane DCGH, which represents a recession of 8 braces. The purpose was to show a rectangular room, with the walls around it, and the two figures set in it. All this appears clearly in Fig. 1 and its captions.

In the sculpture as it can be seen today, the other architect rejected all that was devised by his predecessor; he has taken another vanishing point, 15 *oncie* higher than the first, as shown in Fig. 2 (B) in the center of the picture. He chose a new and very short distance, less than four braces, although the work was meant to be set at $12\frac{1}{2}$ braces above the ground. According to this new vanishing point and new distance point, he has ordered the cant DGEF to be cut, which forms an angle with the pavement, as can be seen in the profile of Fig. 2 (I). Nevertheless the architect insists that it make a continuous plane with the pavement. Moreover, he has set up a simulated wall with a door in foreshortening, a rectangular chimney, and a curtain. All these additions follow the new vanishing and distance points, while the original parts which are still there follow the original vanishing and distance points.

Since a superior of mine asked my opinion on such various matters, before giving it, I desired to know the sentiment of such a man as Your Lordship, and for this reason I have delayed for some time. But I should not withhold my opinion from Your Lordship, and therefore I submit it to Your Lordship's more mature and sound judgment. As I see it, there are two possibilities, which Your Lordship can find in Figures 3 and 4.

First let us consider Fig. 3. Even supposing it to be true that there exists a possibility of showing the ground in works placed higher than

[1] Translated from Martino Bassi, *Dispareri in materia di architettura et perspettiva* (Brescia: 1572), pp. 37-39.

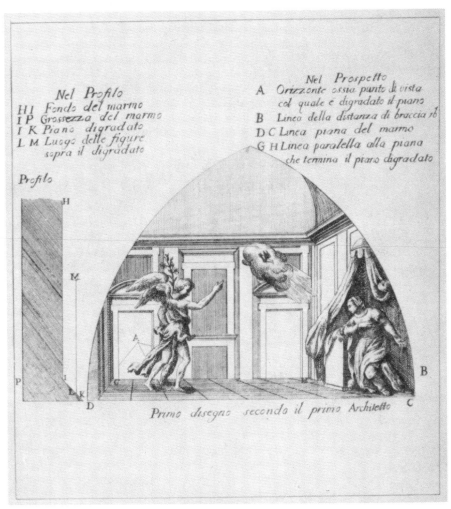

Figure 1

eye level (because I know that many have taken this liberty), I would in order to be less incorrect, draw a line from the first vanishing point (A) to the central axis of the work, parallel to the ground line; down from the second vanishing point (B) I would trace a vertical. At the intersection of the two lines (C) in the middle of the marble, I would construct the principal and only vanishing point of the whole work; and I would abandon the two others. With this point and the original distance of 16 braces I would be able to organize, or at least to mend the whole, con-

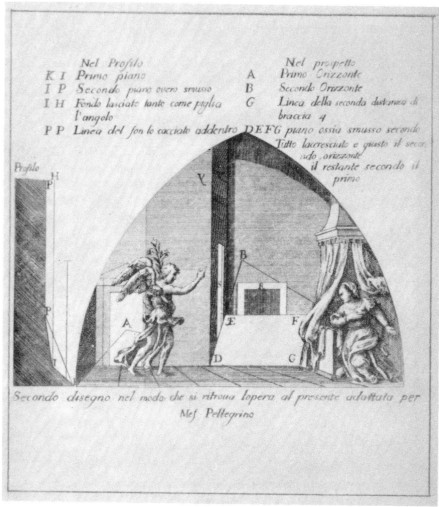

Figure 2

tinuing the plane of the pavement until it meets the farther surface of the marble, so that the prolongation would be continuous with the original ground, and it would represent a recession of 16 braces. I would take away the cant and the foreshortened wall with its door, and diminish the pulpit, the curtain, and everything marked by points in Fig. 3. By doing this, I would avoid giving the work two main vanishing points, and it would have just one in C, which would be nearer to truth; not two viewing distances, which is incorrect, but one, well chosen; not one pavement

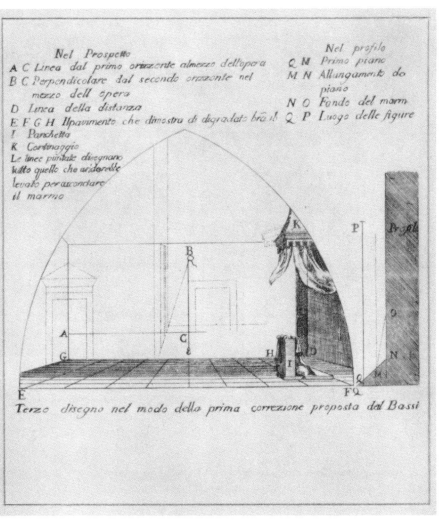

Figure 3

plus a cant, which are discontinuous and form an angle, but only one straight plane; and finally there would not be one main vanishing point ordering one part of the work and another for the other part; but the whole would be ordered by only one, as it should be, and as art requires. One can afterwards make appropriate ornaments, for which there are various possibilities, which I have omitted for brevity along with the figures in Fig. 3. I do not, however, propose to alter the two figures, since

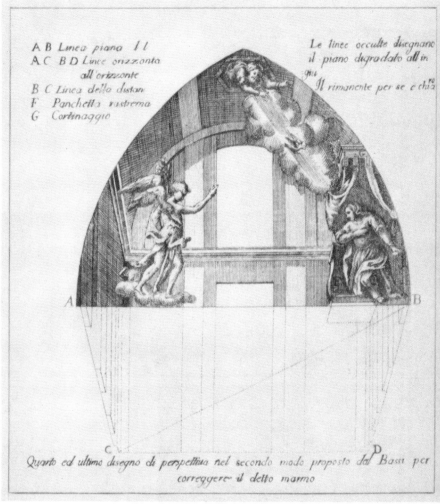

Figure 4

they are already finished in the sculpture in question, as can be seen in Fig. 2.

My other proposal to mend this sculpture would be to put the main vanishing point at eye-level at the intersection of the two lines AC and BD in Fig. 4. The one distance point should be taken at the same level; upon which I would do away with the ground plane altogether and with the cant of the second architect, making a step under the pulpit of the

Virgin, in order to have it rest on the ground which recedes downwards, and putting the whole room together, as Your Lordship can see in the fourth perspective drawing. And my final proposal is to omit the ground because the work will be 17½ braces above the ground, which is much higher than eye level. This is founded on the great authors and on the works of the moderns like Bramante, Baldassare, the profound Mantegna and many others, who (as Your Lordship knows better than I), when they put architecture and figures together in their handling of perspective, have refuted in advance anyone who would want to depart from the sound rules of true theory as well as of good and solid practice. These masters have never shown any ground plane in works higher than the eye level . . .

Lomazzo: On Light

G. P. Lomazzo (1538-1600), a mediocre Milanese artist who became blind in his youth, is known as the author of a vast Trattato della Pittura *(1584) which comprises the sum of all theoretical knowledge of late Italian Mannerism. His second work the* Idea del Tempio della Pittura *(Milan, 1590) was composed by the artist when already blind, with unused notes for his large* Trattato *and the addition of a few new chapters. The book is rather piecemeal in spite of the artificial systematic order of the chapters; one can find in it, however, unexpected developments of great historical interest.*

Chapter 29 is mainly a speech in favor of uniform lighting and an attack on brushing or channeled light. The traditional manner to which Lomazzo always adhered as a painter, but which was giving way to the more recent taste for luminism, created no difficulties in frescoes except when the real light of the room was in contradiction with the diffuse and uniform light cast on the painted figures. The dilemma in this case was unresolvable and the problem could be circumvented only by avoiding it. Cf. Roberto Longhi, Quesiti caravaggeschi, *in* Pinacoteca *(1928-29), I, 17-33 and 258-320.*

How to Distribute Light [1]

All lights have to be distributed in such a way that they show their dependence on their causes, just as surfaces have to be in accord among themselves, so that one obtains that harmonious relation so dear to the eyes of connoisseurs and so agreeable when represented. . . .

Above all, it is necessary to pay attention to the surfaces, to determine whether they are frontal or oblique, how they catch light, either

[1] G. P. Lomazzo, *Ideal del Tempio della Pittura* (Milan: 1590), Chapter 29.

little or much, and how they reflect it, because we see that the same surface can show different effects in the way it catches light. For instance, if you turn the whole palm of the hand towards the light you see it entirely lit, and if you turn it against the light you see it all dark except for some light which edges the outline. The same effects are produced in figures seen from the side or in front view or from the back, or in any other position, which are always principally lit by the greatest light falling on the largest surface, or, to be more precise, by the light nearest the figure and our eyes. . . .

As for daylight, it has to be directed and distributed for every object as if it came from above, i.e., from the sky, because this way the figures seem perfectly detached and in full relief. This is why the ancients, in their round as well as rectangular temples, used to give light from above in order to make the statues of their false gods look more beautiful; this is also the method used by good modern artists, who have discovered this by reason and the study of ancient works; as, among many others, Bramantino has done in the drum and sacristy of Santo Satiro in Milan, especially with the masks in the corner of the octagonal frieze: these masks, larger than life, executed in terracotta by Caradosso Foppa,[2] look up towards the light that falls upon them. But if one would make the light fall from one side or obliquely, one would yield to the manner of some of our contemporaries whose works are unpleasant for this reason, and, by intercepting the rays of light, appear mad rather than just confused.[3] This same light is also necessarily given to figures if represented as lit by the [real] windows close by (at least if one does not paint other windows or apertures, since in this case the light would be falsely distributed). If the painter has to represent on certain walls scenes or figures in the open which are expected to have daylight or, rather, natural light which should penetrate everywhere as if it were real, it should also hit the figures and make its effect; one should avoid imitating those who, painting the vaults of chapels in which the figures are shown in natural light from above, give them a light that comes and falls in from the windows or from close by oculi.[4] This makes the figures take a false and contradictory light, although the painters imagine such lighting to be dictated by reason. Therefore, it is shocking to confront this [painted] daylight with the more intense actual light, even when it is artificial.

[2] We know today that they are by Agostino de' Fonduti, mentioned by documents in Milan between 1483-1502.

[3] Longhi has shown that this polemic of Lomazzo is directed against the Campi of Cremona.

[4] This is, however, the almost general, if discreet, practice of the Renaissance. It is bad, except in a few particular instances, to use the lateral light of neighboring windows for paintings, and it is bad to contradict it. Only cupolas lit from the top, like San Satiro, and classical temples allow ideal solutions.

Lomazzo: Motion in Painting

Human passions and their expression had not been discussed systematically since Leonardo. Lomazzo who, as always, tried to be complete, was able only to gather together scattered and rather contradictory elements.

Music, rhetoric, and, to a certain extent, poetry boasted of their power over human passions. Lomazzo did not forget to call upon their authority. On the other hand, encouraged by the double meaning of the Italian word moto *and by the confusion of his Leonardesque recollections, he went from the idea of the psychic movement produced in the spectator, to that of the production of physical movement in the figures created by the artist, and thus was able to add famous automatons to his list of spectacular performances of the art of "moving."*

Finally, he borrowed from rhetoric the postulate that one can call forth passions by imitating them carefully, and he deduced from it the necessity of studying the expression of feelings. This praise of the observation of nature was taken over from Leonardo, who is, in a way, the hero of this whole chapter. But the rest of Book II (all on moto*) is much less empirical and contains an astrological classification of passions, followed by some chapters on the representation of physical motion.*

G. P. Lomazzo: *Treatise*, Book II, ch. 1, *Of the Vertue and Efficacie of Motion* [1]

It is generally confessed of all men, that all such motions in pictures, as doe most neerely resemble the life, are exceeding pleasant; and contrariwise those which doe farthest dissent from the same, are voide of all gracious beauty; committing the like discord in Nature, which untuned strings doe in an instrument. Neither doe these motions, thus lively imitating nature in pictures, breed only an eie-pleasing contentment, but do also performe the selfe same effects which the natural doe. For as he which laugheth, mourneth, or is otherwise affected, doth naturally moove the beholders to the selfe same passion of mirth or sorrow; (whence the Poet saith,

> If thou in me would'st true compassion breede
> And from my heavy eies wring flouds of teares:
> Then act thine inward griefes by word and deede
> Unto mine eies, as well as to mine eares:) [2]

[1] We use the English translation by Richard Haydock, *A Tracte Containing the Artes of Curious Paintinge, Carvinge, Building* (Oxford: 1598). The translation includes only books 1 to 5, which are slightly abridged, and contain engravings added by the translator.

[2] Horace, *Ars Poetica*, v, 102-103: *Si vis me flere, dolendum est Primum ipsi tibi . . .*

So a picture artificially expressing the true naturall motions, will (surely) procure laughter when it laugheth, pensivenesse when it is grieved, etc.[3] And, that which is more, will cause the beholder to wonder, when it wondreth, to desire a beautifull young woman for his wife, when he seeth her painted naked: to have a fellow-feeling when it is afflicted; to have an appetite when he seeth it eating of dainties; to fall asleepe at the sight of a sweete-sleeping picture; to be mooved and waxe furious when he beholdeth a battel most lively described; and to be stirred with disdaine and wrath, at the sight of shameful and dishonest actions. All which pointes are (in truth) worthy of no less admiration, then those Miracles of ancient Musitians; who with the variety of their melodious harmony, were wont to stirre men up to wrath and indignation, love, warres, honourable attemptes, and all other affections, as they listed: [4] or those strange conclusions of the Mathematical motions,[5] recorded of those undoubted wise men, who made Statues to moove of their owne accord. As those of Daedalus, which (as Homer writeth) came to the battel of themselves.[6] Or Vulcanes Tripodes mentioned by Aristotle: or those gilded servitors which walking up and downe at the feast of Iarbas the Gymnosophist, served at the table: or those ancient ones of Mercury in Aegypt, which spake, etc.[7]

In which kinde of artificial motions Leonard Vincent [8] of our time was very skilfull; who (as his scholer Sig. Francesco Melzi the great Limner hath tolde me) [9] invented a certaine conceited manner, whereof he used to make birdes that would flie in the aire: And on a time he made a most artificial Lyon, which being brought into a large Hall before Francis the first King of France of that name, after he had a while walked up and downe, stood still opening his breast, which was full of Lillies and other flowers of divers sortes.[10] At which sight, the king and the other spectators were rapt with so great admiration, that they easily beleeved, that Architas Tarentinus his wodden Dove flewe; That the brasen Diomedes, mentioned by Cassiodorus, did sound a trumpet; that a

[3] Here, as several times below, the translator signals with *etc.* a slight abbreviation which is entirely justified.

[4] The classical example is Alexander's musician Timotheus.

[5] Automatons.

[6] Homer mentions Dedalus (*Iliad*, xviii, 590 ff.) but not the moving statues; this is a later legend, cf. Aristotle, *Politics*, i, 2, 1253b.

[7] Vulcan's moving tripodes are mentioned by Aristotle, *loc. cit.*, but already in Homer, *Iliad*, xviii, 374 ff. Iarbas is a confusion for Iarchas: cf. Philostratus, *Life of Apollonius of Tyana*, iii, 27. On Hermes Trimegistos' speaking statues, see the *Asclepius*, one of the writings in the *Corpus Hermeticum*, Chapters 23-24.

[8] Leonardo da Vinci, of course.

[9] We do not know why Melzi should be called a miniaturist.

[10] In fact the narrative is taken from Vasari and not from Melzi; the proof is the mistake of Francis I for Louis XII, a mistake which Melzi would not have made, but which comes from the fact that Vasari just writes "the King of France."

Serpent of the same metal was heard to hisse; that certain birdes sange; and that Albertus Magnus his brasen head spake to S. Tho. of Aquine; which he brake, because he thought it the Devil, whereas indeede it was a mere Mathematicall invention (as is most manifest).[11]

But to return thither where I left: I am of opinion, that insomuch as these motions are so potent in affecting our mindes, when they bee most artificially counterfainted, we ought for our bettering in the knowledge thereof, to propose unto us the example of Leonard Vincent, above all others: Of whom it is reported, that he would never expresse any action in a picture, before he had first carefully beheld the life, to the end he might come as neere the same, as was possible: whereunto afterwards joyning art, his pictures surpassed the life.

This Leonarde (as some of his friendes who lived in his time have given out) being desirous on a time to make a picture wherein he would expresse certaine Clownes Laughing: (although he never perfected it more, than in the first drawght) he made choise of some clownes for his purpose, into whose acquaintance after he had insinuated himselfe, he invited them to a feast, amongst other of his friendes, and in the dinner while, he entered into a pleasant vaine, uttering such variety of odde merry conceites, that they fell into an exceeding laughter (though they knew not the reason hereof;) Leon: diligently observed all their gestures, togither with these ridiculous speaches, which wrought this impression in their mindes; and after they were departed, withdrew himselfe into his chamber, and then set them downe so lively, that they mooved no lesse mirth in the beholders, then his jestes did in them at the banquet.[12]

They add moreover that he tooke speciall delight to behold the gestures of the condenned, as they were led to execution, to the ende he might marke the contracting of their browes, the motion of their eies, and their whole body. In imitation whereof I hold it expedient for a painter, to delight in seeing those which fight at Cuffes, to observe the eie of privie murtherers, the courage of wrastlers, the actions of stage-plaiers, and the inciting allures of the Curtisanes[13] to the ende he bee not to seeke in any particular: wherein the very life and soule of painting consisteth. Wherefore, I could wish all men carefully to keepe their braines

11 On Archytas's dove, see Aulus Gellius, X, 2. The reference to Cassiodorus seems to be mistaken. The artificial birds which sing and the snakes which hiss were among the automatons described by Hero of Alexandria. The story of Albert the Great and Saint Thomas is very widespread, but of a late origin.

12 The *Trattato della pittura,* compiled from Leonardo's notes (fo 60ro of ms. no249 of McMahon's ed.), as well as Vasari, speak of observing peculiar people and their gestures, and mention Leonardo's notebooks where he recorded expressions on the spot or later. Leonardo's "caricatures" were very popular during the 16th century.

13 Haydock has noted in the margin: That he may paint them as detestably, as their actions are odious.

waking: which whosoever shall omit, his Invention (out of doubt) will sleepe, studying perhappes tenne yeares about the action of one figure, which in the ende, will proove nothing worth. Whence all famous Inventors, for the avoiding of such grosse defectes, have the rather shewed themselves subtile searchers out of the effectes of nature, being mooved thereunto by a speciall delight of often seeing them and continually attending to the consideration and study of them. So that who so keepeth this order, shall unawares attaine to suche an habite of practize, in lively expressing all actions and gestures best fitting his purpose, that it will become another Nature.

And whosoever shall diligently consider Caesar Sestius [14] his admirable workes, wherein all the actions are most naturally appropriated to the subiect, will easily conclude that he trod in Leon. steppes; and for this cause was he highly esteemed of Raphael Urbine: unto whom they say he was wont jestingly to say often, that it seemed a very strange thing unto him; that they two being such neere friends, yet spared not each other when the arte of Painting was in question. A speach surely well beseeming artists, albeit they lived togither in such sweet emulation: which humour, if it were to be found in these our daies, the world might bee reputed right happye. But now malicious envie (to our shrewd disadvantage) taketh place insteede thereof, ministring matter to ignorant and absurde people, insolently to disgrace and carpe at other mens rare perfections.

[14] Cesare da Sesto.

6

The
Counter-Reformation

INTRODUCTION

In reaction to the Protestants' attacks against images, the Council of Trent, restating the ideas of the 15th century "Catholic Reformation," required art to regain dignity in its forms and coherence in its iconography. The decision of the Council is laconic (p. 120) but it has suscitated other writings which developed its ideas. The Fleming Molanus (1570) and Cardinal Paleotti (1582) (p. 124) drew from it a complete legislative system, both iconographic and moral. [Cf. E. Mâle, L'Art religieux après le Concile de Trente *(Paris: 1932)].*

Less official works inaugurated counter reformatory art criticism: Gilio da Fabriano's diatribe against Michelangelo's Last Judgment *(1564), used as a source by several generations of critics adverse to Michelangelo, is one of the first examples, still close to the humanistic mentality of the early 16th century.*

The artists of the second half of the century often had to pay for their recently acquired professional emancipation by a more or less willing submission as propagandists for Princes or for the Church. In each case they had to obey some sort of code, the Church's implying mainly decorum and prudishness. Two historical examples make these restrictions manifest in the cases of religious painters: the scandal of the Last Judgment *and Veronese's trial.*

The attacks on the Last Judgment, *among which Aretino's (p. 122) and Gilio's are only the best known, finally forced Paul IV to have the nudes covered by painted drapery. Veronese's trial was more benign and devoid of practical consequences (p. 129), but only because the artist found powerful help in the Venetian Republic, which was very keen on asserting its independence. In fact, however, moral pressure alone was often sufficient to act upon the artists' sensibility; the autocriticism of old Ammannati (1582) (in Barocchi,* Trattati, *III, 117-23) who expressed his regret in a letter to the Florentine Academy for having sculpted nudes is a good example of this, all the more because his motives seem to have been not altogether disinterested. The case of the aging Michelangelo is more complex, because the lines in which he disavows his art (p. 133) reveal less counter reformatory rigorism than his conversion to a religion of interiority and Grace, the Italian participants of which had gathered around Vittoria Colonna and Juan de Valdés.*

The Council of Trent on Religious Art

The official text which contains the Catholic doctrine on images was voted during the last session of the Council of Trent, along with the

decisions on the cult of the saints and of reliques; in fact, these questions were linked in the polemics of the Protestants against the paganism and superstition of the Church.

The text established the difference between idolatry and the proper veneration of images. In order to stress this difference in practice, one had to purify both iconography and the customs of the faithful; ecclesiastical authorities had to look to the orthodoxy and the Christian dignity of the pictures. By defining the aim of images (to instruct the believers, to incite piety) the text implies certain concrete indications to future artists. All this tended toward an art rather traditional in its forms, without individual initiative, clear as to its subject, respecting classical decorum as well as modern decency, but aiming, however, at a dramatic or pathetic effect.

Canons and Decrees of the Council of Trent [1]

TWENTY-FIFTH SESSION, DECEMBER 3 AND 4, 1563 . . . *On the invocation, veneration and relics of saints, and on sacred images.*

The holy council commands all bishops and others who hold the office of teaching and have charge of the *cura animarum,* that in accordance with the usage of the Catholic and Apostolic Church, received from the primitive times of the Christian religion, and with the unanimous teaching of the holy Fathers and the decrees of sacred councils, they above all instruct the faithful diligently in matters relating to intercession and invocation of the saints, the veneration of relics, and the legitimate use of images. . . . Moreover, that the images of Christ, of the Virgin Mother of God, and of the other saints are to be placed and retained especially in the churches, and that due honor and veneration is to be given them; not, however, that any divinity or virtue is believed to be in them by reason of which they are to be venerated, or that something is to be asked of them, or that trust is to be placed in images, as was done of old by the Gentiles who placed their hope in idols; but because the honor which is shown them is referred to the prototypes which they represent, so that by means of the images which we kiss and before which we uncover the head and prostrate ourselves, we adore Christ and venerate the saints whose likeness they bear. That is what was defined by the decrees of the councils, especially of the Second Council of Nicaea, against the opponents of images.

Moreover, let the bishops diligently teach that by means of the stories of the mysteries of our redemption portrayed in paintings and

[1] The excerpt is from *Canons and Decrees of the Council of Trent,* trans. H. J. Schroeder (St. Louis and London: 1941). Charles P. Parkhurst, Jr., wrote the introductory note and selected the material.

other representations the people are instructed and confirmed in the articles of faith, which ought to be borne in mind and constantly reflected upon; also that great profit is derived from all holy images, not only because the people are thereby reminded of the benefits and gifts bestowed on them by Christ, but also because through the saints the miracles of God and salutary examples are set before the eyes of the faithful, so that they may give God thanks for those things, may fashion their own life and conduct in imitation of the saints and be moved to adore and love God and cultivate piety. But if anyone should teach or maintain anything contrary to these decrees, let him be anathema.

If any abuses shall have found their way into these holy and salutary observances, the holy council desires earnestly that they be completely removed, so that no representation of false doctrines and such as might be the occasion of grave error to the uneducated be exhibited. And if at times it happens, when this is beneficial to the illiterate, that the stories and narratives of the Holy Scriptures are portrayed and exhibited, the people should be instructed that not for that reason is the divinity represented in picture as if it can be seen with bodily eyes or expressed in colors or figures. Furthermore, in the invocation of the saints, the veneration of relics, and the sacred use of images, all superstition shall be removed, all filthy quest for gain eliminated, and all lasciviousness avoided, so that images shall not be painted and adorned with a seductive charm, or the celebration of saints and the visitation of relics be perverted by the people into boisterous festivities and drunkenness, as if the festivals in honor of the saints are to be celebrated with revelry and with no sense of decency. Finally, such zeal and care should be exhibited by the bishops with regard to these things that nothing may appear that is disorderly or unbecoming and confusedly arranged, nothing that is profane, nothing disrespectful, since holiness becometh the house of God.

That these things may be the more faithfully observed, the holy council decrees that no one is permitted to erect or cause to be erected in any place or church, howsoever exempt, any unusual image unless it has been approved by the bishop; also that no new miracles be accepted and no relics recognized unless they have been investigated and approved by the same bishop, who, as soon as he has obtained any knowledge of such matters, shall, after consulting theologians and other pious men, act thereon as he shall judge consonant with truth and piety. But if any doubtful or grave abuse is to be eradicated, or if indeed any graver question concerning these matters should arise, the bishop, before he settles the controversy, shall await the decision of the metropolitan and of the bishops of the province in a provincial synod; so, however, that nothing new or anything that has not hitherto been in use in the Church, shall

be decided upon without having first consulted the most holy Roman pontiff.

Aretino's Attack on Michelangelo

Aretino tried several times to obtain some of Michelangelo's draw-ings by the direct means of writing and asking the artist, as well as through the intercession of common friends. His first letter on the Last Judgment *(see above pp. 56-58) was one of these attempts. Hurt by hav-ing obtained nothing and by seeing his advice disregarded, he turned to shameful blackmail in the letter reprinted here. He claimed to be shocked by the nudes in the* Last Judgment, *and then hinted threaten-ingly at accusations currently made against Michelangelo: the breaking of his contract for Julius II's tomb, and his inclination for young men.*

In a post scriptum to his letter, Aretino assures Michelangelo that he will not let the letter circulate and damage his reputation. Notwith-standing the assurance, a few years later, having received nothing from the artist, Aretino published the letter in a slightly different version.

To the Great Michelangelo Buonarroti in Rome [1]

Sir,

When I inspected the complete sketch of the whole of your Last Judgment, I arrived at recognizing the eminent graciousness of Raf-faello in its agreeable beauty of invention.

Meanwhile, as a baptized Christian, I blush before the license, so forbidden to man's intellect, which you have used in expressing ideas connected with the highest aims and final ends to which our faith aspires. So, then, that Michelangelo stupendous in his fame, that Michel-angelo renowned for prudence, that Michelangelo whom all admire, has chosen to display to the whole world an impiety of irreligion only equalled by the perfection of his painting! Is it possible that you, who, since you are divine, do not condescend to consort with human beings, have done this in the greatest temple built to God, upon the highest altar raised to Christ, in the most sacred chapel upon the earth, where the mighty hinges of the Church, the venerable priests of our religion, the Vicar of Christ, with solemn ceremonies and holy prayers, confess, contemplate and adore his body, his blood, and his flesh?

If it were not infamous to introduce the comparison, I would

[1] Text of the original manuscript published by Gaye, *Carteggio inedito*, II, 332 ff. Trans. J. A. Symonds, *The Life of Michelangelo* (London: 1899), pp. 333-36.

plume myself upon my discretion when I wrote *La Nanna*.[2] I would demonstrate the superiority of my prudent reserve to your immodesty, seeing that I, while handling themes lascivious and immodest, use language comely and decorous, speak in terms beyond reproach and inoffensive to chaste ears. You, on the contrary, presenting so awful a subject, exhibit saints and angels, these without earthly decency, and those without celestial honors.

The pagans when they made statues I do not say of Diana who is clothed, but of naked Venus, made them cover with their hand the parts which should not be seen. And here there comes a Christian who, because he rates art higher than faith, deems a royal spectacle martyrs and virgins in improper attitudes, men dragged down by their genitals, things in front of which brothels would shut their eyes in order not to see them. Your art would be at home in some voluptuous bagnio, certainly not in the highest chapel of the world. Less criminal were it if you were an infidel, than, being a believer, thus to sap the faith of others. Up to the present time the splendor of such audacious marvels has not gone unpunished; for their very superexcellence is the death of your good name. Restore it to good repute by turning the indecent parts of the damned to flames, and those of the blessed to sunbeams; or imitate the modesty of Florence, who hides your David's shame beneath some gilded leaves. And yet that statue is exposed upon a public square, not in a consecrated chapel.

As I wish that God may pardon you, I do not write this out of any resentment for the things I wished to have. In truth, if you had sent me what you promised, you would only have been doing what you ought to have desired most eagerly to do in your own interest; for this act of courtesy would have silenced the envious tongues which say that only certain Gerards and Thomases dispose of them.[3]

Indeed, if the treasure bequeathed you by Pope Julius, in order that his remains may be deposited in the shrine of your sculptures, was not enough to make you keep your plighted word, what can I expect from you? It is not your ingratitude, your avarice, great painter, but the grace and merit of the Supreme Shepherd which determined his sepulture. God wills that Julius' renown should live for ever by itself, in a simple tomb, and not by the strength of your genius in some proud monument. Meantime, your failure to discharge your obligations is reckoned to you as an act of thieving.

[2] That is parts I and II of Aretino's *Ragionamenti* (1534 and 1536), famous for their licentiousness.

[3] This is a slanderous allusion to Gherardo Perini and Tommaso Cavalieri, intimate friends of Michelangelo. There is no trace of such a promise as Aretino claims to have received.

Our souls need the tranquil emotions of piety more than the lively impressions of plastic art. May God, then, inspire His Holiness Paul with the same thoughts as he instilled into Gregory of blessed memory, who rather chose to despoil Rome of the proud statues of Idols than to let their magnificence deprive the humbler images of saints of the devotion of the people.

Lastly, when you set about composing your picture of the universe and hell and heaven, if you had remembered the glory, the majesty, and the terror which I sketched out for you with learning and science in the inspiring letter I wrote you and which the whole world reads,[4] I venture to assert that not only Nature and all kind influences cease to regret the illustrious talents they endowed you with, and which today render you, by virtue of your art, an image of the marvelous: but Providence, who sees all things, would herself continue to watch over such a masterpiece, so long as order lasts in her government of the hemispheres. Of November 1545, in Venice.

Your Servant,

THE ARETINE

Now that I have blown off some of the rage I feel against you for the cruelty you used to my devotion, and have taught you to see that, while you may be divine, I am not made of water,[5] I bid you tear up this letter, for I have done the like, and do not forget that I am one to whose epistles kings and emperors reply.

The Didactic Task of Painting

The Council of Trent had entrusted the application of the decree on images to the bishops. The Bishop of Bologna, Cardinal Gabriele Paleotti, proposed to develop it into a kind of complete legislative digest. His Discorso intorno alle imagini sacre e profane—*in fact the collective work of a commission—was to comprise five books of which only two ever appeared (1582).*

The first one deals with generalities; the second and more interesting concerns the errors of sacred and profane artists (for the Church must rule the one as well as the other). The following books were to treat of licentious pictures, of a constructive iconography of sacred subjects, and finally of the uses of works of art.

The Discourse *is exclusively a work of moral theology. It deals with art in the abstract and never attempts a criticism of existing works. Although the authors have read such writers as Pliny, Dürer, and Vasari,*

4 See above, p. 56.
5 Pun on *divino (di vino)* and *d'acqua.*

they considered only the subjects and the moral and didactic value of works of art. The search for artistic perfection implied the danger of vanity, and the imitation of antiquity smelled of paganism; a private citizen who had his portrait painted was already suspect of pride.

The chapter on obscure pictures which we translate is part of a section on "errors common to sacred and profane images." Obscurity was considered to be a sin against the essential didactic function of any art, and could not be tolerated even for the most profound mysteries of faith. The aesthetic taste for obscurity, with which Michelangelo was so often reproached and which had such an immense vogue with Mannerist artists, especially during the second part of the 16th century, was no more commendable than obscurity caused by ignorance.

Pictures with Obscure and Difficult Meaning [1]

One of the main praises that we give to a writer or a practitioner of any liberal art is that he knows how to explain his ideas clearly, and that even if his subject is lofty and difficult, he knows how to make it plain and intelligible to all by his easy discourse. We can state the same of the painter in general, all the more because his works are used mostly as books for the illiterate, to whom we must always speak openly and clearly. Since many people do not pay attention to this, it happens every day that in all sorts of places, and most of all in churches, one sees paintings so obscure and ambiguous, that while they should, by illuminating the intelligence, both incite devotion and sting the heart, in fact they confuse the mind, pull it in a thousand directions, and keep it busy sorting out what each figure is, not without loss of devotion. Thus whatever good intention that has been brought to the church is wasted, and often one subject is taken for another; so much so that, instead of being instructed, one remains confused and deceived.

To obviate such a great ill, one must look carefully for the roots of that error, which we shall find comes from one of three things: either the painter or the patron that commissions the work lacks will, or knowledge, or ability; and in this we take an example from the writers, in so far as their art is on this point comparable to the painters'.

As to intention, it must seem strange that there are persons who like to be obscure and not to be understood, but it is true; and for this reason, Heraclitus, in antiquity, was called σχοτεινός for his obscurity,[2] and Quintilian [3] tells us that there once was a rhetorician who did not

[1] Gabriele Paleotti, *Discourse on Sacred and Profane Images*, 1582, book II, chapter 33. Translated from Barocchi, *Trattati*, II, 408-12. The notes 2 to 13 are Paleotti's.

[2] Cicero, *De finibus*, ii, 5.

[3] *Instit. orat.*, VIII, 2.

teach his disciples anything but to make their speech obscure, and would say: σχότισον , σχότισον ; which means: "be obscure, be obscure." But we must point out that there are two kinds of voluntary obscurity, one praiseworthy, the other reprehensible: the first was practiced since the time of the Hebrews and the Egyptians by philosophers and others when they wanted to discuss sacred matters which, for that reason, they called mysteries because of the meaning of the word in Greek, which is "to conceal"; for they considered that the lofty secrets of God should not be disclosed to the profane multitude,[4] but should be handled through enigmas and allegorical meanings; this was accepted by our holy doctors in the principal mysteries of our religion [5]; they wanted, in the same way that a thin cloth or a transparent crystal is put in front of the sacred relics, the great secrets of things eternal to be protected in their majesty, and also, by this means, the people more efficiently kept in due reverence.

But this argument of the theologians could not have much relevance to painters who, in such matters, only represent what is proposed by holy doctors and accepted unanimously by the Church, without adding, removing, or changing anything, either in content, or as to the way of expression or other particulars.

Therefore we shall proceed to the second kind of obscurity, which is blamed because it may come from a hidden pride and the affected vanity of being considered great and admirable for not exposing and painting trivial objects, but sublime ideas and ones, so to speak, taken from the third heaven. This is a most foolish stupidity, not only because its one and only end is one's own and vain reputation, but also because it perverts the course of the science or the art that one practices, as St. Augustine says [6]: *Loquendi omnino nulla est causa, si quid loquimur homines non intelligunt* (There is no reason at all to speak unless people understand what one says). Whence those vain people should be told what was said to the author that was chided for his obscurity: *Si non vis intelligi, nec intelligaris* (If you do not want to be understood, you will not be).

Sometimes also this happens when one wants to display one's knowledge of nature and one's familiarity with different parts of the world; thus one represents animals without any reason, or plants or technical devices used only in foreign countries and unknown in our part of the world. This introduces obscurity.

[4] A. Fiocchi, *Lucii Fenestellae De Romanorum magistratibus liber* (1561), ch. 13; Clemens of Alexandria, *Stromata*, V; Eusebius, *Praeparat. evang.*, XII, 4; Valerius Maximus, I, 1, 13.

[5] Dionysius Areopagita, *De eccles. hierarch.* I, 1; Clemens of Alexandria, *Stromata*, VI; St. Gregory of Nazianzus, *Homil. 27 (De theol.,* I); Beda, *In Lucam*, 4; Origenes, *Hom. in Num.*, 5; St. Basil, *De Spiritu Sancto*, 27.29.

[6] *De doctrina christiana*, IV, 10.

In other cases the cause is that one wants to be brief, and embrace much in few words or little space; wherefrom springs the popular saying: *Brevis esse laboro, obscurus fio* [7] (I strive to be short, I become obscure). Therefore, to avoid all this, the good painter must propose to try and be useful to others first of all, and to use a manner convenient to this end, expressing the necessary particulars and thereby avoiding misunderstandings or any ambiguous figures, as much as possible.

Obscurity can also come from ignorance; but we do not intend to discuss here the skill of the art, because, as we have said several times, we treat the subjects and not the norms of design, presupposing that the painter has learnt them as necessary. Otherwise, there is no doubt that, if he does not possess the art of imitating, his works will be most obscure, and unrecognizable to the observer, as is the case of a previously mentioned painter who was forced to add to the pictures that he made: "this is a lion, this is a dog, this is a tower, this is a fountain." [8] But we are concerned with the obscurity that comes from the painter's not understanding well the subject that he wants to represent; for, as Socrates said [9]: the things that man knows well and understands completely, he also expresses them easily when he wants to; and on the contrary, who is not sure of his knowledge of something, often speaks about it confusedly, without order, and very imperfectly. Thus, in painting, he who has a good and sound knowledge of the subject of his picture, and who knows the aim of this holy action or the meaning of that figure, undoubtedly will be able to bring it out much more clearly and with greater expressiveness through the details that he will insert, than a painter who understands little. And in the same way that, in trying to resolve properly a question in any science, he who proceeds by distinguishing and studying different points, will succeed much better and with these distinctions will in fact quiet the intellect that is in doubt; thus there are many sacred stories and mysteries such that if the painter has the intelligence to divide them in an orderly way, and to separate them in several panels or spaces, and if he refrains as much as possible from accumulating and pressing in a multitude of figures and events which confuse both sight and intellect, undoubtedly he will give more satisfaction to everybody and will show greater signs of his judgment and skill. For this end, it will be particularly useful to add in a convenient place the name of the holy action or of the saint, when it is not a well known figure (as we see it was done in ancient time according to St. Paulin's [of Nola] statement) [10]: *Martyribus mediam pictis pia nomina signant* (The

7 Aelian, *Var. histor.*, X, 10.
8 Horace, *Ars poetica*, 25 s.
9 Cicero, *De oratore*, I, 14.
10 *De S. Felice Natalitium carmen*, X, 20.

middle entrance is inscribed with the holy names of the martyrs depicted); or else to indicate the passage of the author of the holy story which is represented, or even some short and significant quotations, taken from the same book of the author, and relevant to the action.

Finally, obscurity can come also from incompetence; because sometimes one tries to express things which by their nature can not be expressed, and are so recondite and difficult that one can not conveniently make people grasp them; such are the operations of spiritual beings, the secrets of Divine Providence, the mysteries of predestination, and so on: the safest remedy in this difficulty is to abstain from such subjects as much as possible, accepting them however internally with the faith, as we are admonished by St. Augustine with the words [11]: *Sunt quaedam quae sua vi non intelliguntur, aut vix intelliguntur, quantumvis plenissime dicentis versentur eloquio, quae in populi audientiam, vel raro si aliquid urget, vel nunquam omnino mittenda sunt* (There are things which can not be understood by themselves, or can hardly be understood, however eloquently they are exposed; these should be brought up in public either rarely when necessary, or not at all). Also, at times, things should be represented which, because of their great resemblance to others, can not be clearly distinguished by drawing, such as many kinds of plants, birds, fish, and animals.

But such obscurity can also come from or be increased by the restriction of the space where the painting is located, as the space would not actually contain the multitude of things that should be represented, unless mixed and pressed together; on the other hand, the restriction shrinks the drawing, which by nature would require a larger field, as is the case of a painter who had painted a running horse with the bit in its mouth on a tiny panel; when the patron who had commissioned the work complained that the painter had added the bit, he answered that in such a tiny space it had been necessary to put the bit in the animal's mouth lest it should burst out.

We do not, however, deny that an excellent artist could express whatever he wants effectively in a minute space, as we read of one *qui Alexandrum ex equo venantem et beluam ferientem finxerat, cuius magnitudo unguem digiti non superabat et tamen terrorem vultu incutiebat, et equus ipse consistere recusans arte moveri videbatur* [12] (who made a picture of Alexander hunting on horseback and wounding a beast, no larger than a fingernail; nevertheless, his face inspired terror and the horse itself, refusing to stop, seemed to be in motion by the strength of art). And Pliny tells of other astonishing examples.[13] But

11 *De doctrina christ.*, IV, 9.
12 Julian the Apostate, *Epist. ad Georg.*
13 *Natur. hist.*, VII, 21.

we mention this only as a notable exception, because it can not be accomplished by everybody, and because a proportionate space makes things more successful.

The Investigation of Veronese *

The examination of Paolo Veronese by the Holy Office was hardly a trial. The picture painted for the convent of SS. Giovanni e Paolo which was the origin of the convocation, represented a Last Supper or a Feast at the house of Simon (the subject does not seem to have been clear either to the painter, the monks, or the judges). In fact, the painter was not charged for his infidelity to the text but for the lack of decorum displayed in the picturesque accessories. Veronese did not comply with the order he had received to alter his work, but he was content, it seems, to change the title and make it the "Feast at the house of Levi."

The Inquisitors were much more lenient than Gilio in his concern for "historical truth." The rather liberal atmosphere of the discussion can be explained by the fact that in Venice, the Holy Office worked under an agreement which gave the Republic a part in the trial and a right to withhold the sentence.

One will notice that to protect himself, Veronese used Aretino's charges against the Last Judgment *in the Sistine; the Inquisitors then felt obliged to defend Michelangelo.*

Veronese Before the Holy Tribunal [1]

VENICE, JULY 18, 1573. *The minutes of the session of the Inquisition Tribunal of Saturday, the 18th of July, 1573.*

Today, Saturday, the 18th of the month of July, 1573, having been asked by the Holy Office to appear before the Holy Tribunal, Paolo Caliari of Verona, domiciled in the Parish Satin Samuel, being questioned about his name and surname, answered as above.

Questioned about his profession:

Answer: I paint and compose figures.

Question: Do you know the reason why you have been summoned?

A: No, sir.

Q: Can you imagine it?

A: I can well imagine.

Q: Say what you think the reason is.

* Cf. A. Baschet, *Paolo Veronese au tribunal du St-Office à Venise (1573)* (Paris: 1880); Percy H. Osmond, *Paolo Veronese* (London: 1927), pp. 68-70.

1 The translation and notes are borrowed from E. G. Holt, *Literary Sources of Art History* (Princeton: Princeton University Press, 1947), pp. 245-48. Reprinted by permission of Princeton University Press.

A: According to what the Reverend Father, the Prior of the Convent of SS. Giovanni e Paolo, whose name I do not know, told me, he had been here and Your Lordships had ordered him to have painted [in the picture] a Magdalen in place of a dog. I answered him by saying I would gladly do everything necessary for my honor and for that of my painting, but that I did not understand how a figure of Magdalen would be suitable there for many reasons which I will give at any time, provided I am given an opportunity.[2]

Q: What picture is this of which you have spoken?

A: This is a picture of the Last Supper that Jesus Christ took with His Apostles in the house of Simon.

Q: Where is this picture?

A: In the Refectory of the Convent of SS. Giovanni e Paolo.

Q: Is it on the wall, on a panel, or on canvas?

A: On canvas.

Q: What is its height?

A: It is about seventeen feet.

Q: How wide?

A: About thirty-nine feet.

Q: At this Supper of Our Lord have you painted other figures?

A: Yes, milords.

Q: Tell us how many people and describe the gestures of each.

A: There is the owner of the inn, Simon; besides this figure I have made a steward, who, I imagined, had come there for his own pleasure to see how the things were going at the table. There are many figures there which I cannot recall, as I painted the picture some time ago.

Q: Have you painted other Suppers besides this one?

A: Yes, milords.

Q: How many of them have you painted and where are they?

A: I painted one in Verona for the reverend monks at San Nazzaro[3] which is in their refectory. Another I painted in the refectory of the reverend fathers of San Giorgio here in Venice.[4]

Q: This is not a Supper. We are asking about a picture representing the Supper of the Lord.

A: I have painted one in the refectory of the Servi of Venice,[5] another

[2] Percy H. Osmond, *Paolo Veronese* (London: 1927), p. 68, calls attention to the fact that the report is merely notes, not a verbatim report. Paolo seems to be feigning ignorance and to have little interest in the doctrinal significance of his pictures, as is shown by his mention of omitting Magdalen and then naming the picture "The Last Supper that Jesus took with His Apostles in the house of Simon."

[3] *The Feast at the House of the Pharisee,* painted for the refectory of SS. Nazzaro e Celso, Verona, *ca.* 1560, Pinacoteca, Turin.

[4] *The Wedding Feast of Cana,* 1562-63, Louvre, Paris.

[5] *The Feast in the House of Simon, ca.* 1570, Louvre, Paris.

in the refectory of San Sebastiano in Venice.[6] I painted one in Padua for the fathers of Santa Maddalena and I do not recall having painted any others.

Q: In this Supper which you made for SS. Giovanni e Paolo what is the significance of the man whose nose is bleeding?

A: I intended to represent a servant whose nose was bleeding because of some accident.

Q: What is the significance of those armed men dressed as Germans, each with a halberd in his hand?

A: This requires that I say twenty words!

Q: Say them.

A: We painters take the same license the poets and the jesters take and I have represented these two halberdiers, one drinking and the other eating nearby on the stairs. They are placed there so that they might be of service because it seemed to me fitting, according to what I have been told, that the master of the house, who was great and rich, should have such servants.

Q: And that man dressed as a buffoon with a parrot on his wrist, for what purpose did you paint him on that canvas?

A: For ornament, as is customary.

Q: Who are at the table of Our Lord?

A: The Twelve Apostles.

Q: What is St. Peter, the first one, doing?

A: Carving the lamb in order to pass it to the other end of the table.

Q: What is the Apostle next to him doing?

A: He is holding a dish in order to receive what St. Peter will give him.

Q: Tell us what the one next to this one is doing.

A: He has a toothpick and cleans his teeth.

Q: Who do you really believe was present at that Supper?

A: I believe one would find Christ with His Apostles. But if in a picture there is some space to spare I enrich it with figures according to the stories.

Q: Did any one commission you to paint Germans, buffoons, and similar things in that picture?

A: No, milords, but I received the commission to decorate the picture as I saw fit. It is large and, it seemed to me, it could hold many figures.

Q: Are not the decorations which you painters are accustomed to add to paintings or pictures supposed to be suitable and proper to the subject and the principal figures or are they for pleasure—simply what comes to your imagination without any discretion or judiciousness?

A: I paint pictures as I see fit and as well as my talent permits.

6 *The Feast at the House of the Pharisee,* 1570, Brera, Milan.

Q: Does it seem fitting at the Last Supper of the Lord to paint buffoons, drunkards, Germans, dwarfs and similar vulgarities?

A: No, milords.[7]

Q: Do you not know that in Germany and in other places infected with heresy it is customary with various pictures full of scurrilousness and similar inventions to mock, vituperate, and scorn the things of the Holy Catholic Church in order to teach bad doctrines to foolish and ignorant people?

A: Yes that is wrong; but I return to what I have said, that I am obliged to follow what my superiors have done.

Q: What have your superiors done? Have they perhaps done similar things?

A: Michelangelo in Rome in the Pontifical Chapel painted Our Lord, Jesus Christ, His Mother, St. John, St. Peter, and the Heavenly Host. These are all represented in the nude—even the Virgin Mary—and in different poses with little reverence.

Q: Do you not know that in painting the Last Judgment in which no garments or similar things are presumed, it was not necessary to paint garments, and that in those figures there is nothing that is not spiritual? There are neither buffoons, dogs, weapons, or similar buffoonery. And does it seem because of this or some other example that you did right to have painted this picture in the way you did and do you want to maintain that it is good and decent?

A: Illustrious Lords, I do not want to defend it, but I thought I was doing right. I did not consider so many things and I did not intend to confuse anyone, the more so as those figures of buffoons are outside of the place in a picture where Our Lord is represented.

After these things had been said, the judges announced that the above named Paolo would be obliged to improve and change his painting within a period of three months from the day of this admonition and that according to the opinion and decision of the Holy Tribunal all the corrections should be made at the expense of the painter and that if he did not correct the picture he would be liable to the penalties imposed by the Holy Tribunal. Thus they decreed in the best manner possible.

Michelangelo: Sonnet

This sonnet was sent to Vasari in 1554 by Michelangelo together with his refusal of an offer from the Grand Duke, who wanted him in

[7] A. Baschet, "Paolo Veronese," *Gazette des Beaux-Arts*, XXIII (1867), p. 382, has here the following, omitted in this text:

 Q: Why did you do it then?

 A: I did it because I supposed these people were outside the room in which the supper took place.

Florence. The poem, however, was probably written some time before (1552?), and is known in six different versions.

A careful reading shows that the poem does not express the artist's decision to abandon art, but his dissatisfaction with the vanities of painting and sculpture; it reveals a religious experience, or rather a longing for religious experience which made its influence strongly felt in Michelangelo's latest works.

Sonnet (1554) [1]

My course of life already has attained,
Through stormy seas, and in a flimsy vessel,
The common port, at which we land to tell
All conduct's cause and warrant, good or bad,

So that the passionate fantasy, which made
Of art a monarch for me and an idol,
Was laden down with sin, now I know well,
Like what all men against their will desired.

What will become, now, of my amorous thoughts,
Once gay and vain, as toward two deaths I move,
One known for sure, the other ominous?

There's no painting or sculpture now that quiets
The soul that's pointed toward that holy Love
That on the cross opened Its arms to take us.

[1] Sonnet No. 283 in *Complete Poems and Selected Letters of Michelangelo,* trans. and notes by Creighton Gilbert (New York: Random House, Inc., 1963), p. 159. Reprinted by permission of the publisher.

/

7

Artists,
Amateurs, and Collectors
in the Second Half
of the Century

INTRODUCTION

One of the characteristics of mannerism in the second half of the 16th century is its strong historical consciousness. Artists became accustomed to considering the past both as a period of progress in the arts and as a repertory of heroic examples and of distinct "manners" among which one could choose. In addition there emerged an ever growing feeling that the quality of art had been declining since the High Renaissance. Vasari had made all this very clear for his many readers and had taught them how to look at the art of their own time as through the eyes of a future historian.

Many of the texts left us by the second mannerist generation bear witness to this state of mind. Several artists, feeling a need to justify themselves in the eyes of their contemporaries and of posterity, attempted some form of autobiography. Cellini's, by far the most complete example, is a masterpiece of Italian literature and a mine of information (p. 138); his rival, Bandinelli, left at least some reminiscences, a sort of literary self-portrait (p. 146); others are known: Raffaele da Montelupo's, Lomazzo's (in verse), to which should be added many diaries and ricordi, Fed. Zuccaro's travelogue, Vincenzo Danti's lost autobiography, Vasari's and Zucchi's descriptions of their own works. Other artists imitated Vasari and became art historians or biographers: Condivi on Michelangelo, Marco da Pino on the art of Naples. Historical disquisitions and anecdotes became almost obligatory in theoretical treatises. Whoever writes on art has read Vasari and uses him, sometime with violent reactions, like Lamo (p. 150). Lomazzo tries to go beyond him by an effort at systemization (Idea, ch. 9).

By then, the great majority of writings on art came from artists. Earlier, professionals had excused themselves for writing without having a literary training; now men of letters were embarrassed to be writing about art without being artists. Raffaele Borghini shows us, in the figure of Bernardo Vecchietti, a type of amateur readier to learn than to give advice (p. 153). The new public made up of such men gave rise to a specialized literature within its reach, in particular guidebooks for artistic cities, like Fr. Sansovino's Dialogo di tutte le cose notabile che sono in Venezia (1556, often reprinted), Bocchi's Bellezze di Firenze, or the many guidebooks of Rome.

The humanist was no longer the artists' teacher, and could contribute little besides iconographic programs, for which he was often solicited (p. 155). But the cultured collector asked an artist's advice on his acquisitions, and, on the other hand, ambitious artists sought the friend-

ship of poets and writers in much the same way and for much the same reason as they would today that of critics.

The living conditions of artists were hard. The atmosphere of courts was a stifling one because of envy and constant intrigue, particularly in Florence (p. 165). Michelangelo, with a prestige so great that each of his moves was watched by everyone and assumed an almost political importance, was overburdened with requests and responsibilities (p. 167). The young—too numerous, insufficiently trained, and underemployed—stopped taking art seriously (p. 167). The competition of the market embittered the relations among artists to the point of open fights and legal suits (Zuccaro's trial, p. 168).

To put an end to this deplorable state of affairs, academies were created in Florence, Rome, and, shortly afterwards, almost everywhere else. Federico Zuccaro, who had suffered more than anyone from the wretchedness of artistic life, advocated the multiplication of academies in his Letter to Princes *(1605). The situation was such that his appeal had to be heard.*

Cellini: Casting the Perseus

Cellini's Autobiography *(Vita scritta da lui medesimo) was written between 1558 and 1566, and published for the first time in 1728. It is a work of exceptional literary value and is an inestimable source of knowledge of artistic life in different centers—Florence, Rome, Paris—although, as is well known, his facts are often drastically twisted and dramatized. The famous episode of the casting of the* Perseus, *his most celebrated statue, which stands in the Loggia de' Lanzi in Florence, was also narrated another time by Cellini himself* (Trattato della Scultura, ch. 3); *on the whole, the two versions agree.*

Some technical commentary is necessary to understand the narration (cf. in particular ch. 1-4 of the Trattato della Scultura). *Cellini used the technique called lost wax in its simplest form, which is also the riskiest because, if the cast is not successful, the model is lost. This explains the nervous tension of the artist.*

First one makes a clay core (anima) *which approximates the shape of the statue; it is completed with a layer of wax which is given the exact appearance of the finished work. The figure is then wrapped in a "cloak" made with a specially prepared clay, and the solidity of the whole is secured by a system of iron rods and circles. One heats the figure so that the wax melts and runs out through holes pierced in the "cloak." Then the empty mold is baked in a kiln built around it for this purpose* (manica).

Afterwards the molten metal must be poured into the space left by

the wax between the core and the cloak. For this, one buries the mold in a pit while arranging pipes to pour the bronze and let out the air. The metal (copper and pewter) is melted in a furnace and conveyed to the mold through buried pipes and channels. Once the metal is poured, one has only to wait for it to cool to dig out the mold, break it, and repair the defects of the cast.

The few pages which precede the actual narration illustrate the relations between Cellini and Grand Duke Cosimo, or at least convey the idea that the artist wanted to give the reader of his difficulties with his patron. One will notice the rather low level of this admirable practitioner's scientific notions.

From Cellini's Autobiography [1]

LXIII

Having succeeded so well with the cast of the Medusa, I had great hope of bringing my Perseus through; for I had laid the wax on, and felt confident that it would come out in bronze as perfectly as the Medusa. The waxen model produced so fine an effect, that when the Duke saw it and was struck with its beauty—whether somebody had persuaded him it could not be carried out equally well in metal, or whether he thought so for himself—he came to visit me more frequently than usual, and on one occasion said: "Benvenuto, this figure cannot succeed in bronze; the laws of art do not admit of it." These words of his Excellency stung me so sharply that I answered: "My Lord, I know how very little confidence you have in me; and I believe the reason of this is that your most illustrious Excellency lends too ready an ear to my calumniators, or else indeed that you do not understand my art." He hardly let me close the sentence when he broke in: "I profess myself a connoisseur, and understand it very well indeed." I replied immediately, saying "Yes, like a prince, not like an artist; for if your Excellency understood my trade as well as you imagine, you would trust me on the proofs I have already given. These are, first, the colossal bronze bust of your Excellency, which is now in Elba [2]; secondly, the restoration of the Ganymede in marble, which offered so many difficulties and cost me so much trouble, that I would rather have made the whole statue new from the beginning [3]; thirdly, the Medusa, cast by me in bronze, here now before your Excellency's eyes, the execution of which was a greater triumph of strength and skill than any of my predecessors in this fiendish art have yet

[1] *The Life of Benvenuto Cellini,* English translation by John A. Symonds (New York: 1906), ch. 73, 255-269.

[2] Executed between 1543 and 1548. Today in Florence, Bargello.

[3] 1545-1554.

achieved. Look you, my lord! I constructed that furnace anew on principles quite different from those of other founders [4]; in addition to many technical improvements and ingenious devices, I supplied it with two issues for the metal, because this difficult and twisted figure could not otherwise have come out perfect. It is only owing to my insight into means and appliances that the statue turned out as it did; which was judged impossible by all the practitioners of this art. I should like you furthermore to be aware, my lord, for certain, that the sole reason why I succeeded with all those great and arduous works in France under his most admirable Majesty King Francis, was the high courage which that good monarch put into my heart by the liberal allowances he made me, and the multitude of workpeople he left at my disposal. I could have as many as I asked for, and employed at times above forty, all chosen by myself. These were the causes of my having there produced so many works in so short a space of time. Now then, my lord, put trust in me; supply me with the aid I need. I am confident of being able to complete a work which will delight you. But if your Excellency goes on disheartening me, and does not advance me the assistance which is absolutely required, neither I nor any man alive upon this earth can hope to achieve the slightest thing of value."

LXXIV

It was as much as the Duke could do to stand by and listen to my pleadings. He kept turning first this way and then that; while I, in despair, poor wretched I, was calling up remembrance of the noble state I held in France, to my great sorrow. All at once he cried: "Come, tell me, Benvenuto, how is it possible that yonder splendid head of Medusa, so high up there in the grasp of Perseus, should ever come out perfect?" I replied upon the instant: "Look you now, my lord! If your Excellency possessed that knowledge of the craft which you affirm you have, you would not fear one moment for the splendid head you speak of. There is good reason, on the other hand, to feel uneasy about this right foot, so far below and at a distance from the rest." When he heard these words, the Duke turned, half in anger, to some gentlemen in waiting, and exclaimed: "I verily believe that this Benvenuto prides himself on contradicting everything one says." Then he faced round to me with a touch of mockery, upon which his attendants did the like, and began to speak as follows: "I will listen patiently to any argument you can possibly produce in explanation of your statement, which may convince me of its probability." I said in answer: "I will adduce so sound an argument that your Excellency shall perceive the full force of it." So I began: "You must

[4] Cf. *Trattato della Scultura*, chap. IV.

know, my lord, that the nature of fire is to ascend, and therefore I promise you that Medusa's head will come out famously; but since it is not in the nature of fire to descend, and I must force it downwards six cubits by artificial means, I assure your Excellency upon this most convincing ground of proof that the foot cannot possibly come out. It will, however, be quite easy for me to restore it." "Why, then," said the Duke, "did you not devise it so that the foot should come out as well as you affirm the head will?" I answered: "I must have made a much larger furnace, with a conduit as thick as my leg; and so I might have forced the molten metal by its own weight to descend so far. Now, my pipe, which runs six cubits to the statue's foot, as I have said, is not thicker than two fingers. However, it was not worth the trouble and expense to make a larger; for I shall easily be able to mend what is lacking. But when my mold is more than half full, as I expect, from this middle point upwards, the fire ascending by its natural property, then the heads of Perseus and Medusa will come out admirably; you may be quite sure of it." After I had thus expounded these convincing arguments, together with many more of the same kind, which it would be tedious to set down here, the Duke shook his head and departed without further ceremony.

LXXV

Abandoned thus to my own resources, I took new courage, and banished the sad thoughts which kept recurring to my mind, making me often weep bitter tears of repentance for having left France; for though I did so only to revisit Florence, my sweet birthplace, in order that I might charitably succor my six nieces, this good action, as I well perceived, had been the beginning of my great misfortune. Nevertheless, I felt convinced that when my Perseus was accomplished, all these trials would be turned to high felicity and glorious well-being.

Accordingly I strengthened my heart, and with all the forces of my body and my purse, employing what little money still remained to me, I set to work. First I provided myself with several loads of pinewood from the forests of Serristori, in the neighborhood of Montelupo. While these were on their way, I clothed my Perseus with the clay which I had prepared many months beforehand, in order that it might be duly seasoned.[5] After making its clay tunic (for that is the term used in this art) and properly arming it and fencing it with iron girders, I began to draw the wax out by means of a slow fire. This melted and issued through numerous air-vents I had made; for the more there are of these, the better will the mold fill. When I had finished drawing off the wax, I

[5] The preparation of this clay in which one had to let some cloth rot for several months is described in the *Trattato*, ch. II.

constructed a funnel-shaped furnace all round the model of my Perseus.[6]
It was built of bricks, so interlaced, the one above the other, that nu-
merous apertures were left for the fire to exhale at. Then I began to
lay on wood by degrees, and kept it burning two whole days and nights.
At length, when all the wax was gone, and the mold was well baked, I
set to work at digging the pit in which to sink it. This I performed with
scrupulous regard to all the rules of art. When I had finished that part
of my work, I raised the mold by windlasses and stout ropes to a per-
pendicular position, and suspending it with the greatest care one cubit
above the level of the furnace, so that it hung exactly above the middle
of the pit, I next lowered it gently down into the very bottom of the
furnace, and had it firmly placed with every possible precaution for its
safety. When this delicate operation was accomplished, I began to bank
it up with the earth I had excavated; and, ever as the earth grew higher,
I introduced its proper air-vents, which were little tubes of earthenware,
such as folk use for drains and such-like purposes. At length, I felt sure
that it was admirably fixed, and that the filling-in of the pit and the
placing of the air-vents had been properly performed. I also could see
that my work-people understood my method, which differed very con-
siderably from that of all the other masters in the trade. Feeling con-
fident, then, that I could rely upon them, I next turned to my furnace,
which I had filled with numerous pigs of copper and other bronze stuff.
The pieces were piled according to the laws of art, that is to say, so
resting one upon the other that the flames could play freely through
them, in order that the metal might heat and liquefy the sooner. At last
I called out heartily to set the furnace going. The logs of pine were
heaped in, and, what with the unctuous resin of the wood and the good
draught I had given, my furnace worked so well that I was obliged to
rush from side to side to keep it going. The labor was more than I could
stand; yet I forced myself as much as I could. To increase my anxieties,
the workshop took fire, and we were afraid lest the roof should fall
upon our heads; while, from the garden, such a storm of wind and rain
kept blowing in, that it perceptibly cooled the furnace.

Battling thus with all these untoward circumstances for several
hours, and exerting myself beyond even the measure of my powerful
constitution, I could at last bear up no longer, and a sudden fever, of the
utmost possible intensity, attacked me. I felt absolutely obliged to go
and fling myself upon my bed. Sorely against my will having to drag my-
self away from the spot, I turned to my assistants, about ten or more in
all, what with master-founders, hand-workers, country fellows, and my
own apprentices, among whom was Bernardino Mannellini of Mugello,

6 *Manica.* See introduction.

my apprentice through several years. To him in particular I spoke: "Look, my dear Bernardino, that you observe the rules which I have taught you; do your best with all despatch, for the metal will soon be fused. You cannot go wrong; these honest men will get the channels ready; you will easily be able to drive back the two plugs with this pair of iron crooks; and I am sure that my mold will fill miraculously.[7] I feel more ill than I ever did in all my life, and verily believe that it will kill me before a few hours are over." Thus, with despair at heart, I left them, and betook myself to bed.

LXXVI

No sooner had I got to bed, than I ordered my serving-maids to carry food and wine for all the men into the workshop; at the same time I cried: "I shall not be alive to-morrow." They tried to encourage me, arguing that my illness would pass over, since it came from excessive fatigue. In this way I spent two hours battling with the fever, which steadily increased, and calling out continually: "I feel that I am dying." My housekeeper, who was named Mona Fiore da Castel del Rio, a very notable manager and no less warmhearted, kept chiding me for my discouragement; but, on the other hand, she paid me every kind attention which was possible. However, the sight of my physical pain and moral dejection so affected her, that, in spite of that brave heart of hers, she could not refrain from shedding tears; and yet, so far as she was able, she took good care I should not see them. While I was thus terribly afflicted, I beheld the figure of a man enter my chamber, twisted in his body into the form of a capital S. He raised a lamentable, doleful voice, like one who announces their last hour to men condemned to die upon the scaffold,[8] and spoke these words: "O Benvenuto! your statue is spoiled, and there is no hope whatever of saving it." No sooner had I heard the shriek of that wretch than I gave a howl which might have been heard from the sphere of flame. Jumping from my bed, I seized my clothes and began to dress. The maids, and my lad, and every one who came around to help me, got kicks or blows of the fist, while I kept crying out in lamentation: "Ah! traitors! enviers! This is an act of treason, done by malice prepense! But I swear by God that I will sift it to the bottom, and before I die will leave such witness to the world of what I can do as shall make people marvel."

When I had got my clothes on, I strode with soul bent on mischief

[7] The plugs (*spine*) are the opertures of the kiln through which one poured the bronze; they were controlled by iron crooks (*mandriani*).

[8] More precisely: like those who must spiritually assist people sentenced to death during their last moments (*coloro che danno il commandamento a quei che hanno andare a giustizia*). In Florence, this was the duty of a particular religious confraternity.

toward the workshop; there I beheld the men, whom I had left erewhile in such high spirits, standing stupefied and downcast. I began at once and spoke: "Up with you! Attend to me! Since you have not been able or willing to obey the directions I gave you, obey me now that I am with you to conduct my work in person. Let no one contradict me, for in cases like this we need the aid of hand and hearing, not of advice." When I had uttered these words, a certain Maestro Alessandro Lastricati [9] broke silence and said: "Look you, Benvenuto, you are going to attempt an enterprise which the laws of art do not sanction, and which cannot succeed." I turned upon him with such fury and so full of mischief, that he and all the rest of them exclaimed with one voice: "On then! Give orders! We will obey your least commands, so long as life is left in us." I believe they spoke thus feelingly because they thought I must fall shortly dead upon the ground. I went immediately to inspect the furnace, and found that the metal was all curdled; an accident which we express by "being caked." I told two of the hands to cross the road, and fetch from the house of the butcher Capretta, a load of young oak-wood, which had lain dry for above a year; this wood had been previously offered me by Madame Ginevra, wife of the said Capretta. So soon as the first armfuls arrived, I began to fill the grate beneath the furnace.[10] Now oak-wood of that kind heats more powerfully than any other sort of tree; and for this reason, where a slow fire is wanted, as in the case of gun-foundry, alder or pine is preferred. Accordingly, when the logs took fire, oh! how the cake began to stir beneath that awful heat, to glow and sparkle in a blaze! At the same time I kept stirring up the channels, and sent men upon the roof to stop the conflagration, which had gathered force from the increased combustion in the furnace; also I caused boards, carpets, and other hangings to be set up against the garden, in order to protect us from the violence of the rain.

LXXVII

When I had thus provided against these several disasters, I roared out first to one man and then to another: "Bring this thing here! Take that thing there!" So, when the whole gang saw the cake was on the point of melting, they did my bidding, each fellow working with the strength of three. I then ordered half a pig of pewter to be brought, which weighed about sixty pounds, and flung it into the middle of the cake inside the furnace. By this means, and by piling on wood and stirring

[9] Sculptor and bronze caster; documents prove that he was employed by Cellini for the casting of the Medusa's head.

[10] *Bracciaiuola*, the pit arranged to receive the cinders and coals fallen from the furnace; Cellini fills it with wood to which he sets fire.

now with pokers and now with iron rods, the curdled mass rapidly began to liquefy. Then, knowing I had brought the dead to life again, against the firm opinion of those ignoramuses, I felt such vigor fill my veins, that all those pains of fever, all those fears of death, were quite forgotten.

All of a sudden an explosion took place, attended by a tremendous flash of flame, as though a thunderbolt had formed and been discharged amongst us. Unwonted and appalling terror astonied every one, and me more even than the rest. When the din was over and the dazzling light extinguished, we began to look each other in the face. Then I discovered that the cap of the furnace had blown up, and the bronze was bubbling over from its source beneath. So I had the mouths of my mold immediately opened, and at the same time drove in the two plugs which kept back the molten metal. But I noticed that it did not flow as rapidly as usual, the reason being probably that the fierce heat of the fire we kindled had consumed its base alloy. Accordingly I sent for all my pewter platters, porringers, and dishes, to the number of some two hundred pieces, and had a portion of them cast, one by one, into the channels, the rest into the furnace. Now every one could perceive that my bronze was in most perfect liquefaction, and my mold was filling; whereupon they all with heartiness and happy cheer assisted and obeyed my bidding, while I, now here, now there, gave orders, helped with my own hands, and cried aloud: "O God! Thou that by Thy immeasurable power didst rise from the dead, and in Thy glory didst ascend to heaven!" [11] . . . even thus in a moment my mold was filled; therefore, I fell upon my knees, and with all my heart gave thanks to God.

After all was over, I turned to a plate of salad on a bench there, and ate with hearty appetite, and drank together with the whole crew. Afterwards I retired to bed, healthy and happy, for it was now two hours before morning, and slept as sweetly as though I had never felt a touch of illness. My good housekeeper, without my giving any orders, had prepared a fat capon for my repast. So that, when I rose, about the hour for breaking fast, she presented herself with a smiling countenance, and said: "Oh! is that the man who felt that he was dying? Upon my word, I think the blows and kicks you dealt us last night, when you were so enraged, and had that demon in your body as it seemed, must have frightened away your mortal fever! The fever feared that it might catch it too, as we did!" All my poor household, relieved in like measure from anxiety and overwhelming labor, went at once to buy earthen vessels in order to replace the pewter I had cast away. Then we dined together joyfully; nay, I

[11] Apparently, Cellini means to compare the "resurrection" of his Perseus to that of the Lord.

cannot remember a day in my whole life when I dined with greater glad-
ness or a better appetite. . . .

<p style="text-align:center">* * *</p>

After I had let my statue cool for two whole days, I began to uncover
it by slow degrees. The first thing I found was that the head of Medusa
had come out most admirably, thanks to the air-vents; for, as I had told
the Duke, it is the nature of fire to ascend. Upon advancing farther, I dis-
covered that the other head, that, namely, of Perseus, had succeeded no
less admirably; and this astonished me far more, because it is at a consid-
erably lower level than that of the Medusa. Now the mouths of the mold
were placed above the head of Perseus and behind his shoulders; and I
found that all the bronze my furnace contained had been exhausted in
the head of this figure.[12] It was a miracle to observe that not one frag-
ment remained in the orifice of the channel, and that nothing was want-
ing to the statue. In my great astonishment I seemed to see in this the
hand of God arranging and controlling all.

I went on uncovering the statue with success, and ascertained that
everything had come out in perfect order, until I reached the foot of the
right leg on which the statue rests. There the heel itself was formed, and
going farther, I found the foot apparently complete. This gave me great
joy on the one side, but was half unwelcome to me on the other, merely
because I had told the Duke that it could not come out. However, when
I reached the end, it appeared that the toes and a little piece above them
were unfinished, so that about half the foot was wanting. Although I
knew that this would add a trifle to my labor, I was very well pleased,
because I could now prove to the Duke how well I understood my busi-
ness. It is true that far more of the foot than I expected had been perfectly
formed; the reason of this was that, from causes I have recently described,
the bronze was hotter than our rules of art prescribe; also that I had
been obliged to supplement the alloy with my pewter cups and platters,
which no one else, I think, had ever done before.

Bandinelli as a Nobleman-Artist

B. Bandinelli's Memoriale *comprises 50 pages dictated by the artist
to his son Cesare; it is a speech to his sons, a kind of spiritual testament,
the composition of which, begun in 1552, must have gone on for several
years. While the* Ricordi *of previous artists noted mainly family or public*

12 It is, of course, at the edge of the pipes that one notices if one has introduced
too much or too little metal in the mold.

*events, commissions, and payments, Bandinelli seemed more interested in
painting a general picture of himself, his ancestry and supposed nobility,
and all the marks of his social success. The central episode is not made up
of his artistic accomplishments but of his admission to the order of Saint
James. This was a very high distinction and only noblemen had access to
it; Bandinelli was certainly the first artist to be thus honored. A century
later it was also the most important event in the life of Velasquez who had
the greatest difficulty in obtaining that honor and the greatest pride in
having received it. Bandinelli, a by no means negligible artist, though
often disregarded, was altogether a quite colorful figure. He was the very
prototype of the court artist; loathed by most of his fellow artists, he was
maintained in a high position only by the favor of the Medici.*

From Bandinelli's *Memoirs* [1]

I shall only speak about the distinctions I have obtained through
my other particular studies for which I would have had the greatest
inclination if I had had more time—for I can say that I must study at
night and stealthily—or if fortune had given me some of those goods
which my ancestors once spent too readily, especially the Cavaliere Fran-
cesco who, when he was knighted, displayed the munificence of a royal
hand rather than of a private knight, so that, having accumulated debts
in Siena, he was in great part the cause for the fall of our house, in ad-
dition to the errors of Viviano,[2] who almost entirely ruined it.

As I had an intense desire to regain some luster for my family, I
took the occasion of Charles V's visit to Italy, the year when he was
crowned by Clement VII in Bologna and when the state of Milan was
restored to Francesco Sforza,[3] and asked the Emperor to make me a
knight of Saint James, the Pope whom I had accompanied on this occa-
sion as his courtier having attested to him that I was born of the very
ancient and noble blood of the Bandinelli from Siena, and that Pope
Alexander III, who fought against Frederick Barbarossa, was of my
house.[4] But because many princes and lords who wore the habit of St.
James opposed this, saying ignorantly that as a sculptor I was not eligible,
without regard to the fact that painting and sculpture were practiced
by the Fabii [5] and other noble people and that in a nobleman any art
is noble; thus in Thebes Epaminondas ennobled a very low office by

[1] Published by Arduino Colasanti in *Repertorium für Kunstwissenschaft* (1905),
XXVIII, 406-443.

[2] Bandinelli's grandfather.

[3] 1530.

[4] Bandinelli's noble origin appears to have been invented by him.

[5] On Fabius Pictor, Pliny, *Nat. His.*, XXXV, 19. This is a traditional example.

practicing it.[6] But the Pope proposed to the Emperor that I should give the due proofs, according to the rules, whereupon the Emperor said to me: *"Si provereis que sois noble, os dare el avito"* (If you prove you are a nobleman, I shall give you the habit). Then he ordered his courtier Don Garcia Manriquez to come to Florence and in his position as knight and Commander of the Order of Saint James to investigate and, this being done, to send the result to him. Whereupon, having gone with him to Florence and having received him in my house which I had entrusted to my great friend Antonio Francesco Doni [7] who was staying in Florence, and since I could not go to Siena lest I should leave the said Lord Commander, I wrote a pressing letter to Niccolo, Belisario, and other Bandinellis in Siena so that they would be ready to give a public and written testimony that I was a descendent of Count Bandinelli through Francesco di Bandinelli who had come to Florence, and that I was, therefore, of their very own blood. I begged the said Messer Antonio Francesco Doni to take these letters and arrange to send them, and thus they left on January 10, 1530. Then they were delivered in Siena and after a few days the Bandinellis wrote the document requested, proving that I was one of them, which was notarized (. . .) with the attestation and validation of the Captain of the people,[8] and it was in good form. I kept a copy and gave the document to Signore Don Garcia along with other documents concerning the same business, together with a recommendation from the Medici; Don Garcia was convinced and perfectly satisfied, and we left together for Rome, and from there sent the documents to the Emperor. He and the Lords, members of the Order, were convinced by the proofs of my nobility; His Imperial Majesty sent me the privilege signed by Him from Innsbruck in Tyrol, so that the habit would be given to me . . . And thus I received the habit in the chapel of the Holy Palace of the Vatican, in the presence of three cardinals, Salviati, Ridolfi, and Sta Maria in Portico [9] who wanted to show me their favor; the Chaplain of the Emperor said the mass; Don Garcia Manriquez passed me the spurs, Don Ferrante Caracciolo, the sword, in the presence of Signore Jacopo Biusco and other knights of the Order of Saint James. Then, after the very solemn ceremony, the Cardinal of Sta Maria in Portico invited me to dinner with the other knights. . . .

Afterwards, the Emperor graciously granted that I should not have

[6] Cornelius Nepos explains at length to his Roman readers that Epaminondas did not disgrace himself by learning music and dance. But he did not practice them professionally, and, moreover, was not a nobleman.

[7] Anton Francesco Doni, the well-known writer and printer, born in 1503.

[8] *Capitano del popolo,* a magistrate whose functions were identified, in the literature of the time, with those of a Roman tribune.

[9] Cardinal of Sta Maria in Portico was no longer Bibbiena, Raphael's friend, but his successor, the Prothonotary Apostolic Francesco Pisano.

to go to Vales in Spain [10] and that I could profess myself in Rome. In 1536 Emperor Charles V was in this city again, and when I went to kiss His Majesty's coat, he told me: *"Yo os è dado un avito y crux de Principes"* ("I have given you a habit and cross of Princes"). To which I answered: "It is true, unvanquished Caesar; but Your Imperial Majesty should enable me to wear it like a prince." Turning to some Lords he laughed and replied: *"Mucho sabe esto Cavallero"* ("This is a very smart Knight"). But in spite of all, I was not able, either then or later, to obtain pension or commissions or any donation in connection with the habit, although he showed some signs of being well disposed to me, and in spite of the entreaties of the said Don Garcia, Sgr. D. Francisco de Cobos,[11] and the Bishop of Mâcon, then ambassador of the Most Christian King.

. . . Also note that, though there are some highly praised paintings from my hand, this was never the principal direction of my talent, as I have said and written many times to Their Excellencies; [12] among these paintings, I ask you to have particular regard for the picture which I leave for you in the house, in which I have painted myself with the help of a mirror; in keeping it, remember me and pray for my soul.[13]

I principally applied myself to drawing, in which I was outstanding in the judgment of Michelangelo, of our Princes, and of the best people; Their Excellencies have a great many of my drawings, others were sent to Germany and to France, and others scattered through Italy, some of which I know to have been sold for as much as two hundred scudi; [14] some, also, have been printed, like Saint Lawrence in Rome on his grill, the Deposition from the Cross and others; besides all those I leave you almost a chestful of them, which you will keep as so many jewels; and do not let them go, because the time will come when they will be worth treasures; and God bless you. There appeared one error, however, in the engraving of St. Lawrence, when the engraver, instead of engraving Band., engraved Brand., whence many people who did not know interpreted it as Brandi, Brandini and Brandinelli. For that reason I had another smaller and better one printed, with the full name Bandinelli.[15]

It also occurs to me to tell you, my sons, that many people, and

10 Vales is unexplainable; the mother establishment of the Order was in Leon.

11 Francisco de los Cobos was one of Charles V's most important advisers.

12 The phrase imitates, probably on purpose, Michelangelo's well-known apology for the Sistine ceiling. "Their Excellencies" are Grand Duke Cosimo and his wife.

13 Today in the Uffizi, Florence.

14 Bandinelli's drawings were really highly valued, and their price was constantly increasing during the second half of the 16th century.

15 In fact the artist was called Brandini and changed to Bandinelli to assume the relation described above with a noble Sienese family. The *Martyrdom of Saint Lawrence* is one of Marcantonio's most famous engravings (1524-25); we have not traced any copy with the name Bandinelli; it is hard to imagine that it might be better than Marcantonio's except for the improvement in the name.

particularly the good Buoniaruoti,[16] whose judgement I respected above all others because he was a connoisseur and because he was not motivated by malice, blamed me sometimes because, once I had started and carefully drawn my more important works, I let Rossi, Ammannati, Clemente, and others have a hand in them. I do not deny that in a great measure he was right, because it may be that the works did not come out with that great perfection which they would have had with my own hand, but one must consider that I had and have always had, many troubles in which, in addition to the illnesses and the family cares of my house and my children, my studies had a good part.[17] I had, as I told you already, a great inclination for studies, which brought me much honor on several occasions, particularly in history and poetry, as I have remarked to you, having written many compositions in the vernacular as well as some in Latin, although few; among the latter, for instance, is the one addressed to Signor Don Pietro di Pina of the Order and Chaplain of the Emperor Charles, from whom I received the habit; [18] this I composed in my own honor, after having taken the holy communion, and before taking the habit. . . .

A Cremonese Vasari

Vasari's example was fruitful; if the general history of Italian art had been treated by him in a manner obviously unsurpassable, the field was open for local art historians who imitated Vasari while reacting against his alleged partiality. Alessandro Lamo's Discorso intorno alla scultura e pittura, Cremona, 1584 (with the significant sub-title dove si ragiona della vita ed opere . . . fatte dall'eccell. e nob. M. Bernardino Campo, and with a text by Campi himself as an appendix) is the first example of such historical works. One finds in it the Vasarian combination of theoretical pretension, serious documentation, and briskly narrated anecdotes; but Lamo's work is on a much inferior level and betrays excessively encomiastic intentions.

From Lamo's Discourse on Sculpture and Painting [1]

Ah Vasari, Camillo Boccaccini's works [2] seem small things to you, and of little importance? The works which have amazed and still amaze

16 *Sic.* Bandinelli stresses the etymological meaning "good whetstone," perhaps not unintentionally. The same play on words can be found elsewhere; cf. *Esequie del divino Michelangelo Buonarroti*, ed. Wittkower (London, 1964), p. 30. In view of the Florentines' general admiration for Michelangelo and the partiality of the Grand Duke himself, Bandinelli could only minimize his quarrel with the master and invent a flattering rebuke.

17 Another commonplace: this is a characteristic of the ideal image of the artist.

18 The Order and habit of Saint James.

1 Lamo, *Discorso, op. cit.,* pp. 33-34.

2 Camillo Boccaccino was probably born in 1501 and not, as Lamo says, 1511. He died in 1546; his works in San Sigismondo in Cremona were executed around 1537.

the greatest painters in the world, what were you thinking about when you were shown some of them and judged them? Where was your wish to be unfair to no man's talent when you made no effort to see the rest of his work, which you did not know and which would have easily obscured the fame of those who are so highly praised in your *Lives* as the ultimate masters of the Art? The paintings of Camillo are alive, they are a mirror and example of how to paint well for the most famous artists of Italy. Say, why, since you praised Michelangelo's *Jonah* in the Sistine Chapel so much, why did you not praise, if not in everything at least on some point, the *St. John* painted by Camillo in the apse of S. Sigismondo? Does it not make a more beautiful and livelier effect than that of Michelangelo's *Jonah*? Does not *St. John* seem to turn completely backwards to look at the sky in spite of the vaulting? This figure alone would merit your celebrating it at length; you have not, however, even deigned to mention it. By God, tell me without passion whether Art itself can do better, can Nature create more beautiful and well proportioned bodies, can real little children, to raise a weight, force their own weakness with more beautiful and varied gestures than the little putti who try to carry the Cross in the octagon on the front of the organ loft in the Church of S. Sigismondo? In fact, you have not harmed Camillo's merit so much as your own *History*, for the former will be well known and praised for ever, while the latter will be reprehended and blamed by sound judges at least for this if for no other reason. But why speak further of this?

As for the figures painted by Camillo above a shop on the Piazza of the City of Cremona, which you have barely deigned to mention, did they not deserve to retain for a while the attention of your sound mind and of your pen to examine them and describe the qualities of the design, their perfection, their colors and their finish, since they deserved to be contemplated by His Imperial Majesty Charles V? You say that Camillo's style was ample and free, but you do not say that if Michelangelo had died young he would not have left us any painting. Camillo died at thirty five, when his value had just begun to become known, and nevertheless he has left us so many studies for paintings he had started, that they sold for hundreds of scudi, and our Campi, who understood their outstanding quality very well, did not shrink from any expense to obtain them.

THE YOUTH OF BERNARDINO CAMPI [3]

At the time that Camillo Boccaccino, Bernardo Gatto called Sogliaro,[4] and Giulio Campi, three bright stars and shining lights of Paint-

[3] *Discorso*, pp. 28-29.

[4] Bernardo Gatto called Soiaro, c.1495-1575; Giulio Campi, active from 1525, died 1572; and Bernardino Campi, born 1522, died after 1584; brought to the Cremonese school the influence of Parma and of Pordenone.

ing, illustrated the city of Cremona, their home, with most brilliant rays of honor, there was born there in 1522 Bernardino Campo, son of Pietro, a goldsmith who was highly esteemed at that time for his talents as well as for his good character. As is usual with fathers, once his young son had easily learned how to read and write, he made him apply his talent to his own occupation of designing and making works in low relief which any excellent goldsmith must know how to do. But Heaven, which had given the youngster an inclination for a more beautiful and noble profession, arranged that in his first years he should see, with mature judgment rather than puerile eyes, canvases where Giulio Campi had painted the *Annunciation* and the *Adoration of the Magi,* after compositions by Raphael, to make tapestries for the canons of Santa Maria della Scala in Milan; [5] this inflamed his mind with noble enterprises, and he was so enthused by Painting that he easily obtained permission from his father to give more time to the study of both painting and drawing. Whereupon, the child showing signs of alertness and giving hopes for excellent results, he was confided by Pietro to Giulio Campo so that the latter would teach him the elements of painting. He was glad to accept the youngster, readily promising to look after the child as he would after his own son, and to introduce him to the profession. But he was unable to put his good intention into effect because, keeping shop like ordinary painters, although he was very well-known and esteemed as an excellent master, he was forced by his many works to occupy the talent of Bernardino with things of little value,[6] and unworthy of employing his beautiful mind, which was anxious to gain honor for himself and to satisfy his father. For this reason, having spoken of this to his father, he was taken away from Giulio's apprenticeship and immediately sent to Mantua to the house of Hipolito Costa, just at the time when Giulio Romano made Rinaldo Mantovano and Fermo Guifoni paint the Story of Troy from his cartoons in the Castello of Mantua.[7]

A Competition in Portrait Painting [8]

Later on, Signora Donna Ippolita Gonzaga, who wanted some of the portraits in Mgr. Giovio's Museum at Como, commissioned Bernardino to go there and copy them.[9] She had him accompanied by her

5 These cartoons are lost.

6 A painter who "kept shop" was obliged to conform to corporative rules and to accept commissions from any client.

7 Ippolito Costa (c.1506-1561); Rinaldo Mantovano (active from 1528, died after 1564); and Fermo Guisoni or Ghisoni (c.1505-1575) were Giulio Romano's assistants and continued painting in his manner. Bernardino Campi's early works are also painted under Giulio's influence.

8 *Discorso,* p. 53.

9 Paolo Giovio had created a celebrated "Museum" or Gallery of famous men's portraits, which was reproduced in engraving and copied and imitated by several contemporaries. The episode which follows took place around 1564.

secretary, who, having found there one Cristoforo, a Florentine pupil of Bronzino,[10] sent by His Highness the Grand Duke also to copy some of the portraits, he wrote to his Mistress of the excellence of this Cristoforo, and that because of the task he was assigned as well as the grandeur of the Prince who had sent him, he was considered a painter of the greatest merit. Whereupon, the Lady wrote back that he should bring Cristoforo along when he returned. When Bernardino had copied the commissioned portraits, he and the secretary returned, taking Cristoforo with them. Since the Lady desired to know who was the better and more excellent painter of the two, she had her portrait painted by both of them. The Florentine portrayed her twice from life, and Bernardino only once. Then the portraits by both painters being exhibited for comparison, not only the sound judgment of Princess Ippolita, but also that of many connoisseurs at her Court decided that Bernardino's was a better likeness, more beautiful, more expressive, and of a better manner. For this reason, not only did she give him the portraits painted by the Florentine, she also gave him other presents of no small importance, granting him an appointment among the most privileged servants of the House Gonzaga by the following privilege [follows the document, which is a letter of recommendation to all officials of her state].

Borghini's Circle of Amateurs

Little is known about Raffaele Borghini, the author of a long dialogue, Il Riposo *(Florence, 1584) which is our main source of information about the art and artistic circles of Florence during Vasari's epoch. The characters are Vecchietti, one of Giambologna's patrons, the sculptor and collector Lorenzo Sirigatti, and other distinguished figures of the Florentine milieu.*

Il Riposo, Vecchietti's still extant villa, where the conversation takes place, is described to us as a very different kind of dwelling from Sabba di Castiglione's cabinet. The connoisseur of 1584 had much more precise historical and technical knowledge, a less archaeological turn of mind, and he entered actively into the artist's life as patron and friend. He was, however, ready to learn humbly from the artists whom he protected, and was willing to practice some artistic profession, be it that of working a lathe, better to understand them. Borghini himself felt he had to apologize in his introduction for writing about art without being an artist.

[10] Cristofano dell'Altissimo, a painter in the service of the Grand Duke of Tuscany, is mainly known for his mediocre copies of Giovio's Museum. His competition with Campi is obviously arranged to humilate the Florentines in front of the Cremonese.

Description of Vecchietti's Villa [1]

The building which is well organized has large halls, elegant and ornate rooms, luminous loggias, a great abundance of very cool water, and cellars filled with the best wines. But what attracts everybody's attention is the rare paintings and sculptures which it contains; because there is the famous cartoon of *Leda* by Michelangelo, and a piece of another cartoon, also by Buonarruoto, that of the Pisan war, which was to be painted in the Palace of Florence; by Leonardo da Vinci there is a skull with all its details; by Benvenuto Cellini, the design of the *Perseus* now on the Piazza; by Francesco Salviati four very beautiful sheets,[2] two drawings of Bronzino's best manner; a very beautiful painting by Botticelli; by Antonello da Messina, who introduced oil painting in Italy, there is a picture with two heads; by Giambologna, many wax, clay, and bronze figures in different attitudes and representing several kinds of personages like prisoners, ladies, goddesses, rivers, and famous men; and there were quite a few things by many other painters which it would be too long to mention, and in particular, very beautiful landscapes by some Flemings. But something particularly admirable is a cabinet with five shelves, where in beautiful order are distributed small marble, bronze, clay, and wax figures; and there, too, are arranged fine gems of many kinds, porcelain vases and others of rock-crystal, shells of many sorts, pyramids of stones of great value, jewels, medals, masks, very fine fossil fruits and animals, and ever so many extraordinary and rare objects imported from India and Turkey which amaze whoever sees them.[3] After other rooms, in another part of the building, there is a similar cabinet all decorated with gold and silver vessels, with prints and drawings by the best masters of sculpture and painting; and there are precious distilled perfumes and oils of great virtue, many retorts, very beautiful oriental knives, Turkish scimitars with different kinds of ornamentation, and a great number of cups and porcelain vases. From the first floor one goes down to three rooms where Vecchietto withdraws when he wants to apply himself to praiseworthy manual occupations in which he is very proficient.[4] The first room is entirely surrounded with models by Giambologna, and statues by other masters, with paintings and drawings; the second is filled with iron work, and there is the anvil and all the things one works with, and also many instruments used for mathematics; the third contains the

1 R. Borghini, *Il Riposo* (Florence: 1584), pp. 13-15.

2 *Carte* can be either drawings or prints.

3 Collectors' cabinets often included natural curiosities or exotic objects besides works of art.

4 Vecchietti's two favored crafts, the forge and the lathe, were popular with distinguished amateurs; the Grand Dukes of Tuscany themselves enjoyed using them.

lathe and its accessories, and many pieces of ivory, ebony, mother of pearl, and fish bone worked with the lathe with great dexterity by Vecchietti. In sum, all that can give pleasure to the body and nourish the mind is found in this villa.

Iconographical Program for a Room in the Palazzo Farnese at Caprarola *

In 1559 the Farnese started the second campaign of construction and decoration of their castle at Caprarola, their summer residence designed by Vignola. Taddeo Zuccaro was in charge of the painting. The iconographical program was slowly elaborated by the famous scholars, Annibal Caro, Onophrio Panvino, and Fulvio Orsini.

Annibal Caro (1507-1566) was the secretary of several members of the Farnese family for many years. Writer, wit, and numismatist at the same time he was well equipped to contrive imprese *and iconographic programs; his correspondence, still a model of literary elegance, is full of them. The long letter to Taddeo Zuccaro (November 11, 1562), containing the program for the* stanza dell' Aurora, *was already reproduced by Vasari in his life of the painter. The letter to Panvinio reprinted here gives another program for the* stanza della Solitudine; *it also reveals the contemporary artists' resistance against unrewarding and abstruse iconographies (in fact even Caro's revised program was not followed fully).*

Annibal Caro: Letter to Father Fra Onofrio Panvinio [1]

The subjects to be painted in the study of the illustrious Monsignor Farnese must be adapted to the disposition of the painter, or his disposition to your subjects, and since it is obvious that he has refused to adapt himself to you, we must, perforce, adapt ourselves to him to avoid disorder and confusion.

The theme of both is things that concern solitude. He divides the whole ceiling into two main parts, consisting of compartments for pictures with ornaments around the compartments. Let me start with the compartments where there must be the important pictures. There are four kinds of these compartments: large, medium, small and tiny ones; and therefore one must find four sorts of subjects to paint in them. For the large spaces, large subjects, for the medium ones subjects with less figures, for the small ones subjects of one figure only, and for tiny ones, which can not contain figures, subjects of symbols and other things which are not human figures.

* Cf. Fr. Baumgart, "La Caprarola di Ameto Orti," in *Studj Romanzi* (1935), XXV, 77-179.

1 Annibal Caro, *Lettere,* ed. Aulo Greco (Florence: 1957-1961), III, 237-40.

Of the four large compartments, two are in the middle of the ceiling and two at the ends. In one of the middle ones, which is the most important, I should portray the most important and praiseworthy kind of solitude, i.e., that of our religion, which is different from that of pagans; because Christians have abandoned solitude to instruct the people, and the pagans have abandoned the people to withdraw into solitude.

Large paintings. Thus in one of the large pictures of the middle I would show the solitude of Christians: and in the middle of this I would represent Christ Our Lord, and then on the sides in the following order, St. Paul the Apostle, St. John the Baptist, St. Jerome, St. Francis, and others, if it can contain more, who could come out from the desert at different places and would go and meet the people to preach the evangelical doctrine, showing the desert on one side of the painting and the people on the other. In the opposite picture, I would show, as a contrast, the solitude of the pagans, and I would put all sorts of philosophers, who would not leave but enter the desert and turn their backs to the people, depicting particularly some of the Platonicians who even put out their own eyes so as not to be distracted from philosophy by the sense of sight.[2] I would show Timon who threw stones at people; I would show some who, without being seen, hand some tablets or writings of theirs out of the thicket to instruct people without conversing with them. These would be the subjects of the two main compartments of the center, which would expound the theme of solitude in general.

At one end, which would be the third large picture, I would come to the episode of the lawgiver of the Romans, and I would show Numa Pompilius in the Valley of Egeria and the nymph Egeria conversing with him near a fountain, with forest, grottoes, and tables of the law around them. At the opposite end, I would show Minos, first lawgiver of Greece, coming out of a grotto with some tablets in his hands, and in the shade of the grotto there would be Jupiter, from whom he claimed to have received the laws.

Medium-sized spaces. In the four medium-sized pictures we shall show the four nations as you have proposed. And, so that the painter should understand: in one, the gymnosophists, nation of India, also in a desert, naked, in the attitude of people meditating and arguing; and I would show some of them turned towards the sun which would be in the middle of the sky, because their custom was to sacrifice at noon. In the second the northern Hyperboreans, clothed, also with the same gestures of arguing and contemplation, under fruit trees, with sacks of rice and of flour around them, which was their food; and since I do not know

2 The legend attributes this trait to Democritus and Plato.

their costume, I leave it up to the painter. In the third, the Druids, mages of Gaul, in forests of oak, because they venerated them and never made any sacrifice without their foliage; and they worshipped the mistletoe which grows on oak trees; they can be clothed at the painter's will, but all in the same way. In the fourth, the Esseneans, a Jewish people, holy, chaste, without women, solitary, and meditating only on holy and moral things. These also shall be clothed all in the same way, and with winter clothes in the summer, and summer clothes in the winter. They keep them in common and store them all together; and one can show a place which will be the storehouse for the clothes of the community.

Small elongated spaces. The small compartments are all contained within the ornament, as are all the tiny ones also; and we call small the ones which can contain only one figure, and tiny those that can not include figures. The small ones are seventeen altogether, ten of one kind, and seven of another. In the ten, which are in the exterior ornamentation which runs all around the compartments, since they are horizontal, I would show reclining figures, and would represent ten great authors who have talked about solitude. In the seven which are inside the ornament, since they are vertical, I would show, standing, those who have practiced it. In the first of the ten I would put Aristotle resting horizontally, in accordance with the picture's shape, in the costume which he is given today, whether it is authentic or not, with a tablet in his hand or between his legs or being written upon by him, with these words: *ANIMA FIT SEDENDO ET QUIESCENDO PRUDENTIOR.*[3] In the second, Cato in the costume of a Roman senator; and we have a portrait which is supposed to be his, although it is not; and on his tablet I would write his motto: *QUEMADMODUM NEGOTII SIC ET OTII RATIO HABENDA.*[4] In the third, Euripides, and for him, too, there is a portrait taken from some ancient herms; his tablet, or his cartouche should say: *QUI AGIT PLURIMA, PLURIMA PECCAT.*[5] In the fourth a Seneca the Moralist in the costume of a philosopher (I know not where to find his portrait), with the sentence in a similar tablet: *PLUS AGUNT QUI NIHIL AGERE VIDENTUR.*[6] In the fifth Ennius crowned and clothed as a poet, whose tablet would say: *OTIO QUI NESCIT UTI PLUS NEGOTII HABET.*[7] One must make sure that the tablets or cartouches or letters, whatever you call them, be held and placed differently for variety's sake. In the sixth Plutarch, in philosopher's costume, writing, or holding his motto: *QUIES ET OTIUM IN SCIENTIAE ET*

[3] The soul becomes wiser by sitting and resting.
[4] One needs a method for resting as well as for working.
[5] Who does more, makes more blunders.
[6] Those who seem to do least do most.
[7] Who does not know how to rest has more work.

PRUDENTIAE EXERCITATIONE PONENDA.[8] In the seventh I would show Marcus Tullius, also as a senator, with a scroll tied in the middle in classical style which would hang and show this inscription *(volume all'antica rinvolto al umbilico che pendesse): OTIUM CUM DIGNITATE NEGOTIUM SINE PERICULO*.[9] In the eighth Menander in the Greek costume for comedy, with a mask near him and with his tablet saying: *VIRTUTIS ET LIBERAE VITAE MAGISTRA OPTIMA SOLITUDO*.[10] In the ninth Gregory of Nazianzus in bishop's garments, his tablet with this saying: *QUANTO QUIS IN REBUS MORTALIBUS OCCUPATIOR TANTO A DEO REMOTIOR*.[11] In the tenth Saint Augustine with the costume of the order and this sentence of his: *NEMO BONUS NEGOTIUM QUAERIT, NEMO IMPROBUS IN OTIO CONQUIESCIT*.[12]

Small vertical compartments. In the small vertical compartments one should put (as I said) those who have devoted themselves to solitude, among which I would chose seven from seven different conditions of life, as the spaces are seven. In the first, I would place a Roman Pontiff: and this would be Celestin, who renounced the Papacy. In the second, an Emperor, and this would be Diocletian who, having abandoned the Empire, went away to Dalmatia to be a farmer. Among the moderns we could also chose Charles V. As an ancient king we could put Ptolemy Philadelphus, who, retiring from the administration of his Kingdom, dedicated himself to studies and created the famous library. Among modern kings, Peter of England who, having abdicated came to Rome and lived retired in poverty.[13] For a cardinal: Saint Jerome himself, and among the moderns Ardicino della Porta, cardinal of Aleria, under Innocent VIII.[14] For a tyrant: Hieron of Syracuse who, taken ill, and having called for Simonides and other poets, dedicated himself to philosophy. For a great captain: Scipio Africanus who, having abandoned the worries of politics, retired to Linternum. For a famous philosopher: Diogenes with his barrel.

Tiny spaces. We are left with twelve other tiny spaces which come in between the small ones already mentioned. Since one can not put human figures in these, I would show some animals as fanciful motives

8 Rest and quiet are necessary to the application of science and intelligence.

9 Rest with dignity, action without danger.

10 Solitude is the best master of virtue and freedom.

11 The more one is involved in the business of this world, the farther one runs from God.

12 No good person wants turmoil, no evildoer is satisfied with rest.

13 Ceadwalla, king of Wessex, abdicated in 688 and left for Rome where he was baptised under the name Peter.

14 Bishop of Aleria (1475), appointed cardinal and datary under Innocent VIII (1488); retired to a monastery in 1492.

and as symbols of the theme of solitude, and of what is related to it. And first, I would put the four principal animals in the four corners. In one Pegasus, the winged horse of the Muses, in another the Griffon, in the third the elephant with his trunk turned towards the moon; in the fourth the eagle which kidnaps Ganymede.[15] Because all these would signify the elevation of the mind and contemplation. Then, in the two little pictures which are at the two opposite ends of the room, in one I would put the eagle alone looking at the sun, which in this fashion signifies speculation; it is a solitary animal by nature, and always throws away two of the three young it produces and brings up only one. In the other I would put the phoenix, also turned towards the sun, which will signify the elevation and excellence of ideas, and it would also signify solitude since it is unique. We are left with six tiny pictures, which are round. In one I would show a snake, signifying astuteness, diligence, and prudence in contemplation, which for this reason was attributed to Minerva. In another, a solitary percher [16] which by its very name signifies solitude. In the third an owl; because this too is dedicated to Minerva, since it is a nocturnal fowl and signifies studies. In the fourth I would put a red-breasted robin, a bird so solitary that one reads that two of them can never be found in the same wood. I can not find, however, what it looks like, therefore I leave it up to the painter to do it as he pleases. In the fifth a pelican, to which David compared himself in his solitude when fleeing from Saul: it will be shown as a white bird, thin, because of the blood it draws from itself to feed its children. Some people say that this bird is the *sultana*; if this is so, it should have its bill and feet very long and red. In the last one a hare, of which one reads that it is so solitary that it never rests if it is not alone, and also that when it snows, so as not to be discovered because of its foot-prints, it makes a great big leap from its last step to the place where it will rest.

By now we have given the contents of all the pictures. The ornaments remain, which are left up to the painter's imagination. However, it is a good idea to advise him if he thinks it appropriate, to arrange in some places, as grotesques, instruments of solitary and studious people, like spheres, astrolabes, armillary spheres, quadrants, pairs of compasses, set-squares, levels, mariners' compasses, laurels, myrtles, ivy, caverns, little chapels, hermitages, and such new. . . .

MAY 15, 1565

UNFINISHED

15 Ganymede represents the soul raped to heaven in divine enthusiasm.
16 *Passer solitarius.* Cf. Psalm 102, 7.

Michelangelo's Account of the Julius Monument

The intricate history of the projects and contracts for Julius II's tomb between 1534 and 1542 (when this letter was written) is greatly enlightened by the difficult political relations between the reigning Pope, Paul III Farnese, and the Dukes of Urbino, Francesco Maria della Rovere (dead 1538) and his successor Guidubaldo, heirs to Julius II.

Michelangelo's precise engagements were defined by a contract of 1532, but Paul III had canceled the artist's obligations to enable him to paint the Last Judgment, *and was anxious to keep him free for the frescoes in the Pauline Chapel. Therefore, he forced Guidubaldo to make a compromise very favorable to Michelangelo with the contract of August 20, 1542. The Duke tried a last resistance by refusing to ratify the document unless the artist should promise, in addition, to finish the two statues of Rachel and Lea with his own hand.*

The following letter was written by Michelangelo in a moment of panic and rage when he heard of some new difficulties, probably in October 1542. Soon after, however, the agreement was concluded, and the artist made the desired concession.

The addressee of the letter is not known, although several plausible names have been proposed. The original manuscript is lost but is known through a copy, probably by Luigi del Riccio's hand, to whom has been attributed, but with no apparent reason, the last and scandalous sentence.

Letter to an Unknown Prelate [1]

MONSIGNORE,

Your Lordship has sent to me saying I am to begin painting and to have no fear. My answer is that a man paints with his brains and not with his hands, and if he cannot have his brains clear he will come to grief. Therefore I shall be able to do nothing well until my affair is settled. The ratification of the last contract is not forthcoming, and under the terms of the other, which was drawn up in Clement's presence,[2] I am daily pilloried as though I had crucified the Christ. I refuse to admit that the said contract was read over to Pope Clement in the same form as the copy I afterwards received, the reason being that Clement sent me to Florence the very day, and the Ambassador, Gianmaria da Modena,[3] went

[1] English translation by Robert W. Carden, *Michelangelo, A Record of His Life as Told in His Own Letters and Papers* (London: Constable & Co., Ltd., 1913), pp. 194-201; completed by R.K. and H.Z.

[2] The contract was drawn up on April 29, 1532.

[3] Giovanmaria della Porta da Modena, ambassador of Francesco Maria della Rovere, Duke of Urbino.

to the notary and had the scope of the contract extended to suit his own ends. When I came back and went to see the deed, I found that it included a thousand ducats more than it had done before; I found that it included the house I live in, with many another barbed shaft, all meant to goad me to my ruin.[4] Clement would never have countenanced this. Fra Sebastiano can bear witness to this,[5] since he wanted me to tell the Pope about it and have the notary hanged. I did not want to, because I was not bound to do something which I could not have done, had I been free to. I swear that I have not had the money mentioned by the said contract, and which Gianmaria said he found I had had. But let us assume that I have had it, since I have acknowledged it and cannot repudiate the contract, and other sums too, if others can be found, and put it all together; and then consider what I have done for Pope Julius at Bologna, at Florence and at Rome, in bronze, in marble and in painting, and all the time I have served him, which is the whole of his Papacy; and consider what I deserve. I claim with a clear conscience that, on the basis of the salary paid to me by Pope Paul, the heirs of Pope Julius owe me five thousand scudi. I shall also say this: if this was my reward for my work from Pope Julius, it was all my fault for not having known how to handle my affairs; were it not for what Pope Paul has given me, I should starve to death today. And according to those ambassadors, it appears that I have enriched myself and that I have robbed the sanctuary, and they raise a great uproar; I could find a way to keep them quiet, but I am no good at it.

When the contract mentioned above was made in the presence of Clement, Gianmaria, the old Duke's ambassador, told me on my return from Florence that if I wished to do the Duke a good turn I should go away altogether because he did not care about the tomb but wished to prevent my working for Pope Paul. Then it was that I understood why my house had been put into the contract. It was so that I might be got rid of, and they, by virtue of the agreement, would then have been free to take possession of the house. Thus one can see what they are hunting, and they bring shame to our opponents, their patrons. The ambassador who came recently,[6] first enquired about what I owned in Florence, before he even tried to see what stage the tomb had reached.

Here I am, having lost my whole youth, chained to this tomb, defending it as well as I could against Popes Leo and Clement; and my excessive loyalty which is unrecognized has been my ruin. Such is my

4 See the account in Condivi's biography.

5 Sebastiano del Piombo was one of the witnesses for the 1532 contract.

6 Girolamo Tiranno, who had just passed with Michelangelo's assistants, Raffaello da Montelupo and Urbino, a contract which seems to take for granted the terms of that one which the Duke refused to ratify.

fate. I see many people with an income of two or three thousand scudi remain in bed, and I, with the greatest labor, toil at impoverishing myself.

But to return to the painting.[7] There is nothing I can deny to Pope Paul: I shall paint miserable, and paint miserable things. I have written thus to your Lordship so that when occasion arises you will be able to tell the Pope the truth. Also I should very much like the Pope to know all about it, so that he should know what is at the bottom of this campaign waged against me. Understand who should.

<div style="text-align:right">Your Lordship's servant,</div>

<div style="text-align:right">MICHELANGELO</div>

There is another thing I wish to say, and it is that the Ambassador declares I have used the Pope's money for moneylending purposes and that I have grown rich on the proceeds, as though I had actually received the eight thousand ducats from the Pope. The money mentioned as having been received by me refers to the amount spent up to that time on the tomb, which, as may be seen, would come to about the same sum as that mentioned in the contract made in the time of Clement: for in the first year of Julius' pontificate, when he gave the contract for making the tomb, I spent eight months at Carrara quarrying the blocks which I transported to the Piazza di San Pietro, where I had a workshop behind the church of Santa Caterina. Afterwards Pope Julius did not want to proceed with the tomb during his life, and set me to paint: then he kept me at Bologna for two years working on the bronze Pope which later was destroyed: then I went to Rome and remained in his service till he died, keeping open house all the time, without allowance and without salary, living upon the money for the tomb, as I had no other source of income. Then, after the death of Julius, Aginensis [8] wanted to continue the tomb, but on a greater scale, so that I transported the marbles to the Maciello dei Corvi, and had that part executed which is now built in San Pietro in Vincoli, and made the statues which are in my house. Meanwhile, Pope Leo, not wishing me to make the tomb, pretended that he was going to build the façade of San Lorenzo in Florence. He begged me of Aginensis, therefore, who was compelled to set me at liberty but stipulated that I was still to go on with the tomb of Julius while in Florence. Then while I was in Florence occupying myself with the façade of San Lorenzo, I found I had not sufficient marble for the tomb of Julius, so I went back to Carrara for thirteen months, brought back all the necessary blocks to Florence, built a workshop, and set to work. About that time Aginensis

[7] The Pauline Chapel.

[8] Leonardo Grosso della Rovere, Cardinal of Agen. Macello de' Corvi is the location of the artist's house.

sent Messer Francesco Palavicini—now Bishop of Aleria—to hurry me up.[9] He inspected my workshop and saw all the marble and the statues which were blocked out for the said tomb, as they are still to be seen today. When this became known, that is, when it became known that I was working on the tomb, the Medici who was then in Florence—he afterwards became Pope Clement—forbade me to go on with it, and I remained impeded in this way until Medici became Clement. Then the last contract but one was made, in his presence; the contract in which it is alleged that I have received the eight thousand ducats I am supposed to have laid out at usury. I have a sin to confess to Your Lordship; when I stayed those thirteen months at Carrara on account of the tomb I ran short of money and spent on this work a thousand ducats of the money Pope Leo had given me for the façade of San Lorenzo, or rather to keep me occupied. And I told him some story about arising complications. But I have had my reward in being called a thief and a moneylender by ignoramuses who were not even born at the time.

I write this long history to your Lordship because I am almost as anxious to justify myself in your eyes as in the Pope's; for according to what Messer Piergiovanni [10] writes, the Pope has been told lies about me to such an extent that he was obliged to speak in my favor. Another reason is that when your Lordship finds an occasion for it, you will be able to put in a good word for me, for what I am saying is the truth. Before men—I will not say before God—I consider myself to be an honest man, for I never deceived any one; finally, I must sometimes go mad, as you must realize, in protecting myself against the attacks of spiteful persons.

I beg your Lordship to read this when you have time and to keep it for my sake, remembering that there are witnesses available to prove practically all I have said. I should also be very glad if the Pope could see it—nay, I would like all the world to see it, because what I have written is the truth, and even understates it: I am not a thieving moneylender but a citizen of Florence, born of noble stock and the son of an honest man. I am not of Cagli.[11]

After I had written I received a message from the Urbinate Ambassador, saying that if I wanted the ratification I could get it by first purging my conscience. I tell you that he must have thought the Michelangelo he was dealing with was made of the same stuff as himself.

To proceed with the story of the tomb of Pope Julius, I repeat that

9 This visit took place on May 31, 1519. Francesco Pallavicini was in the service of Cardinal of Agen at that time.

10 Piergiovanni Aliotti, Bishop of Forli, majordomo of the Pope. Michelangelo used to call him Tantecose (Busybody).

11 A village near Urbino. The phrase expresses disdain for the Urbinates, that is, Julius II's heirs and their agents.

he subsequently changed his mind about having it made during his own life as he had originally intended; and when sundry barge-loads of marble which had been ordered from Carrara some time before arrived at Ripa, I could not get any money from the Pope because he had decided not to go on with the work. I had to pay the freightage, between a hundred and two hundred ducats, with money borrowed from Baldassare Balducci— from Messer Iacopo Gallo's bank, that is—for the purpose of discharging the said account. Then a number of masons whom I had engaged in Florence to work on the tomb arrived in Rome, some of whom are still living, and as I had already furnished the house Julius gave me at the rear of Santa Caterina with beds and other household necessities for the masons and for the other work connected with the tomb, I found myself in dire straits for lack of money. I urged the Pope to allow the work to proceed as fast as possible, and one morning when I went to discuss the matter with him he caused me to be turned out by one of his grooms. The Bishop of Lucca, who witnessed the act,[12] said to the groom: "Do you know who that is?" to which he replied: "Pardon me, Sir, but I have been ordered to act as I am doing." I went home and wrote to the Pope as follows: "Most holy Father: this morning I was driven from the Palace by your Holiness' orders; I give you to understand that from henceforth if you desire my services you must seek me elsewhere than in Rome." I sent this letter to Messer Agostino, the steward who was to give it to the Pope. Then I sent for a certain joiner named Cosimo to come to me, a man who used to work for me and was making furniture for the house, as well as for a stonemason who is still living and who was also in my service at the time. To these men I said: "Go and fetch a Jew; sell all the house contains and follow me to Florence." I went out and took the post, departing in the direction of Florence. As soon as the Pope received my letter he sent five horsemen after me, who came up with me at Poggibonsi about the third hour of the night, and presented a letter to me from the Pope of the following tenor: "Immediately on receipt of this present thou must return to Rome on pain of Our displeasure." The horsemen desired me to send a reply in order to show that they had delivered the letter; so I answered the Pope that as soon as he would carry out his obligations towards me I would return, otherwise he need never expect to see me again. And afterwards, while I was living in Florence, Julius sent three briefs [13] to the Signoria. At last the Signoria sent for me and said: "We cannot go to war with Pope Julius on your account; you must go back. If you will return to him we will give you a letter making it clear that any

12 Cardinal Galeotto Franciotti (d.1508), a nephew of Julius II, a young churchman of high repute.

13 Only one brief addressed to the Signoria is known concerning this business.

injury done to you will be an injury done to us." So they did; I went back to the Pope; and it would take a long time to narrate all that ensued. Let it suffice that I lost more than a thousand ducats over it, for directly I had left Rome there was a great disturbance to the Pope's shame; nearly all the marble I had collected in the Piazza di San Pietro was stolen, especially the small pieces, and I had to replace them subsequently. In short, I maintain and affirm that in respect of damages and interest I am entitled to receive five thousand ducats from the heirs of Julius. Yet the very people who robbed me of my youth, my honour, and my possessions now call me a thief! And at the end of it all, as I have said already, the Ambassador from Urbino sends word that I am to purge my conscience and then the Duke will send the ratification. He did not speak like that before he made me deposit the 1,400 ducats. If there is any inaccuracy in all that I have written it is only in the matter of dates. Everything else is the truth, it is even more true than I have written it.

I entreat your Lordship, for the love of God and of truth, to read this when you have time, so that when the occasion arises you will be able to defend me against those who speak evil of me before the Pope without knowing anything about the matter, and who have given the Duke of Urbino to understand that I am a great scoundrel by their false representations. All the disagreements that arose between Pope Julius and myself were due to the jealousy of Bramante and of Raffaello da Urbino: it was because of them that he did not proceed with the tomb during his own life, to ruin me. Yet Raffaello had good reasons to be jealous of me, for all he knew of art he learnt from me. [14]

Bandinelli versus Cellini: An Intrigue over a Commission

Cellini, as we may guess from his own memoirs, tried to obtain the commission for some, at least, of the reliefs for the choir enclosure of the Cathedral of Florence which had been entrusted to Bandinelli in 1547. In 1556, Benvenuto succeeded in obtaining the commission for one of the pulpits which were to flank the enclosure, and later, after his rival's death, that for the rest of the work; but he never executed any of it.

Bandinelli's letter to the majordomo Pierfrancesco Ricci was a defensive move. It was not dated, but must have been written shortly before the completion of the statues on which Bandinelli seems to have counted to regain the confidence of the Grand Duke (either Adam and Eve, *1551, or the* Dead Christ Supported by Angels, *1552).*

[14] This hostility is probably due to Bramante's and Raphael's Urbinate origin. Michelangelo must have often heard, from flatterers like Sebastiano, sentences like the one he stoops to here. He was, however, perfectly able to vindicate Bramante when he could thereby criticize the work of the Sangallos at Saint-Peter's.

Two important points should be noted: first, the artist's insistence on disegno, which, from all reports, was Bandinelli's forte; he brought up the Florentine view that good draughtsmanship is the source of all the arts, the art of bronze in particular (this is a point against the bronze sculptor Cellini, because some of the reliefs in dispute were to be cast in bronze); secondly, the place taken by historical examples, which, by the way, are false and perhaps invented for the occasion, but characteristic of a time when it had become possible to crush one's opponent with the great names of the local past.

Bandinelli to the Majordomo [1]

MY LORD MAJORDOMO,

I have again been asked for the measurements of the bronze reliefs of the choir; and since I do not want to know where this question comes from, I have answered that Benvenuto could make them all freely, and should no longer fear me. But Your Lordship must know for certain that if these reliefs are not made by a fine draughtsman, the church and our epoch will gain a very ugly reputation because of the remarkable things that are there for comparison; for Benvenuto is much more fit to clean such pictures than to make them himself, as can be seen by his sculptures which, although small, are full of errors; and the reason is that he does not command any draughtsmanship. And to make His Excellency [2] know the true way to create beautiful things, take the example of Lorenzo di Bartolo [Ghiberti] who was an outstanding draughtsman: when he was commissioned the doors, he hired, to help him, youths who could draw very well, and thus produced two good things: admirable works and good artists; the comparison can be observed on the doors, for the lower reliefs of the door, because they were the first, are very ugly in comparison with the others; but during the execution the youths became very good, since one was Maso Finiguerra, another Desiderio [da Settignano], Piero and Antonio Pollaiuolo, and Andrea Verrocchio, all of them both good painters and good sculptors. Now, you can see that, if Benvenuto is compared to any of them, ten artists as good as him would not amount to one of their little fingers. Nevertheless I want to comply to what His Excellency wants. I only pray that he might be patient enough and wait for my statues to be shown [3] and I recommend myself to Your Lordship.

1 Translated from Bottari-Ticozzi, *Lettere pittoriche,* I, 104-105.

2 The Grand Duke.

3 The statues for the enclosure of the choir or for the main altar; see introduction. In fact, these works were failures in Florentine opinion.

Plight of Young Milanese Painters

G. B. Armenini, 1530-1609, was a mediocre painter with equally modest theoretical ambitions. His De' veri precetti della pittura, Rimini: 1587, *takes a place by its very title in the tradition of practical advice and recipe books. The author, a native of Faenza, lived for a long time in Rome, travelled extensively throughout Italy, and commanded some experience of the several artistic centers of the peninsula. The book is precious to us for its wealth of precise, if poorly expressed, technical information and anecdotes.*

The great increase in the number of artists and commissions during the second half of the Cinquescento brought about a considerable lowering of the level of average productions which were carried out faster and faster. The taste for gold and variegation, as well as the unintelligent imitation of engravings, are characteristic traits of artistic Philistinism in provincial centers; Armenini, himself a second rate painter, was still able to notice these shortcomings.

Armenini: From the True Instructions to the Painter [1]

Having arrived, after a long detour, in Milan, I was put up there by one Messer Bernardino Campi of Cremona, quite a well known painter in that city, for whom and on whose cartoon I sketched a picture of the Assumption,[2] for which, once it was done, I received one hundred scudi in gold which fulfilled handsomely what he had promised me. He also put me up for another few months, during which time I associated with some of the young Milanese whom I found much more inclined to adorn themselves with all sorts of clothes, and with beautiful shining arms, than to handle pens and brushes with any sort of application: there, also, I saw many palaces painted by those Milanese in a vulgar fashion at great expense of money and time; and among many others, I was taken to see a large hall, in which they had recently painted the ceiling, and this was in the palace of a very wealthy merchant, whose name I shall not mention. Once I had looked with him to this ceiling and to other frescoes in his house, this man swore to me that painting had been going on continuously in his house for more than ten years, and that the father of that young man who had taken me there and was now in charge of the work had died at his work. But the young man who, like the others, was more partial to the sword than to the pen, made me come up on the scaffolding

1 *De' veri precetti* (Rimini: 1587), pp. 221 f.
2 On this *Assumption*, cf. Lamo, *Discorso . . . ,* p. 57.

of the ceiling, which he had just finished, helping himself with prints and stencils, and he had put a lot of fine gold in many places, and sometimes on top of pallets of wax.[3] Considering the great expense of these trifles, it can be considered as thrown away, since there was nothing there either of importance, or that would resemble anything with a form or shape. Then he told me that below this there would be a great frieze painted in fresco, but at this point the master of the place came back and, therefore, we went down to him, and when we were all three in the hall the painter asked him what subject should be represented in the frieze; but the patron said without giving it much thought, "Make it like a pair of those trousers that are now so fashionable with many colors." This remark left the young man half stunned and I went away at once without saying anything else. But the young man, who walked faster, had soon caught up on me and talking this over with me, he told me that there were some prints which represented the story of Psyche and that they were compositions by Raphael of Urbino; and did I think he would be successful if he painted those? I told him I thought so, if they were well painted. Consequently, he roughed through a good part of it, and he often took me to see the work. But once, the patron himself stopped to see it while I was there, and asked the painter what story he represented; he answered that it was the story of Psyche, and the other said: "Don't make me too many of those *psighi,* because the fine paints don't come off so well in them." Hearing these blunders on both sides, I decided, once I had taken leave, that I had better not go again.

Zuccaro Sued for Slander *

Federico Zuccaro had executed a Vision of Saint Gregory *for a church in Bologna on the commission of the pontifical chamberlain, Paolo Ghiselli. The Bolognese painters criticized the picture violently, and Ghiselli communicated their reaction to Zuccaro; the artist retaliated by having his assistant Domenico Passignano paint an allegory where his detractors were represented with asses' ears. He showed the cartoon in public at the entrance of St. Luke's church on the day when the Roman painters assembled to celebrate their patron saint's day. Zuccaro delivered a commentary on the picture to whoever wanted to hear him, and then wrote it down.*

The superstitious power which was still associated with portraits explains why defamatory pictures were considered a more severe offense than a lampoon. The public authorities started a trial; Domenico went

[3] This archaic manner of applying gold was considered in very bad taste.

* Cf. R. and M. Wittkower, *Born under Saturn* (London: 1963), pp. 249-51.

to jail, while Zuccaro went free on bail. The legal action was still follow-ing its course when the Pope cut it short with a sentence of banishment.

From Zuccaro's First Hearing [1]

The accused was asked about the exercise of his profession, where he lived, and for how long.

Answer: I have stayed in Rome continuously for two years in the service of His Holiness to paint in the Apostolic Palace, particularly in the Pauline Chapel where during this time I have been painting con-tinuously because this has been my profession ever since I was able to tell good from evil.

And questioned, he answered: Before the two years which I spent continuously in Rome, I have been, so to speak, brought up here for twenty successive years under the discipline of Master Taddeo Zuccaro, my brother, who was of the same profession.

Asked if he had painted in the city in other places than the Pauline Chapel and to give the details of the places and if he had painted other panels and pictures for private people, and to say how, and what kind of pictures.

Answer: During this period of two years I have not worked or painted panels or pictures for any private people outside the Apostolic Palace, except that I have obliged the people of the Palace and the do-mestics of His Holiness as, for instance, Paolo Ghiselli, chamberlain of our Lord, for whom I painted a picture or altarpiece called the *Miracle of the Angel of the Castle* from the life of St. Gregory; the picture was finished within one year and sent to Bologna by His Lordship to put in his chapel in the church of the Madonna del Baraccano.[2]

Asked whether since he had done the said painting or altarpiece he had heard anything about the said work, what, and how.

Answer: I have heard nothing else of the picture or altarpiece which I painted for the Lord Chamberlain, except what was told to me by the Lord Chamberlain and by the Lord Majordomo, i.e., that the picture and altarpiece was deficient in many respects, as though it was painted by the worst of painters and by a man who had never handled a brush, which left me amazed and bewildered, although I am conscious that I am not as perfect as I should be.

The accused was asked whether he had had any discussions about the preceding with the aforementioned Reverend Ghisello, if so at what occasion, and what was said.

[1] Minutes of the procedure published by Bertolotti in *Giornale di erudizione artistica* (Perugia, 1876), V, 129-52; cf. pp. 133-37 and 147 f.

[2] The altarpiece is lost.

Answer: Upon hearing that the Lord Chamberlain was not satisfied with my work on the picture or altarpiece I painted for him, I talked to His Most Reverend Lordship and told him that if the altarpiece I had made did not satisfy him, I would make him another, two, three, ten if needed, to show him my wish to please him. But I was answered that His M. R. Lordship did not need any other picture because he had abandoned the business and had given the commission to his people in Bologna.

And being asked, he said: Sir, His M. R. Lordship has never given me the name of any particular person or painter who has judged my work to be deficient; it is true, however, that His M. R. Lordship showed me a piece of writing, which was on a half folio, and in which were listed all the shortcomings found in the painting; and he said it was the unanimous opinion of all the connoisseurs of the profession, but without giving any names or appellations.

The accused was asked what he had said or done after seeing the sheet or document listing the defects of the said picture or altarpiece.

Answer: I did not say or do anything when I had knowledge of the report listing the alleged defects of my painting, except that I shrugged my shoulders, trusting in time who would be the judge; all the more so because I could see that the defects that I was charged with were not serious or of any importance.

Questioned, he said: The defects raised against my painting were of this kind: that in some places the colors which should have been light were dark, and those which should have been dark, light; and that the figures which ought to have been large were small, and the small, large; and that the figures in perspective did not recede, and that the foreshortenings were deficient; but about proportions and the due measurements, which are the foundation of our profession, they said nothing; and for this reason I remained quiet and without concern, because theirs were criticisms of the kind usually made by people who know little about this art.

The accused was asked whether he had taken the charge of the aforementioned defects badly, and whether he had discussed it with anybody, if so, how and in what way.

Answer: I have not complained of this to anybody, but as for myself, I remained bewildered and I was sorry that, in doing this service which had been forced on me by that Lord whom I was so keen to please and to serve, I had been prevented by my hard luck from satisfying him; and this was the only source of my displeasure.

Asked whether ever since that time he had made another picture

or work either in canvas, or on paper, or anything else, if so how and what, and that he should be sure to tell the truth.

Answer: Ever since I have painted the altarpiece in question, I have not done any other work for private people, although I was asked to by many people, particularly by the brother of the Grand Duchess of Tuscany who wanted a work for a chapel of his; I have always refused, saying that as long as I was in the service of His Holiness I did not want to touch any other work, because it went against justice and duty.

And I, the Notary, entreated the accused to think again about it and to say the truth and to say if he had done any other work in Rome since that time, and of what kind.

Answer: Between August and the end of August or the beginning of September, unless I am mistaken, a work on paper was started by an apprentice of mine called Domenico Fiorentino, who has been in my service for about five years. This picture is called *Porta virtutis* [3] and in it are shown some fifteen principal figures.

Questioned about what figures the said work contained and how they were called, and told that he should say in truth for what purpose it was made.

Answer: The most important figures represented in this picture are: *Labor, Diligence, Study, Love, Intelligence,* the *Spirit* and the *Graces, Virtue* under the appearance of Pallas, the *Four cardinal virtues,* and *Virtue* treading on *Vice* portrayed as a monster, and beneath this is *Envy* with vipers entwining themselves around her, and *Ignorance* near by flattered by *Adulation* and by *Presumption,* not far away is *Slander* and her companions, i.e., small satyrs; and there are some Latin and Italian inscriptions.

Questioned about the content of the aforementioned inscriptions and about what he meant by them.

Answer: Those inscriptions are intended to give the meaning of the figures; and the purpose of the picture and figures was only that, having been myself persecuted by slander and envy wherever I have been, I wanted, in this picture, to make those who are not of the profession understand that they should not be so quick to criticize other people's labor, since they do not have that much experience; and such people have always done me harm.

And questioned, he said: Truly, the invention, the conception, and the idea were mine, and it is quite true that I had it executed by that apprentice, having other things to do myself; and, starting in August, the picture was painted in my mansion where I usually retire without

[3] The cartoon is lost but the composition is known through three drawings.

anybody else other than the said Domenico, my assistant; the inscriptions and the figures were invented by me.

Questioned about the purpose of the said work and told that he should forget about anything he had said before and should speak candidly.

Answer: Really, I have made the said picture or painting with a general intent; I meant that I had always had the misfortune to be attacked for my works, and I did not want to allude to anyone in particular. . . .

Questioned whether the said picture was exhibited in public in any place, if so in which place, and how.

Answer: This picture was not shown in public except that these last days, on St. Luke's day, it was brought to the church of Saint-Luke on the hill of Sta Maria Maggiore where we painters hold the celebration of our patron saint, and there it was interpreted by me, as I said before, for people of the profession and others who approached me,[4] especially because it is a custom among us painters that on these occasions our apprentices exhibit something new and show how they are progressing in the profession. . . .

FROM THE SECOND HEARING [5]

Answer: Between the aforementioned sketches and this cartoon or painting by my apprentice Domenico there is this difference that, in the first sketch, in the two statues which represent Labor and Diligence there is, in the body of each, a roundel in form of a medal, and in the cartoon or painting by Domenico these roundels are absent, and this is the whole difference between the sketch and the painting.

Was there any other difference between the painting or cartoon and the first sketch? and if so, what?

Answer: No, Sir, between the painting and the sketch there is no difference but for what I said about the two roundels.

What did he mean by these two roundels set on the bodies of the figures representing Labor and Diligence?

Answer: If I wanted to say what I meant by these two blank roundels set in the bodies of Diligence and Labor, I could not do it.

Afterwards, spontaneously: I mean that I included these two

[4] This was, in fact, the widest publicity available to a noncommissioned painting.

[5] A few days after his first hearing, Zuccaro asked for a second one and insisted that the sketch given to Domenico had been made a few years before the Bolognese incident, and did not, therefore, attack any particular persons. He was then summoned to explain the differences between this drawing and the final cartoon.

roundels intending to make in them something appropriate and relevant to the work, but I did not come to any decision about their content, and therefore left them unfinished.

He was told that it was unlikely for an excellent and accomplished artist like the accused to do something without function and without purpose, especially when it comes to the point of finishing what he has conceived knowingly; and because this is unlikely, it sounds like a lie, and, therefore, the accused should say the truth about what he meant by these two roundels set in the bodies of the said figures.

Answer: I do not know about others; as for myself, very often I leave some empty space in my designs so that I can think of something to put there later; and thus I set these two roundels in the bodies of the figures; and if this does not seem likely to others, it does to me.

8

On
Beauty

INTRODUCTION

The definition of painting and sculpture as arts of imitation explains their kinship with poetry, their scientific and technical pretensions, their didactic value, and their popularity with amateurs who appreciated likeness and illusion. This is why the authors of treatises of art had not much to say about beauty, which was considered as secondary. If we are to look for the real taste of the time, we must turn to writings which deal with beauty independently of its artistic implications.

From the start we find two opposite currents, which philosophical tradition called, with some oversimplification, Platonic and Aristotelian. The first insisted on the impossibility of a purely formal definition of beauty; all was grace, spirit, and life. The other was formalist and based on harmony and decorum. They are here illustrated respectively by one of Michelangelo's sonnets, which recalls Ficino's ideas, and by an extract from Nifo representative of the Aristotelianism of his circle in Padua.

Vincenzo Danti proposed a modernized version of Aristotelianism. To the harmonic correspondence of parts as criterion of beauty, he substituted the adaptation of the organs to their function. Thus he improved on formalism, which was unable to offer, as it should have, a precise canon of beauty. On the other hand, Giordano Bruno—initiating a theory of aesthetics based on the values of expression and pathetic effect —represented an improvement on Platonism, which he enriched with the contributions of natural magic and Venetian sensualism.

Michelangelo: Sonnet

This sonnet is known in eight versions; the first one, addressed to a lady, dates back to c. 1533; the last one, probably sent to Cavalieri, would be c. 1542-46.

The mood of the sonnet is Petrarchian, and Michelangelo certainly did not intend to put Neoplatonic philosophy into verse; but he has definitely injected his Petrarchism with Neoplatonism: beauty is not formal, and does not reside in any corporeal object, but acts as a force which makes the soul remember its divine nature and feel the frustration of its terrestrial condition. But Michelangelo admitted the possibility that the fundamental principle expressed by this indefinable attraction might be of a less metaphysical nature: a reflection or a dream of the ideal world of antiquity (lines 3-6).

Sonnet [1]

I do not know if it's the wished-for light
Of its first maker that the soul can sense,
Or whether, out of popular remembrance,
Some other beauty shines into the heart,

Or someone's formed from dreams, or from report,
Plain to my eyes, and in my heart's presence,
From whom I do not know what smoldering remnants
May be are what now makes my weeping start.

What I sense and I search, and who's my guide
Is not with me, I truly don't see whither
To find it out; it seems I'm shown by others.

This happens to me since I saw you, Lord,
Moved by a yes and no, a sweet and bitter;
I'm sure it must have been those eyes of yours.

A Naturalistic Theory of Beauty

A Paduan view of the theory of beauty has been expressed with remarkable boldness and coherence by Agostino Nifo (Niphus or Suessanus, 1473-1546). His De Pulchro et Amore, 1529, is diametrically opposed to Florentine idealism: formal beauty is a physical property of bodies, and beauty in general, either formal or spiritual, is defined as that which stimulates lust. Aware of the consequences of his position, Nifo stated that neither nature nor art could be properly called beautiful.

His argumentation is scholastic and his reasoning poor, but his radical anti-Platonism corresponds to the manner in which certain Venetian amateurs spoke about Giorgione and Titian; we can trace here a relation comparable to that between the Platonism of the Florentines and their actual artistic taste.

From Agostino Nifo: *On Beauty and Love* [1]

Chapter 1. How Protagoras Has Denied that Beauty Is in the Nature of Things

Since, as we have said, we shall have to speak about beauty and love,

[1] Sonnet No. 74 in *Complete Poems and Selected Letters of Michelangelo,* trans. and notes by Creighton Gilbert (New York: Random House, Inc., 1963), p. 53. Reprinted by permission of the publisher.

[1] Translated from the edition of Lyon, 1549.

it will first be necessary to establish whether beauty is in the very nature of things or not. Because in all scientific problems, this is the first question. Protagoras, the Sophist, who has denied or at least questioned the existence of the gods, has excluded beauty from nature; this has been confirmed by Aristotle's great genius in the first book of the *Ethics* where he says: "what is proper and what is just, the object of political science, is so changeable and so different [according to the case], that it seems to exist only by convention, and not by nature"; [2] in Greek, "what is proper" *(honestum)* is expressed by χαλά . And Plato, in the *Hippias major,* in the *Banquet,* and in the *Phedrum,* seems to mean by χαλά things beautiful. If, therefore, there is such a variety and difference among beautiful things that they seem to be so by convention only, and not by nature, this implies that beauty itself is not grounded in the very nature of things, but that it is only relative to those who love, so that one calls beautiful that which the lover longs for, and ugly that which the lover would absolutely not want to possess.[3] Furthermore, Aristotle, the greatest of all philosophers, always refers the beauty of things to our desires; and desires are not identical in everybody, and do not refer to the same objects. Thus there would be nothing beautiful which would not be sometimes beautiful, sometimes ugly, according to the lover's personality; like food, which is sweet to a healthy organism and bitter to a sick one.

Chapter 4. THAT BEAUTY IS IN THE NATURE OF THINGS

That beauty is in the nature of things is proved by Socrates, according to Plato in the *Hippias major:* to start with, it is through justice that the just are just; and through wisdom that the wise are wise; in the same way, all good things are so through the good. But justice, wisdom, and the good must exist by themselves; because, if they did not exist, nothing could participate through them in these qualities. And since all beautiful things are beautiful through beauty itself, it follows that beauty, through which we know things to be beautiful, does exist. Furthermore, if it is true, according to the method of demonstration used by Aristotle in the *De Caelo,*[4] that when one of two contraries is in the nature of things, the other is too, since nobody doubts that the ugly is in the nature of things, there follows that the beautiful which is the contrary of the ugly, must be in the nature of things too. Finally: love

[2] *Nicomachean Ethics,* A I, 1094 a.

[3] The same Greek word means the beautiful and what is convenient. Aristotle says that what is convenient is established by convention; therefore beauty is a matter of convention. This ridiculous reasoning is, of course, put in the mouth of the contradictor.

[4] *De Caelo,* II, 3, 286a.

exists; therefore, beauty, too, must exist. All lovers bear witness that love exists, and since love, according to Plato's definition, is nothing but the desire to enjoy beauty, the beauty that lovers long to enjoy must exist.

[The next chapter, 5, is titled: *"Here It Is Demonstrated, by the Beauty of the Illustrious Joanna,*[5] *that Beauty as Such Exists in the Nature of Things."*]

Chapter 17. Beauty Is not an Immaterial Image, Issued from the Thing which Pleases and Filling the Lover's Soul

The most learned Ficino, confusing, if I may speak so, *id quo* (the instrument) and *id quod* (the subject), states that beauty is an image issued from the thing toward the soul [of the lover]. This as false, because in this case beauty would not be real *(realis)* as the philosophers say, but dependent on an action of the mind *(intentionalis)*.[6] But the image dependent on an action of the mind does not please; it is that through which the object, of which it is an image, pleases. Furthermore, the image of the beautiful thing represents something to the soul: either beauty, and in this case the beautiful thing contains, besides the image of beauty for the mind, real beauty itself, which is the object of the philosophers' investigation; or ugliness, which can absolutely not be asserted, for in this case the image would not correspond to that of which it is an image.

Chapter 18. In What Sense Beauty Is Corporeal, and in What Sense It Is Incorporeal

But since Plato assures us that beauty is noncorporeal and spiritual, we are going to explain in what sense it is corporeal, and in what sense it is incorporeal and spiritual.[7] He thinks that beauty is either identical with grace, or at least never without that grace which makes the beautiful object agreeable *(gratus)* to those who love it. Now, grace does not have one particular part of the beautiful body to which it would be attached precisely and definitely, so that it could not be found in any other part of the body; because with some girls grace is in their voice and the sweetness of their speech, with others in the eyes, with others in the mouth, the hand, the gait, the jaw; and to end this enumeration, it does not have any part of the body in proper, but it resides in that which makes the lover's mind want to enjoy it. Now, since the lover's soul is

[5] Joanna of Aragon, to whom this book is dedicated.

[6] The Latin words in parentheses are borrowed from the scholastic vocabulary which Nifo apologized for using in a work intended for the public rather than philosophers.

[7] The actual existence of beauty in things is proved both by deduction and empirically (Joanna of Aragon, for example); Nifo proposed to conciliate this merely physical existence with Plato's theory of beauty.

enraptured sometimes by the hand, sometimes by the eyes, at other times by the mouth, it follows that grace does not reside in any part of the body, but that, in each part, it is that by which the body can sometimes enrapture the lovers' souls. With Lesbia, grace was in her eyes, because it is with her eyes that she caught Catullus; the same with Laura, for it is with her eyes that Laura touched the soul of Petrarca. But Fulvia, your Lady in waiting, Illustrious Joan, had grace in her eyes as well as in the sweetness of her speech; for it is through these means, I must confess, that she has caught me and has enraptured me. Thus, since grace at the origin of the affect is not linked to any part of the body, Plato is right in declaring it incorporeal and spiritual, because it does not reside in any particular part of the body otherwise than through the lover's passion. It is, however, corporeal, because, when it has enraptured the soul, it renders the whole body graceful and agreeable to the lover. And what inhabits the whole body is corporeal and has the same extension as the body itself.[8]

Chapter 31. IN WHICH THE PROPER SENSE OF BEAUTY IS EXPLAINED ACCORDING TO THE PERIPATETICIANS

It is not hard, from what precedes, to deduce what beauty is in the proper sense. Because, if beauty is that which incites souls to desire, which is a form of love, nothing would be beautiful which would not have some connection with desire which is an affect of the senses. Thus, since neither intelligible substances, the sky, the world, nor the elements arouse desire which is an affect of the senses' thirst, none of these can be properly called beautiful. Hence the sky which is, in Pliny's words carved,[9] and a discourse or a poem are not beautiful, but full of ornament and decorum; the same holds true for good conduct and for buildings, because they do not arouse lust in our souls. That is beautiful, therefore, which by itself arouses desire, which is an affect of the senses, full of apprehensive eagerness.[10] But we shall return to this topic at greater length.

[8] Grace which does not reside in any precise part of the body cannot, therefore, have spacial and physical definition. But when it "inhabits equally the whole body," it actually resides in each part, and becomes identical to the body's appearance. This naïvely pedantic demonstration actually covers a thesis which must have seemed cynical: beauty is spiritual only in the beginning of love.

[9] Pliny, *Nat. Hist.*, ii, 8, gives the etymology of *caelum* as derived from *caelatum* which would mean either ornate (with the stars) or carved, i.e., vaulted. (Cf. Gauricus, *De Sculptura*, ed. Brockhaus (1886), p. 238). Nifo wanted to establish that the beauty of nature is of the same order as that of art—an ornament which pleases, and not true beauty which excites love.

[10] A reminiscence of Ovid, *Heroides*, I, 12: *Res est soliciti plena timoris amor.* Landscape and art, which do not provoke this "apprehensive eagerness," are not truly beautiful.

Danti's Aesthetic Idealism

Starting from his functional conception of beauty (see above, pp. 100-105), in the following text Danti developed the academic opposition, dear to Michelangelo's disciples, between idealism and realism.

Danti: Of the Distinction that I Make Between Imitation and Copying [1]

To copy would be the perfect means to practice the art of design, except that the things which are produced by nature and by art are, as I have said, most of the time imperfect both in quality and quantity, because of many accidents. All the forms as intended by Nature are very beautiful and perfectly proportioned in themselves, but matter is not always able to receive them perfectly.[2] This shortcoming, i.e., that most of the time matter does nòt admit the perfection of form, is the reason why we use the method of working by imitation, as I have indicated in the beginning. This method is first to consider and make intelligible the formal concept in the thing that Nature has actually produced. And this consideration, or rather reasoning, applied to sentient animals makes us understand that we must elucidate the movements of the animals' limbs, because of which Nature has given a particular shape to each species of animal.[3] Knowing this, we shall also consequently know the quality and quantity of the limbs which move in this or that movement, and, furthermore, the proper and particular proportion of the members. This proportion can also be seen and recognized from the qualities and quantities formed by these members, by seeing which quantity and quality of strength, shape, and placement are necessary for this and that movement. These things, I say, can be known by the example of those movements which animals make perfectly, each according to its kind, because for each species all the perfection of both movements and proportions can be seen [distributed] in this and that specimen, as I have said at other times. Considering that one given animal shows one member, and another animal another member perfectly proportioned relative to the purpose of the motion of each particular member or part of it, then, from the example of the perfect parts which are seen in the universal of the species, our imaginative faculty composes in the mind the particular, perfect, and proportionate animal of any species. When

[1] Translated from Barocchi, *Trattati,* I, 264-267.

[2] A philosophical commonplace; the novelty is to use it to motivate artistic idealism.

[3] This functional conception of the shape of organs will be elaborated below into a functional conception of animal beauty. This idea is less audacious than it appears at first: it stems from the finalism of Christian natural philosophy, joined to the general conviction that the good and the beautiful coincide.

to this [mental] composition are joined hands able to execute it perfectly in a work, just as it exists perfectly in the intellect, and if the material in which it is to be cast is adequate, this will result in the perfect use of imitation by any artist, either sculptor or painter.

Thus, through these paths, analysis, reasoning, and elucidation, one moves toward the operation of imitating and one creates in one's mind the perfect form as intended by Nature, which we afterwards try and make into a picture either with marble or paints, or another material used in our arts; and this is not only true for the figure of man, but also for that of all the other sentient animals, and vegetable, and inanimate objects, and for all the artefacts. It is, however, true that we use a way of reasoning for inanimate, vegetable, and artificial bodies which is different from that used for sentient and intellective ones; and the method of reasoning described above applies to sentient and intellective animals. The method which applies to the other bodies is much easier, as it happens that all the things which do not have sentient faculties can be observed and understood much easier as to their being and to their parts, proportions, and shape, because, lacking sentient faculties, they lack motion, and the most difficult reasoning there is of this kind is that which concerns the movements of animals, due to their infinite changes and variety, as we said.

As for the method of copying things, it is much easier than imitating. Because the artist who wishes to copy this or that object with no reasoning or elucidation concerning the being of the object, only tries to remember what he sees with his eyes; and in this case memory is used, since once a thing has been seen, the memory retains the image of it until the hand and the eyes of the artist are put to work. And for this reason one can say that copying is as different from imitating as the writing of history is from the making of poetry, as I have said above; and that the artist who uses imitation is as superior in nobility and in dignity to the copyist as the poet is incomparably nobler and on a higher level than the historian.[4] This road of imitation uses all the powers of the intellect, treading in this pursuit the most noble and perfect paths of philosophy, which are the reasoning upon, and consideration of, the causes of things. And this is what ennobles and has ennobled our art in the past, i.e., that our art is a faculty dependent on philosophy and on some of the other sciences, as we shall see later in the following books. And this art can really not be practiced with perfection if it does not follow the method of imitation, because, without it, it lacks that part of philosophy which is relevant. But copying can not have in itself any artistic perfection if it does not depend upon imitation, nor can a por-

[4] Aristotle, *Poetics*, ix, 3, 1451b.

trayal from the hand of any artist at all be very good if it does not contain some part of imitation. And we can not find anyone who can portray living beings well without some ability in the whole process of imitation. There might be many who are well able to draw and copy whatever inanimate bodies they see, but they will never be able to do anything perfect by themselves. And such people can not be counted among the true masters of our arts. Whence it is seen that there are two possible kinds of copying: the first is to copy things either perfect or imperfect as they are seen; this can not be accepted as true design. The other is to copy things which are found to be of total perfection. But even this way is much more perfect when he who copies is able to practice imitation. And thus the artist who uses these two methods in practicing our art— i.e., using imitation when things are imperfect in themselves and need to be perfected, and using copying for perfect things—that artist will be on the true and good path of design. The difference that we have said to exist between imitation and copying is that the latter makes perfect things as they are seen, and the former makes them perfect as they should be seen.[5] And this is the definition of both methods of carrying out the art of design, i.e., copying and imitation. But, as we turn to the artefacts that can be imitated and copied, we have seen that those which have both perfection of art and of material must be copied; and those which are deficient on those points must be imitated, giving them all the perfection that they require.

Giordano Bruno's Aesthetics of Fascination

Towards the end of the 16th century some theoreticians abandoned the idea of equating art with a science or a liberal profession, and considered it as a sort of magic. Art became no longer an imitation of nature in a traditional sense, nor a metaphorical language to communicate ideas, nor a manual craft, but the action of one soul on another. In this way, one accounted for the irrational aspects of art, in particular everything which escaped academic rules: individual taste and style, artistic personality, the fascination of forms, the pathetic, and so on.

The main sources of the new theory were the naturalistic anti-academism of the Venetians like Aretino, and Neoplatonism, strongly influenced itself by astrology and theories of natural magic. The idea of the artist as a force of nature (from Aretino), the concept of inspiration and grace as an irrational psychic attraction (from Neoplatonism), and the theory of the action of individual temperament on taste and style (from natural magic) are an anticipation of baroque aesthetics.

This conception was formulated by Giordano Bruno, the most inspired thinker of Italy, who gave philosophic expression to the new

[5] This distinction also comes from Aristotle's *Poetics*, ii, 2, 1448a.

astronomic vision of the universe and was burned at the stake in 1600. He applied his aesthetics to poetry in Eroici Furori; *in* De vinculis in genere *(Of Bonds in General), however, he gave a more comprehensive theory. He might have found a sketch of it in the theory of fascination expounded in the so called* Theology of Aristotle, *a precis of Plotinus known through an Arabic version, but he was the first to give it systematic expression and to stress its aesthetic aspects.*

According to Bruno, spiritual beings (God, angels, demons, human souls), which evidently can not act by material means, exert their influence through spiritual forces akin to fascination. These forces are called bonds and are manifested in love, art, magic, and in the effects of imagination.

Giordano Bruno: Of Bonds in General

OF THAT WHICH BINDS IN GENERAL [1]

The different kinds of binders.[2] Binders are altogether: God, demon, spirit, animate being, nature, chance and fortune, fate. The binder as such, who can not be designated by any one name, does not bind physically or through the corporeal senses, because the body does not stir the senses by itself, but through a certain force which exists in the body and emanates from it. The "hand that binds" is therefore called thus only figuratively because, through various preparations,[3] it incites and influences the body to become bound.

Operations of the binder. The binder is, according to the Platonists, that which adorns the Intellect with the Ideas [4]; which introduces into the mind the chains of reasons and rhythmic discourse [5]; which fecundates Nature with the different seeds [6]; which shapes matter by innumerable means; which quickens, softens, charms, animates everything; which prepares, creates, governs, attracts, inflames everything; which moves, discloses, enlightens, purifies, gratifies, fulfils everything.[7]

To bind by art. The artist binds by his art, since art is the beauty

[1] First published in Giordano Bruno, *Opera latina,* ed. Tocco, III.

[2] Binders, i.e., those who exercise an action akin to magics.

[3] In the original meaning, preparations are the rites, clothes, or drawings which attract astral influence on a given object. Since Ficino, the term applies mainly to the formal qualities of harmony which, without being themselves beautiful, attract beauty as a kind of grace.

[4] The Intellect (Νοϵς) is the dwelling of Platonic Ideas. Here the binder may be either the One, the Good, or God.

[5] That is philosophy and poetry, which are "inspired" operations.

[6] Bruno thinks of *rationes seminales,* i.e., Ideas as acting in nature.

[7] Bruno shows, according to the Neoplatonic pattern, 1. the action of the binder going down by steps from God to matter; 2. the effects of this action (the upwards attraction), described successively as a) animation of matter, ("quickens stimulates"), b) as love in living beings ("prepare inflame"), c) as mystical itinerary of the soul (illumination, purification, mystical union).

peculiar to the artist. Indeed, one who would look at the beauty of natural or artificial things without at the same time contemplating and admiring the mind through which all this was done, would look at it in a foolish and stupid way; for him it would not be true that "the stars recount the glory of God [8]; and such a crude soul does not love God more than His creations.[9]

What he who binds owes to his own genius.[10] Some say that the binder binds others without being bound in turn, thanks to the superiority of his genius, reciprocal bonds belonging to equal minds and residing in a particular relation between qualities.[11] A consequence of such a thesis would be that genius would have to change and transform itself constantly, as do forms, humors, and images. Who is bound by the boy is less so by the man; and who is bound by the girl is not by the woman. Therefore one must not look for a single or simple principle of binding what is naturally complex, various, and capable of containing opposed elements.[12]

Who is more easily bound. The man who is most truly man is most easily bound by the appearance of the noblest objects; for he would much rather hope for the noblest than possess what is base, and he is soon cloyed by such a possession. We love more ardently what is of difficult access.

The binder binds different objects with different chains. Nothing is absolutely beautiful if it binds by pleasure, nothing is absolutely good if it attracts by utility, nothing is absolutely great if finite. As to beauty, consider that the ape pleases its female, the stallion pleases the mare, and Venus herself is not of another species than men and heroes.[13] As to good, consider that everything comprises contraries: some living creatures seek their good under water, others on land, some in the mountains, others in the fields, some in abysses, others aloft.

No single being can bind all individual beings. What is absolutely beautiful, good, great, and true binds the affections and the intellect and all absolutely, loses nothing, contains all, desires all, is desired and sought

[8] Ps. 18 (19), 2.

[9] Behind this theological commonplace we discern the antiacademic statement that the value and beauty of a work of art are significant mainly in so far as they reflect the "art of the artist."

[10] The Latin *genius* is here given, exceptionally, the meaning of *ingenium*.

[11] Each binds the other by that in which he is superior to the other.

[12] The *ingenium*, although superior to nature, is itself a product of nature and varies with the condition of the body and with objects encountered.

[13] Man can not imagine beauty, even divine, except through the appearance of a being of his own kind, a woman. As long as one does not distinguish between beauty and pleasure, one is condemned to relativism. The following sentence shows that the same happens with the good and the useful. As for the reference to apes, see Erasmus, *Adagia*, ed. (Basel, 1559), No. 4964, pp. 1038-39.

by many, since it commands bonds of several kinds. This is the reason why we strive to command several arts,[14] if it is true that what grieves us is not existence as such, but being one thing or another in particular. . . . All the beauty and good of a given species is found only in the species as a whole, and must be looked for in all its specimens one by one through eternity. This is demonstrated for human beauty by Zeuxis who has painted Helen using several Crotonian maidens as models.[15] Even if it were possible that a girl should be beautiful in everything or entirely so, who could be beautiful in all possible ways? since there are innumerable kinds of physical beauty in women, and since they can not coexist in one subject. Because beauty, whether it consist in some kind of proportion or in something incorporeal which shines through physical nature,[16] is manifold and works on countless levels; just as the irregularity of a stone does not fit, coincide, and join with the irregularity of any other stone (but only there where the reliefs and the hollows best correspond), in the same way any appearance will not strike just any mind [17]. . . .

OF THAT WHICH CAN BE BOUND

The reasons and favorable conditions which help to bind things. It is easier to bind when something that belongs to that which is bound also belongs to that which binds, for then that which binds governs the bound through something which belongs to the latter. This is why necromancers, to take one example, claim to govern a whole living body by means of its nails and hair, or even by means of clothing or footprints; they also summon up the souls of the dead using the bones or some other part of the corpse. Therefore it was not idle to set a careful watch over tombs, to raise funeral pyres in front of them,[18] and to consider it a terrible punishment not to be buried. The orator wins the favor of the listeners and the judge by causing them to share something in common with him.[19]

[14] We strive to command as many bonds as possible to escape our finitude.

[15] A new interpretation of this anecdote: as though Zeuxis wanted to prove in a negative way that perfect beauty is an unattainable concept.

[16] These are the definitions attributed respectively to Aristotelianism and Platonism.

[17] Perfect beauty is as impossible as perfect universality for several reasons: a) nature realizes the perfection of a species only in the whole of the species (cf. Danti, p. 182); b) the different forms of beauty are incompatible; c) one can not dissociate the beauty of an object and the particular disposition of the one who experiences it.

[18] The ancient Romans used to cremate the body on funeral pyres in front of the tomb.

[19] Rhetorical persuasion is here considered as a kind of sympathetic magic, since the orator communicates his emotion to the listeners.

The truth of that which can be bound. To be truly bound, that which can be bound does not so much need true bonds, i.e. those that are fundamentally such, as apparent bonds, i.e. those which are such to the mind, because false imagination can truly bind and that which can be bound may be truly compelled by it. Even if there were no hell, the untrue belief in and the imagination of it would truly constitute a true hell. Because an imaginary representation has its own truth, from which it follows that it is truly efficient and that which can be bound is truly and strongly bound by it. . . .

OF THE BOND OF LOVE, AND, IN A WAY, OF BONDS IN GENERAL [20]

We have said in *Natural Magic* [21] how bonds of all kinds sometimes can be reduced to the bond of love, sometimes derive from it and sometimes are identical with it. Indeed, it will soon become clear to the searcher who investigates thirty kinds of links [22] that love is the foundation of all affects. For he who loves nothing has no reason for fear, hope, boastfulness, pride, audacity, spite, humility, emulation, wrath, no reason to accuse or to forgive and to experience other affects of this kind. We have here abundant material and a wide field for meditation and speculation, to which we open the door in this chapter of the *bond of love,* but this title must not make us believe any longer that this theory gives precedence to political science, since it embraces infinitely more than political science.[23]

Modes of the bonds. Orators and courtiers and professionals in any field bind more effectively if they apply their art with some stealthy dissimulation. He who speaks ever so well, who is ever so anxious to show his knowledge, is not the one who will please; costumes worn with too much care and symmetry, curly hair, eyes, gestures and movements complying with all the rules are repellent, and these things are far from being agreeable. The same holds true for public speeches which are vulgarly called too sophisticated or overelaborate. In fact we should rather explain this shortcoming by the dullness and lack of talent and intelligence; [24] because it is an important part of art to know how to use art in order to dissimulate art.[25] It is not in good taste to display

[20] All the bonds of sympathetic magic, art included, are bonds of love.

[21] There is no work of Bruno with this title; it might refer to *De Magia,* but Bruno often refers the reader to nonexistent works.

[22] I.e., an indefinite number.

[23] "Political" is taken in the wide Aristotelian meaning of "relating to a science of social structures." Bruno's theory of love embraces, besides human society, nature (as one can see from magic) and the metaphysical action of God, the Intellect, the Ideas, etc.

[24] Sophistication shows a lack and not an excess of artistic intelligence.

[25] This is a classical commonplace.

good taste in everything and everywhere,[26] in the same way that someone who has his fingers covered with rings and gems and another who puts on stacks of necklaces do not wear their jewels properly. One must always remember that the brilliance of one light dims another, and that light gleams, glitters, shines, and pleases only in the darkness. An ornament is not one if it is not becoming to the rough object it has to ornate. Thus, art can not be separated from nature, nor elaboration from simplicity. . . .

Classification of bonds. There is no merely natural nor merely conventional bond in the sense that common people distinguish between nature and convention. . . .[27]

26 In the Latin, *belle sapere,* an unusual phrase coined by Bruno to underline the double sense of intelligence (*sapientia*) and taste (*sapere*).

27 In this identification, which is very characteristic of Bruno's thinking, the stress is on nature; all natural activity is, in a sense, artistic, but art is essentially a natural phenomenon.

Index
of Artists